The Amphoto Photography Workshop Series

LIGHT

Working with available and photographic lighting

The Amphoto Photography Workshop Series

LIGHT

Working with available and photographic lighting

Michael Freeman

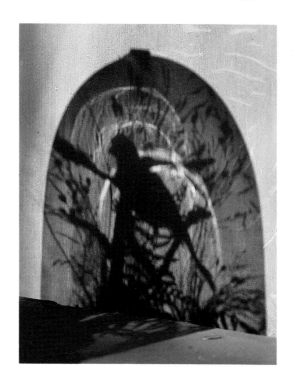

amphoto

First published in 1988 in the United States by
Amphoto, an imprint of Watson Guptill
Publications, a division of Billboard Publications
Inc., 1515 Broadway, New York, New York
10036

**Library of Congress Cataloging-in-
Publication Data**

Freeman, Michael, *1945–*
 The Amphoto photography workshop series.
 Light.

 Includes index.
 1. Photography – Lighting. I. Title.
TR590.F725 1988 778.7 88–6271
ISBN 0–8174–4192–1

Editor	Sydney Francis
Designer	Christine Wood
Illustrations	Rick Blakely

Phototypeset by Qualitext Typesetting,
Abingdon, Oxon
Originated in Hong Kong by Bright Arts (HK)
Ltd
Printed and bound Italy by Amilcare Pizzi,
S.p.A.

The author and publishers also gratefully
acknowledge the assistance of Keith Johnson
Ltd, Kodak (UK) Ltd and Neyla Freeman.

CONTENTS

INTRODUCTION

In photography, light creates the image. The relationship is as basic as that; film is sensitive to light, and cannot produce a visible photograph without it. Yet to make images that have the power to stimulate interest and pleasure, this basic relationship is influenced by a variety of permutations. The effective use of light involves a mixture of the technical and the aesthetic.

The technical light requirements of photography are those of quantity, colour balance and synchronization. The first two of these are set by the limitations of the film, the last by the method of exposing it. A certain amount of light is needed by the emulsion in order to produce an adequately exposed image. There is some leeway in what constitutes "adequate", but broadly speaking, the film speed sets the limit. The range of film speeds available broadens the range of light levels that can be used for photography, but as the by-product of high sensitivity is graininess, slower films are usually preferred when conditions allow them to be used.

The two methods of regulating the dose of light that reaches the film are the shutter speed and the aperture. (This is covered in more detail in volume I of the series, *Cameras and Lenses.*) These introduce extra variables of choice, as they each have other functions beyond just controlling how much light passes through the camera. The shutter speed controls the sharpness with which movement in the image is recorded, and the aperture alters the depth of field.

These in turn depend on the subject and on what the photographer wants from the picture. Any condition that warrants a faster shutter speed (such as a fast-moving subject) or a smaller aperture (such as increased depth of field needed by a deep subject) affects the quantity of light. Clearly, the permutations of all the technical factors are considerable.

Film reacts selectively to light in ways that are different from the eye, and thus the colour of light also needs to be treated with some care. Human vision is sufficiently sophisticated to make its own compensations for many of the colour variations in lighting. Tungsten light, for example, never seems quite as orange to the eye as it really is, nor does skylight on a clear day appear its full blue. Film, on the other hand, has a more literal response, so that if we want the photographic results to look completely realistic, the light reaching the film must somehow be balanced for colour. Filters are the usual method, either over the lens or over the light source. Moreover, the type of response to certain light sources differs between film and the eye. For instance, although most films have a layer to absorb ultraviolet wavelengths (shorter than visible light), they will still give slightly bluer, paler images of things at great distances and high altitudes than appear to the eye.

Finally, the light must be in synchronization with the camera's shutter. For nearly all ambient light this is no problem at all, although fluorescent tubes are a pulsating source and need a relatively slow shutter speed. Flash, however, is an important form of photographic lighting, and has special needs. The single pulse must fit within the duration of the shutter opening.

For some photographers these technical requirements weigh rather too heavily for the good of the aesthetic side of the image, and can demand rather more attention than is really necessary. It is in the *quality* of light that the really important decisions lie. This involves an appreciation of what illumination is really appropriate and effective for different subjects and scenes; also of how to make the best use of what lighting conditions exist. This in no way diminishes the importance of the technical management of light; we will deal thoroughly with the practicalities of, for instance, fitting and positioning studio lamps later in the book. The technical management is the necessary foundation for using light – but it is no more than that.

Ultimately, interesting and successful use of light depends on the ability to judge and feel its character. Although we can describe the effects in detail, and show how the angle strikes the subject to give a certain effect, and atmospheric haze produces a certain colour, and so on, a complete appreciation must come from deeper. In this book, the most valuable descriptions of the essentials of lighting quality are the photographs themselves. Fortunately, photography is not so exact that all of it can be put into words.

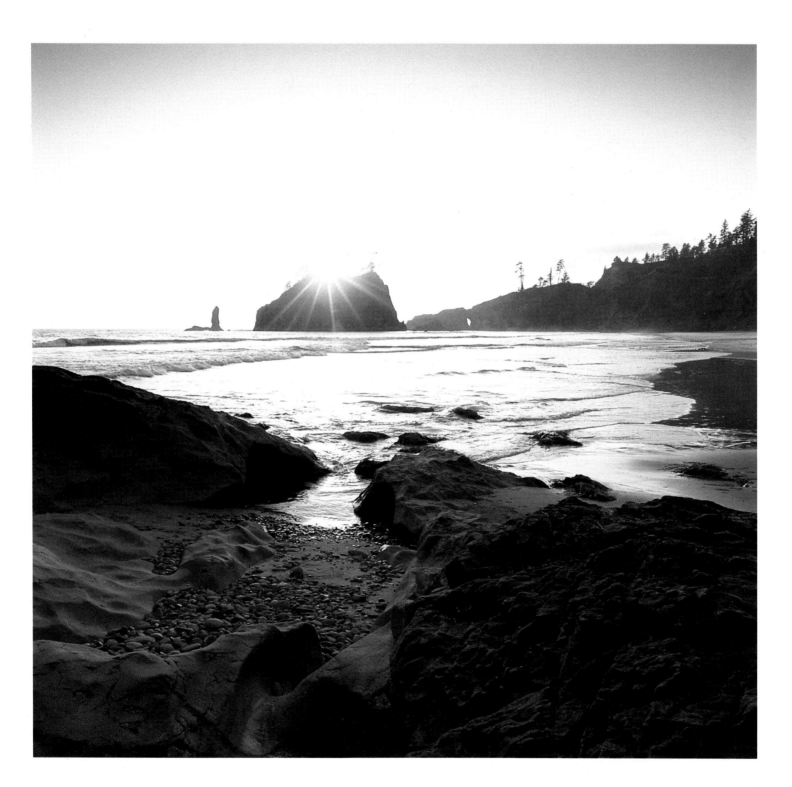

The Spectrum

Light is radiation. Specifically, it is radiation that the eye can see, but it is only one small band in the entire electromagnetic spectrum. This spectrum is a range of wavelengths, from short to long, that includes, in addition to light, gamma radiation, X-rays, radar, radio and other forms. There are no divisions between these groups, and no breaks in the spectrum; instead there is a steady progression of wavelengths.

Gamma rays at the short end of the spectrum have wavelengths of only $1/100,000,000$ mm. Radio waves, by contrast, can have wavelengths of up to 6 miles (10km). Between these extremes, a small band of wavelengths little shorter than $1/1000$ mm stimulates the eye. Wavelength marks the difference between all these types of radiation; the eye is sensitive to the narrow band between 400 and 700 nanometers (nm) or millimicrons (10^{-9} meter or $1/1,000,000$ mm).

Just as most variations in wavelength produce radiation that has very distinctive properties, the small range of visible wavelengths contains a variety of effects. The eye sees these small differences as colour. We perceive the shortest visible wavelengths as violet, and the longest as red. In between are the familiar colours of the spectrum, of which the eye can normally distinguish seven.

These colours "exist" only in our eye and mind. The light waves themselves are not coloured. Also, unlike other senses, human vision is not capable of identifying the component parts of light. We can distinguish the different flavours that make up a particular taste, and the sounds of different instruments in an orchestra, but a full mixture of all these spectral colours appears only as white. What we think of as the colourless, neutral quality of white light is because of the way our eyes have evolved, under sunlight. The sun at noon is our reference standard.

One way in which the full spread of spectral colours becomes visible is through refraction. The classic laboratory demonstration is to shine white light through a glass prism. This splits the light into its component wavelengths. Strictly speaking, it does not actually divide the beam; it displays a continuous band. Our eyes do the dividing. In the natural world, we can see this in a rainbow, which is the result of raindrops acting as tiny prisms to refract sunlight. Another way of making the spectrum visible is through interference, as in the surface of an oil slick.

The second way in which colour is created, and by far the most common, is by filtering out some of the wavelengths. One of the pieces of equipment that you should have for this book is a fairly comprehensive set of filters. Take a strong yellow filter and hold it in front of you. What this filter is actually doing is to block two parts of the spectrum: from violet to green, and from orange to red. In other words, it acts as a window, allowing only one section of the visible band through. This gives us a clue as to why objects have colour. The filter in your hand transmits light, but a solid surface can also act as a filter. The composi-tion of the surface of a lemon does, by reflection, exactly what the filter does. It absorbs all other parts of the spectrum. What is visible is what the surface allows to be reflected: in this case, yellow.

One more factor is needed to complete the picture of the spectrum: our sensitivity to it. As seems logical, human vision is most sensitive to the center of the visible band and least at the edges. The limits of visible light are, at the short wavelengths, violet, and at the long wavelengths, deep red, and both of them are the deepest colours. The eye's maximum sensitivity is in the middle, halfway between 400 and 700 nm, at approximately 550 nm, yellow-green. If you had to choose a single colour that gave the greatest visibility, it would be this. You can demonstrate this for yourself by taking two filters of equal density: one green, and one red. The most easily available are in Kodak's Wratten series, 58 (green) and 25 (red). The 58 is not exactly at 550 nm, but is close enough. In sequence, view any daylit scene through these filters. The green will give the clearer view.

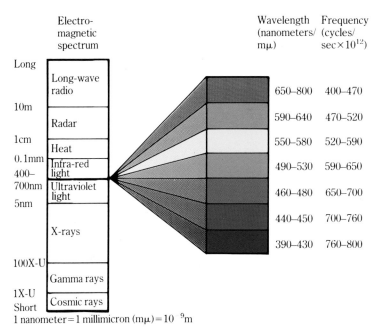

Electro-magnetic spectrum		Wavelength (nanometers/ mμ)	Frequency (cycles/ sec×10^{12})
Long			
	Long-wave radio	650–800	400–470
10m		590–640	470–520
	Radar	550–580	520–590
1cm			
0.1mm	Heat	490–530	590–650
400– 700nm	Infra-red light	460–480	650–700
5nm	Ultraviolet light	440–450	700–760
	X-rays	390–430	760–800
100X-U			
1X-U	Gamma rays		
Short	Cosmic rays		

1 nanometer = 1 millimicron (mμ) = 10^{-9}m

Electro-magnetic spectrum
The visible spectrum of wavelengths is only a small part of the entire electro-magnetic wavelengths, from 400 nm to 700 nm, between infra-red and ultraviolet. X-rays and gamma rays, being much shorter, are more energetic and can pass through many solid materials. The longer radio waves have too little energy to be perceived by the human body.

One of the most common naturally-occurring versions of the spectrum is a rainbow. Raindrops act as miniature prisms, refracting "white" sunlight into its component colours. Weak rainbows usually lack either end of the scale (red and violet).

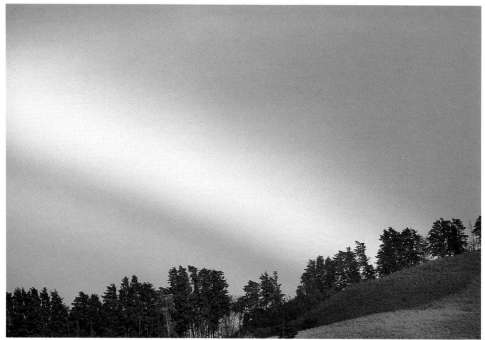

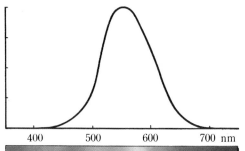

The eye's sensitivity
The human eye is not equally sensitive to all the wavelengths, and peaks in the middle, at around yellow-green. The graph *above*, coloured for the way we perceive the different wavelengths, shows the visual luminosity curve for the eye. Crudely put, this means we see better by green light than by red – something you can check for yourself by using the filters *below* to view any scene.

Use green and red filters in sequence to view any scene. The green view will seem brighter, because of the way the eye responds to the spectrum.

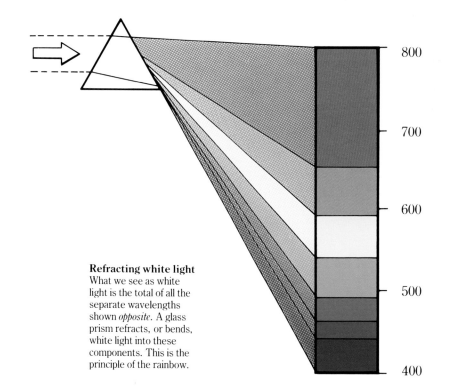

Refracting white light
What we see as white light is the total of all the separate wavelengths shown *opposite*. A glass prism refracts, or bends, white light into these components. This is the principle of the rainbow.

Colour Temperature

Colour temperature is the usual way in photography of describing the main colour differences in light. Although light can be any colour at all, the most important form, daylight, varies along one scale, from reddish-orange to blue. A rich sunset is red, a clear sky, blue. In between, the sun in the middle of the day appears white. This scale is referred to as colour temperature because this range of colour change is exactly what happens when a substance is heated. As the heat increases, the first sign of colour is a dull red glow; just what happens when an electric cooking ring is switched on. As the heat increases, the colour brightens and becomes more orange, and then more yellow, until it reaches the stage of being white-hot. By this time, most things being heated would ordinarily have melted, but for the purposes of working out the scale, the assumption is that the material is non-reactive and cannot melt. Beyond white-hot, the colour changes slowly to blue. Plasma and some stars burn this intensely but temperatures of this scale are out of our ordinary experience.

The point is that, at temperatures above about 1200 or 1300°C (2200 or 2400°F), you can define a colour on this orange-blue scale very precisely simply by referring to its temperature. The temperature scale used is the one used for thermodynamics, kelvin (K), in which the degree intervals are equal to those of degrees Celsius or Centigrade, but which start at absolute zero (i.e. -273°C; approx -492°F). It is used in photography because it puts a measurement on the colour, and so an exact combination of filters can be chosen to change one colour to another.

Why should this be necessary? In fact, it is often not worth bothering with; most red sunsets, for example, look fine as they are. However, there are many other occasions when neutral (that is, white) lighting is needed, and then the colour temperature scale comes into its own.

The eye tends to adjust to changes in colour. For example, if you sit under tungsten lighting at night, it does not take long before the lighting appears to be more or less white – at least, no more than slightly yellow. This ability of the visual cortex is known as chromatic adaptation. Film, understandably, lacks this, and reproduces colour exactly as it is. Tungsten lighting, being created by heat, is right on the scale of colour temperature, and light from a 100-watt lamp, which is fairly bright by domestic standards, is quite orange in appearance, as the table *below* shows. Its colour temperature is 2860 K. In photography, white is 5500 K, the colour temperature of sunlight at midday in summer. To make what you see by the light of the 100-watt lamp look like the image on film, the light passing through the camera's lens must be more blue. Hence the need for colour conversion filters, and the existence of colour film that is balanced for tungsten light (Types A and B film).

Another measurement is used for colour temperature. This is the mired scale (*mi*cro *re*ciprocal *de*gree), and is the result of dividing one million by the colour tempera-

K	Mireds	Natural source	Artificial source
10,000	56	Blue sky	
7500	128	Shade under blue sky	
7000	135	Shade under partly cloudy sky	
6500	147	Daylight, deep shade	
6000	167	Overcast sky	Electronic flash
5500	184	Average noon daylight	Flash bulb
5000	200		
4500	222	Afternoon sunlight	Fluorescent "daylight"
4000	250		Fluorescent "warm white"
3500	286	Early morning/evening sunlight	Photofloods (3400K)
3000	333	Sunset	Photolamps/studio tungsten (3200K)
2500	400		Domestic tungsten
1930	518		Candlelight

The range of colour temperature
In photography, the range of colour temperature that has practical value is from around 2000K (flames) to about 10,000K (the colour of a deep blue sky). The mired shift values are shown alongside the kelvin scale – these can be added and subtracted to calculate differences and which filters to use.

ture in kelvin. The reason for its existence is that the colour temperature scale is not proportional, and the shift from one colour temperature to another is not the same in kelvin at a low colour temperature as it is at a higher level. The mired scale is intended to simplify calculations. Every colour conversion filter has a single mired shift value. If you measure the difference between the colour temperature of the light as it is and the colour temperature that you want it to be, in mireds, you can then select the necessary filter.

All this said, it is worth noting that the blue of the sky has nothing to do with the temperature; it is caused by scattering of the short wavelengths. Nevertheless, the colour coincides with the blue on the scale, and in practice, the system works.

Colour conversion filters

This range of filters, in different strengths, raises or lowers the colour temperature. Their most common use is to normalize the lighting to white, but this is by no means always necessary (sunset lighting "corrected" to white would look quite odd).

To calculate the filter needed, either use the table *right*, or work from the mired shift values given *opposite*. As the numerical differences on the mired scale are consistent whatever the colour temperature, they are easier to use when adding or subtracting filters. The mired scale for light sources is shown alongside the kelvin scale on the main diagram *opposite*. To change the colour temperature of the light reaching the film, first find the mired difference between the light source and the colour temperature you want. Then add together the necessary filters. For example, to convert the blue shadow from a 7000 K (142 mired) clear sky to white (5500 K–181 mired), amber filters are needed that add up to the 39 mired difference. An 81B, with a value of 37, is almost exact. The filter designations quoted are Kodak's; other manufacturers, have equivalents to most or all of these, with different designations.

The colour temperature of midday sunlight is the reference standard for human vision. At 5500 K, its illumination is, to our eyes, neutral. Here the colourless white of gypsum dunes in White Sands, New Mexico, appears pure. Scattering of short wavelengths gives the clear sky a blue colour; in the shade this illumination alone would have a high colour temperature.

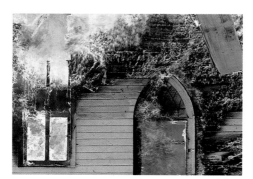

In the opposite part of the colour temperature scale to the blue sky *above*, flames appear red, orange and yellow, all well below 3000 K. Although hot in our experience, flames are cool compared with the white heat of the sun's surface.

Conversion filters
To select filters that will correct a colour temperature, first find the difference between the mired value of the light and the mired value of what you want it to be. Check the table here for the filter (or combination of filters) that will cancel this out.

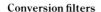

Filter (yellowish)	Shift value	Approx. *f*-stop increase	Filter (bluish)	Shift value	Approx. *f*-stop increase
85B	+131	⅔	82	−10	⅓
85	+112	⅔	82A	−18	⅓
86A	+111	⅔	78C	−24	⅓
85C	+81	⅔	82B	−32	⅓
86B	+67	⅔	82C	−45	⅔
81EF	+53	⅔	80D	−56	⅔
81D	+42	⅓	78B	−67	1
81C	+35	⅓	80C	−81	1
81B	+37	⅓	78A	−111	1⅔
86C	+24	⅓	80B	−112	1⅔
81A	+18	⅓	80A	−131	2
81	+10	⅓			

Using a colour temperature meter

Although not the most commonly owned piece of equipment, a three-way colour temperature meter is unsurpassed in dealing with colour differences in light sources. If balancing light and using filters is likely to be important in the type of photography you will do, make every effort to acquire one. Its principal value is in indoor photography where mixed light sources are usual and where the colour temperature of daylight through windows can vary the full range from a low direct sun (4000 K or less) to intense skylight (12,000 K or more). The eye's chromatic adaptability – its ability to adapt to different colours of illumination and see them as normal – make it a poor instrument for judging colour temperature unaided.

Strictly speaking, this meter measures colour rather than just colour temperature. Apart from the fact that skylight is only coincidentally on the colour temperature scale, the colour cast of fluorescent light is due to quite a different reason: the gaps in its spectrum. A three-way meter, however, can cope with this.

In this Minolta colour meter, the most commonly used make, three silicon photocells are filtered so that blue-green and red light can be separately measured. A flat opal diffuser over the sensors ensures that the light reaching the cells is integrated. The information from the three cells is fed to a micro-processor chip which calculates both the colour temperature and the filters needed to balance the light to the film being used. The principal reading is in kelvins; other displays show the colour compensation needed.

In practice, the film type (daylight, Type B or Type A) is entered into the meter. The meter is then held in the position of the subject, or at least in the same light, in much the same way as you would take an incident reading with an exposure meter. The light level does not affect the colour temperature reading, although it may be too low to register any measurement at all. If the colour temperature is very different from the 5500 K, 3200 K or 3400 K (although this type is rare) of the film you are using, it may be better to change film type.

The colour correction is calculated on two scales: cool-warm, using the normal colour-balancing filters (81, 85, 82 and 80 series), and magenta-green, using Kodak's colour compensating series. The display shows figures that must then be translated into the filters with the table on the back of the meter (the plus and minus figures on the cool-warm scale are the equivalent of mireds). One word of caution: try to combine the filtration so that you can use only one or two filters. Any more than this will lower the image quality.

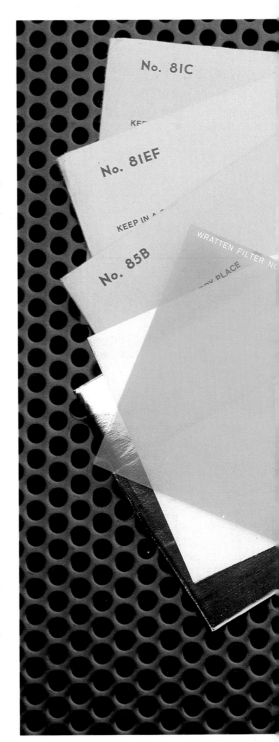

The most useful colour temperature meters measure colour on a three-way scale – strictly speaking, they are *colour* meters. In this well-known model, the information from the sensors behind the opalescent disc at the top is presented on two scales: a colour temperature scale in kelvins, and a magenta to green scale. A set of gelatin filters in the 80, 81, 82 and 85 series is needed to adjust colour temperature; the effect of any filter can be checked by holding it over the sensor.

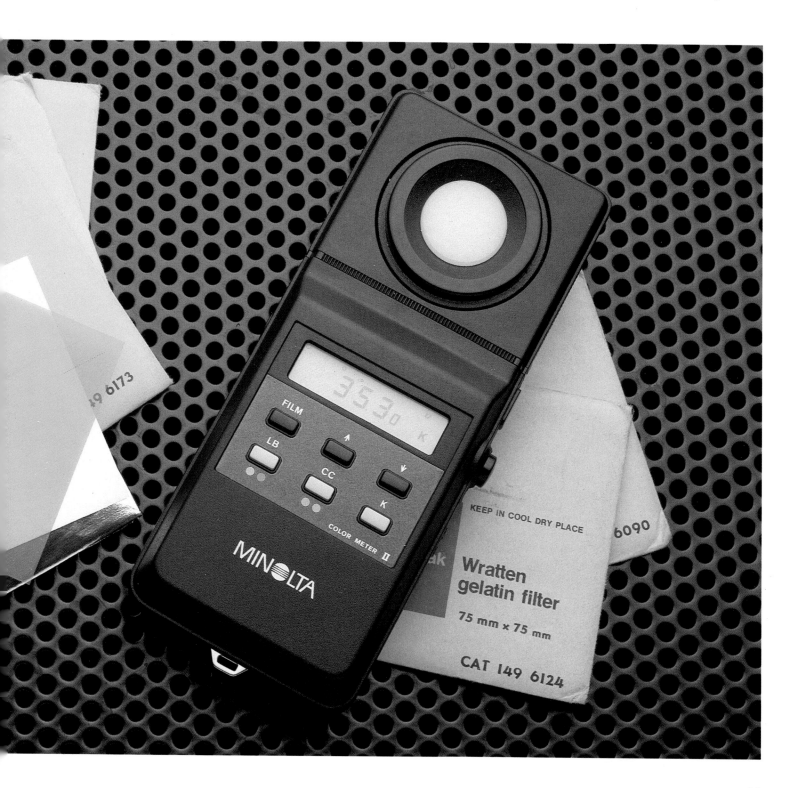

Light Intensity

The intensity of light is, technically, its primary quality. Its strength determines all kinds of operational factors in photography – what the speed of the film should be, the shutter speed, the aperture, the maximum aperture of the lens, even whether a particular kind of photograph is possible at all. If there is a deficiency, it is nearly always that there is insufficient intensity; on the few occasions when there is too much light for the standard camera and lens controls to deal with, the usual remedy is a neutral density filter over the lens to cut down the light level.

We judge the intensity of light in relative terms and, whether we are conscious of it or not, the standard for human vision and for photography is daylight. Specifically, it is direct sunlight during the middle hours of the day (given consistent weather conditions, its level changes very little from late morning to early afternoon). There are remarkably few occasions on which the light seems too bright for our eyes – or for normal film, for that matter – and this standard of light intensity is at the high end of the normal range of our experience. There are, on the other hand, plenty of circumstances under which there seems to be too little light, and these alter both our perception and the possibilities of taking photographs. There is, in fact, no single lower limit. For the eye, the lowest level of light might seem to be obvious – the margins of visibility – but even this varies. Apart from differences between individual people, it varies according to the time spent in semi-darkness. At very low light levels, well below those that allow photography, the sensitivity of the eye improves over about twenty minutes. Below this, light still has an effect: it is easy to make the mistake of light-proofing a darkroom only to the point at which it *appears* dark, but at which undeveloped film and paper will be fogged if left exposed. Also, as image intensifiers show, individual photons of light abound in what the eye might judge, even after a period of time, to be total darkness.

There is more than one way of describing the intensity of light. Scientifically, luminous intensity is the amount of light emitted per second in a particular direction from a source of light, and is measured in candelas (previously, the measurement was candlepower). Another measurement is the lux, used for measuring the intensity of illumination falling on an area. These measurements, however, have limited application to photography, and the normal, and so most useful, method is in terms of the camera settings needed for exposing the film. These may be a little cumbersome to quote, but at least they can be used for taking photographs.

The most common is the combination of shutter speed and aperture, such as $\frac{1}{125}$ second at f 16, even though it refers only to one particular film speed, and presupposes many of the variables in working out an exposure. Nevertheless, it is as universal a method as we have, and it is used throughout this book. For simplicity and brevity, the figures quoted from now on will be for ISO 100 film, unless there is a special reason for mentioning another film speed. To convert these settings to another film speed, simply add or subtract f-stops according to the difference. Use the table shown *below*.

The alternative, rather less common, method of description is exposure value, usually abbreviated to EV. This is a system which combines shutter speed and aperture. Each EV number refers to a particular quantity of light reaching the film, through different combinations of shutter speed and aperture. For example, an EV setting of 12 could be $\frac{1}{250}$ second at f 4, or $\frac{1}{125}$ second at f 5.6 or $\frac{1}{60}$ second at f 8, and so on.

If there is an average source of light in photography, it is normal daylight, and the scale of shutter speeds and aperture settings, as well as the range of film speeds available, are geared to this. A medium speed film, for example, has an ISO rating of about 100, and a normal exposure setting in the middle of a clear day would be about f 16 at $\frac{1}{125}$ second. Against this daylight standard, most artificial light sources are weak. Certainly, non-photographic light, such as domestic lamps and street lighting, causes real problems for photography, as we will see from page 72 onwards. Even photographic lighting causes more difficulties with a shortfall of level than with too much output. At close distances, such as in still-life photography, the problem is rarely severe, but large-scale sets usually need expensive amounts of equipment.

Light intensity depends on three things: the output of the source, how it is modified, and its distance from the subject. The first of these is the subject of the following pages, the second is a major variable in the *quality* of light – its diffusion and reflection. The last, distance, is important for local illumination but not for daylight. Light falls off with distance according to the Inverse Square Law, as shown on page 16.

	ADD (f-stops)						SUBTRACT (f-stops)						
f-stop difference	2	1⅔	1⅓	1	⅔		⅓	⅔	1	2	2½	3	3¼
ISO film speed	25	32	40	50	64	100	125	160	200	400	640	800	1000

Film speed ratings are in proportion to the difference in f-stops. Here, using ISO 100 as a starting point, the f-stop differences are shown for most films.

The weakest normal light source encountered in photography is probably a candle. Although the flame is always bright enough to record an image on even the slowest film, the illumination from the flame usually needs long exposures (see the table on page 74).

As well as being the most common light source in photography, sunlight is also the brightest in normal circumstances (at close working distances, some artificial lamps need smaller exposure settings). Shooting directly into the sun creates images with a range of brightness too great for any film to record fully.

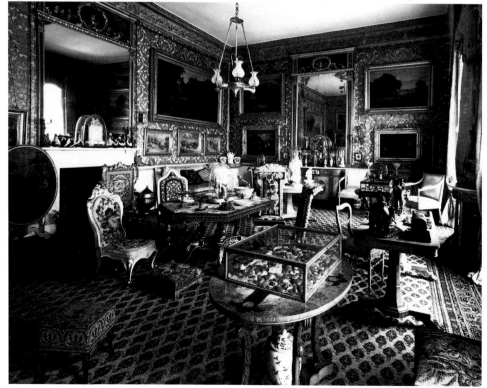

After daylight, the second most common lighting condition is that found in houses and other buildings. The intensity of the light depends on the size of the room and the position of the windows and lamps, but even during the day, light levels are likely to be in the order of 7 stops lower than outdoors.

Light Sources

Although the sun is our main source of light, there are a number of others, man-made, all of which can be used for photography with varying degrees of success. Some, like domestic tungsten lamps, exist simply because they are an easy method of producing light, even if this bears little resemblance to daylight. Others, like fluorescent lamps, are designed to imitate the effect of daylight on a small scale. Still others, such as electronic flash, are intended only to fit the needs of photography. All have different characteristics; to use them for photography, it helps to have a good understanding of what these are and what sort of compensation is necessary when using a camera.

There are three main light sources other than daylight. Incandescent light works by means of intense heat; in a tungsten lamp, the most common type, a tungsten filament is heated electrically, and glows. Fluorescent and vapour lamps produce light by exciting the molecules of a gas, again with an electric current. An electronic flash unit uses the principle of an electronic discharge, but this occurs as a single, very short pulse in a sealed gas-filled tube.

There are three important characteristics for any light source: its intensity, its colour and its duration. We might also treat the ways in which it can be modified as characteristic: most artificial lighting can be diffused, reflected and filtered in similar ways, but sunlight is modified by the atmosphere and weather beyond anyone's control.

Over any but a short distance, the intensity of sunlight during the middle of the day is well beyond that of any artificial lamp, but there is one obvious difference. The sun is so far away that its light is just as intense in one part of a scene as in any other. That is, the difference in distance between the horizon and foreground in a landscape shot is infinitesimal compared with the distance between the sun and the earth. Effectively, the strength of sunlight does not vary with distance. (In reality, of course, it does, but not enough to concern us here). All artificial light does, however, weaken with distance, and the fall-off in illumination is a major consideration with photographic lighting and available lighting at night.

The light from a point source falls off according to the Inverse Square Law, that is, the intensity weakens not just according to the distance from the lamp, but according to the *square* of the distance. Twice the distance does not mean half as much light but *four times* less. The diagram explains this rather better; think of the light as a spreading beam. Better still, measure it for yourself with a hand-held meter and incident readings; face the dome to the light and take successive readings at one foot (0.3m) intervals. As long as the light source is relatively concentrated, the type of light does not matter; the fall-off will be the same from a domestic tungsten lamp as from a flash tube. Diffused light sources affect this fall-off a little, because at close distances the light comes from more than one direction; at a distance, however, even a broad light acts as a point source.

Colour, as we have seen from the spectrum on page 8, is entirely a matter of wavelength. The proportions of each wavelength that any light contains add up to its overall colour. Sunlight combines all seven distinct colours to produce white. Other light sources contain a different spread of wavelengths, as the graphs here show. Skylight is deficient in the longer wavelengths, mainly red and orange, and so appears blue. A domestic tungsten lamp is

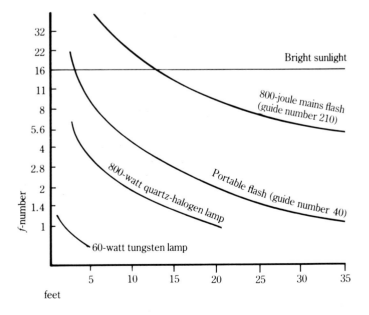

Inverse square law
Light falls off with the square of distance – twice as far from a light source means four times less illumination. The most noticeable thing about this comparison chart of the main light sources used in photography is that the sun's light does *not* seem to change with distance. This is because the distance between the earth and sun is so much greater than any local differences.

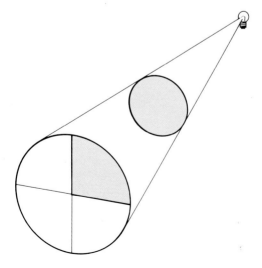

almost the opposite; there are very few of the shorter wavelengths, and so the light appears orange. A flash tube does not have quite the same distribution of wavelengths as sunlight, but the peaks and troughs cancel each other out to produce an overall white. The anomalous light sources that photographers have to deal with are the vapour discharge lamps and fluorescent tubes, which have an uneven collection of wavelengths. Vapour lamps have a discontinuous spectrum, which means that they completely lack some colours. Using these as a light source for photography is more of a problem than with any of the others.

Finally, duration. Daylight and tungsten lamps are continuous and, at least from the point of view of exposing a photograph, steady. Fluorescent lamps, however, pulsate, producing rapid fluctuations in their light output. Flash tubes are built on the principle of a pulse: one single, continuous concentrated discharge that will expose a photograph just as well as a lower level of continuous light, but which is useless for human vision. Synchronizing the flash pulse to the time that the camera shutter is open is critical for regulating the exposure.

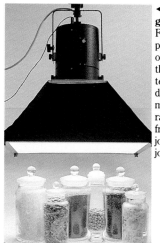

◄ Photographic
Flash is a purely photographic type of lighting with the colour temperature of daylight. Typical mains flash units range in power from about 200 joules to 5000 joules.

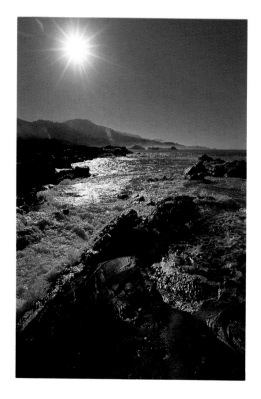

► Natural
As a light source, the sun is relatively unchanging from our point of view. The variations we experience are due to its height above the horizon and the effects of atmosphere and weather.

▼ Artificial
Fluorescent strip-lighting is extremely common, and used both for general illumination and decorative coloured effects (both at the same time in this Chinese gold shop). Visually white, strip-lighting usually has a greenish tinge when recorded on film.

▼ Artificial
Tungsten lighting is one of the oldest forms of artificial lighting. In large areas it has been superseded by vapour and fluorescent lamps, but is still the most common type of domestic lighting.

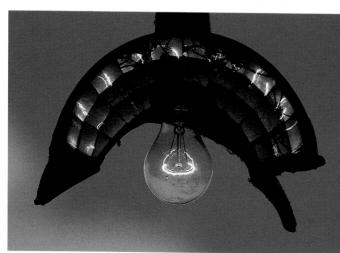

Measuring Light

Although most cameras have through-the-lens metering, a hand-held meter offers much greater flexibility and can be used to measure light under a wider range of conditions in detail. Many of the projects in this book are easier to do with a hand-held meter, and it is a distinct advantage to own one if you intend to treat the subject of light seriously. The purpose of measuring light is so that the amount of light allowed to reach the film can be adjusted. Unlike the eye, film cannot automatically compensate for fluctuations in brightness, and only a certain quantity of light must reach the emulsion to produce a well-exposed photograph. Light measurement, therefore, is a practical procedure, directly related to the two camera settings that can control it: the shutter and the aperture. Meter readings are in the form of *f*-stops at certain shutter speeds, with exposure values as an alternative.

The automatic measurement and exposure system inside most cameras bypasses the photographer's decisions; when this is in operation, the readings are actually superfluous. However, there are some major limitations with automatic exposure, and if your camera has the facility, you should switch it off for the majority of the projects in this book. The principle of automatic exposure is that someone else – the camera manufacturer – decides what makes a satisfactory exposure. This works in the sense that the images will be adequate, but it allows you no personal control. Throughout this book we will be looking at light in some detail, and particularly at ways of using it expressively. In order to do this, you must be able to assign exposure settings with complete freedom. Automatic exposure is useful when it is more important to secure a reasonable recording of a subject than to consider the subtle qualities of the lighting; it has its place, but not here.

There are two ways of measuring light. The first, and more common, is to read the brightness of the subject – in other words, the amount of light reflected from its surface. The second, and more generally useful, is to measure the amount of light falling on the subject – the incident reading of light. Incident readings are simpler in that they are not influenced by how light or dark the subject is, but for practical reasons are limited to hand-held meters. A meter built into the camera is an obvious advantage, and the only workable system is to measure the brightness of the picture itself – a reflected light reading. In fact, through-the-lens (TTL) metering is usually highly successful, but it has to allow for differences in brightness between parts of the subject.

All meter readings work to a single standard: average brightness. This is the most important concept in exposure measurement, and although basically simple, causes all kinds of difficulties if not well understood. The possible range of brightness for a subject is between white and black. These, however, are not such definite limits as they might seem. In theory, black should reflect no light at all; in practice, a visually effective black does give a reading. Take two sheets of paper or card, one white, the other black. Place them in the same light – sunlight, for example – and take a direct reflected reading of each. Note the difference in *f*-stops. Then replace the black card with black velvet and take a reading of this. Black velvet is the most light-absorbent surface that is easily available, and there should be a noticeable difference between the reading of this and of the black card. Even so, the meter is almost certain to register some measurement.

The basic metering tools in photography are, left to right, a hand-held meter capable of both incident and direct readings, depending on the sensor attachment; a spotmeter with a 1° angle of measurement; underneath a white card and 18 per cent grey card for substitute readings; a selenium cell batteryless hand-held meter with incident light attachment; and a camera with built-in through-the-lens (TTL) metering.

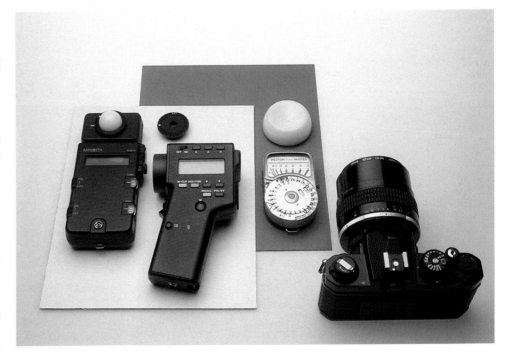

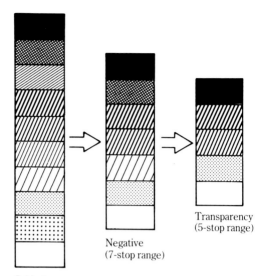

Subject
(Bright day:
10-stop range)

Negative
(7-stop range)

Transparency
(5-stop range)

On a sunny day with strong shadows, the brightness range may cover 10 stops. Negative film, however, can record only about a 7-stop range satisfactorily, and transparency film even less. Coping with high contrast is probably the main problem in calculating exposure.

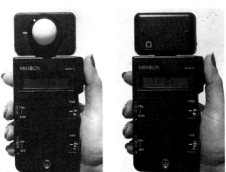

Average direct reading Incident reading

You can demonstrate the difference between direct and incident readings by finding a white wall on a bright day. A direct reading shows an aperture setting of more than *f* 22 with ISO 100 film and 1/125 second shutter speed. The result would be a mid-grey tone to the wall if photographed. An incident reading ignores the wall and measures only the light, showing a setting of 2 *f*-stops more. If this were used, the wall would appear white in the photograph.

The three basic methods of direct light measurement are illustrated here on the façade of a white-painted building.

1 A pattern of near-eclipses is typical of the center-weighted average readings used in most cameras, and measures a broad central area of the scene. The pattern of light and shade in this image makes the area measured average in tone.

2 Two separate measurements of the darkest and lightest areas constitute a range reading, which can be averaged.

3 A key reading is made of a technically important part of the image, in this case delicate white stucco that would disappear in an over-exposure.

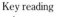

Key reading

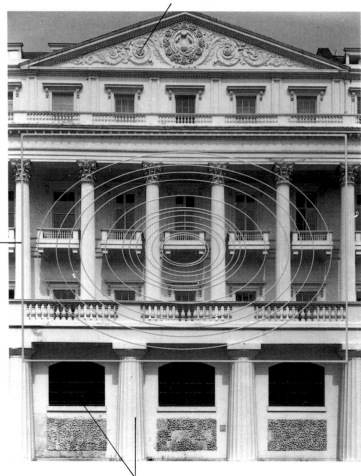

Weighted average
reading (TTL meter)

Range reading

Average area Lightest

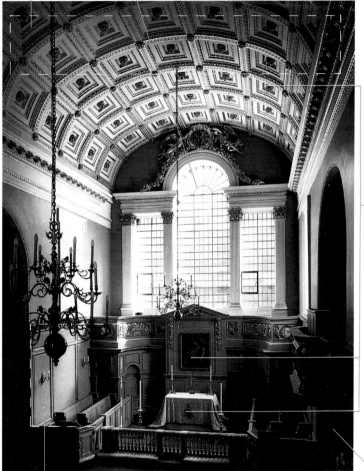

Important detail to preserve

Darkest

Average area

Practise analyzing the tonal structure of a scene as a way of choosing the most appropriate metering method. In particular, identify the brightest and darkest parts of the view that contain significant detail, what area, if any, is average in tone, and any tonal details that are important to the image and must be preserved.

Black, therefore, is certainly not a reliable enough tone to use as a reference in light measurement; white can be used more easily, but is still not completely consistent in the amount of light that it reflects (compare a shiny white card with a matt, off-white painted wall). The mid-point between the two, however, is consistent. It reflects 18 per cent of the light striking it and, by definition, is average. If this grey is photographed so that it appears identical in tone in a negative, print and transparency, we can say that the exposure is technically correct. An average subject, therefore, reflects this amount – 18 per cent – of the light striking it; the colour is irrelevant so long as the meter responds equally to all visible wavelengths.

All meters are calibrated so that they show the exposure setting needed to make an average subject appear in the photograph with the same mid-tone. For an average subject, this works perfectly. If, however, you take a direct reading of a white wall, the reading you will get will show exactly the same thing – how to reproduce it as a mid-grey. The same applies to subjects of any brightness, light or dark. Used indiscriminately, a simple reflected light meter (that is, one that takes direct readings) will produce peculiar results with non-average subjects, whatever the lighting.

In the TTL metering systems built into cameras, the solution to this problem has been to design various systems to allow for over-bright or too-dark picture conditions. The simplest is to weight the sensitivity of the meter to the center of the frame, where most people place the subject, and exclude the top of the frame from the reading (because the manufacturers assume that this is where the sky will be placed in an outdoor shot). The most sophisticated system is to subdivide the frame, read each area individually, and match the resulting pattern with a set of picture conditions that has been worked out in advance and stored in the camera's memory. A certain pattern, for example, may be typical of a back-lit

portrait; the system assumes that this is the case, and sets the exposure at a level that is known to work. All these solutions depend on being able to predict how photographers will take pictures.

Without automation, the way of dealing with bright and dark subjects is to decide how bright or dark you want them to appear in the photograph. This is not too difficult, provided that you are familiar with the materials that you are using. Film can record only a certain range of brightness. As a rule of thumb, this range is 7 stops for negative film and 5 stops for transparencies. Both of these ranges are considerably less than the range between highlights and shadows on a clear, sunny day (this can be as high as 10 stops). However, if you want a white wall to appear white in the photograph, you simply need to increase the exposure that the meter shows by between 2 and 2½ stops. Judging tone is the best exposure technique there is. As long as you can tell with some accuracy how much brighter or darker than average a tone is, you have the ability to make exposures exactly as you need them.

The alternative way of measuring light avoids most of these problems, but cannot be performed through the camera lens. Incident light readings measure the light from its source, not as reflected. The meter has an attachment, usually a white translucent dome, and this is exposed to the light in the position of the subject. The shape and composition of the dome is designed to imitate an average subject, so that the reading is, in nearly every case, the setting needed for a technically correct exposure for an average subject.

The caveat to this summary of light measurement is that a technically correct exposure may not always be the best choice aesthetically. As we will see in this book, the qualities of light are interesting, varied, and often subtle. To assume an average method of exposure for every situation is to miss many of the possibilities for exploring the complex effects of light.

The basic techniques for using an exposure meter are an incident reading (measuring the illumination), direct reading (of the light reflected from the subject), and three kinds of substitute reading. The substitute readings – which are a form of direct reading – are of a hand, a grey card, and a white card.

Incident reading

Direct reading

Reading skin tone

Grey card reading

White card reading

Project: Metering the effect of the surroundings

Standard manufacturers' recommendations for exposing film in bright surroundings, such as beaches, are to use a 1-stop aperture smaller than normal, but this is an over-simplification. Under a bright sun, the surroundings affect only the shadows. Test this for yourself with a hand-held meter set for incident readings. Take a reading in direct sunlight on the meter's dome (picture **1**). Move the meter next to a white wall and take a second reading (picture **2**). If the conditions are similar to the examples shown here, the difference will be about half a stop, because the *shadow* is lightened.

For a smooth surface facing the sun, reflections from the surroundings make virtually no difference. Consider this before automatically reducing the exposure. If what you are photographing has just a few distinct surfaces, such as a building, the exposure will normally have to be based only on the sunlit part. A strongly textured surface, on the other hand, usually needs an overall reading which integrates the fine mixture of light and shade. In filling the pattern of small shadows, bright surroundings will increase the illumination, and thus need less exposure.

1

2

▲The incident measurement *left* was made next to a bright reflecting surface, and the other in normal surroundings. The difference between the shadows on the meter's dome are obvious, but the actual reading differs by only ⅓ stop.

NATURAL LIGHT

The sole source of natural light is the sun (starlight is far too weak to count). Even the moon is simply a reflector of sunlight, as is the sky. Nevertheless, the actual variety of lighting effects is tremendous; there are so many permutations of ways of modifying sunlight that the range of different lighting conditions is infinite.

Condition is, in fact, probably the most appropriate word to use for the effect of sunlight. In its various forms, it is so much a part of everyday visual experience that, except for unusual moments, we tend to see natural illumination as an integral part of the scene. In a typical photograph of a scene, most people would not make a conscious separation between the physical subject and the lighting.

This, however, is exactly what we must do in order to appreciate how natural light works. In this section of the book we will analyze the ways in which sunlight behaves in all possible conditions, beginning with its purest form – a bright, unobscured sun in a clear sky – and moving on to the ways in which the atmosphere and surroundings can modify it.

The direction of sunlight is the first variable. The sun moves across the sky, reaching different heights according to the time of day, the season and the latitude. The camera angle can be altered in any direction, and many subjects can be moved to face towards or away from the sun. The result is a variety of possible angles between the sun on the one hand and both the camera and the subject on the other.

Before it reaches any subject, the sunlight first has to pass through the atmosphere and is modified. It is slightly softened, the more so if it passes through the greater depth of atmosphere, as it does when the sun is low. It is also scattered, selectively, so that the sky appears blue, and the sunlight can be any colour between white and red. Added to this, weather conditions filter and reflect the light even more strongly. Clouds take an infinite variety of forms, combinations and coverage, while haze, fog, mist, dust, rain, snow and pollution have their own distinctive filtering effects. Finally, the surroundings themselves alter the illumination by the way they block off some of the light and reflect other parts of it. The net result of all this is that four things happen to sunlight. It is diffused, absorbed selectively (which changes the colour according to which wavelengths are removed from the spectrum), reflected and selectively reflected (again, with a colouring effect).

Most of this modification happens with very little opportunity for the photographer to control it. At a local level over short distances and with subjects not much larger than a person, screens of various kinds can be used without too much inconvenience; additional lighting can be used for shadow fill or to reinforce the natural conditions. On a broad scale, however, natural light changes according to agencies that are beyond human influence.

The approach to working with natural light differs in principle from the use of artificial and photographic light. The decisions to be made are those of pure judgement rather than of manipulation. The possibilities for control are essentially passive, although no less important for that. Choice of viewpoint, timing, and above all anticipation are the fundamental skills in using natural light.

It may help in understanding the relatively complex effects of weather, angle of sunlight and other variables to think in terms of an oversize studio. The sun becomes a single lamp, and the other conditions have their equivalents in diffusing screens, filters and reflectors. If you can do little or nothing about where these all are, you can at least move the camera around. Perhaps even more important, the better your understanding of how they work and how they change, the more easily you will be able to predict the best lighting conditions for the shot you have in mind.

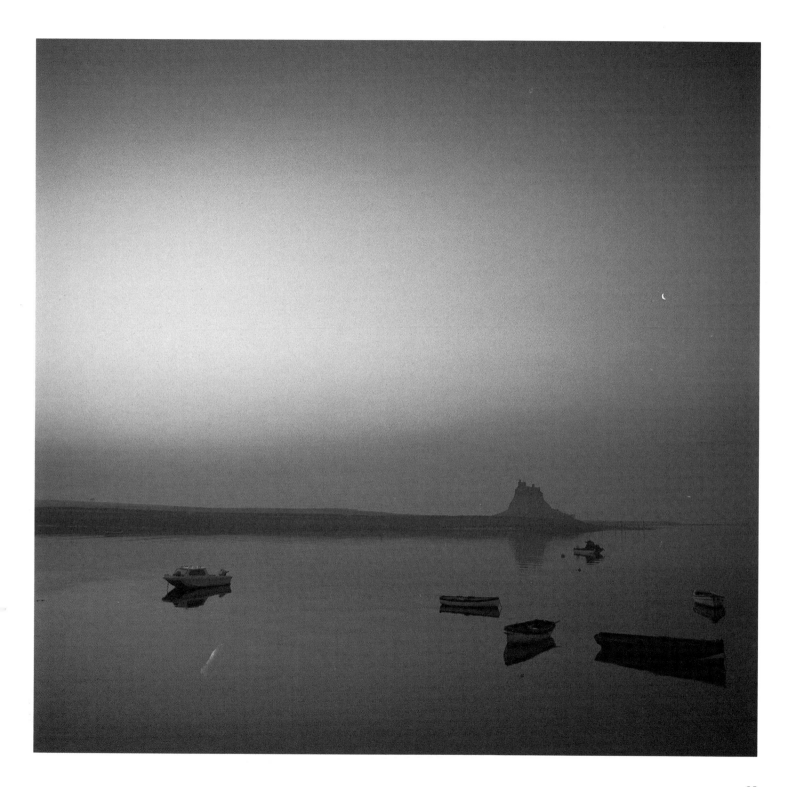

Direct Sun

The least complicated form of natural light is the sun in a clear sky. Without clouds or other weather effects, the lighting conditions are predictable throughout most of the day. The arc of the sun's passage through the sky varies with the season and the latitude, but it is consistent.

As the sun rises in the sky, its intensity increases, partly because it shines through less atmosphere when it is high and partly because it strikes a greater area of most subjects. However, as the diagrams *opposite* show, and as you can measure for yourself, the light levels are not in proportion to the sun's height. They rise quickly in the morning and fall quickly in the late afternoon, but during the middle of the day they change very little. What happens is this: once the sun is at about 40° above the horizon, it is almost at its brightest possible. How many hours it spends above this height depends on the season and the latitude. In the tropics this can be as much as 7 hours, in a mid-latitude summer 8 hours, in a mid-latitude winter, no time at all. On a winter's day in the northern United States or Europe, the light levels change steadily but slowly from sunrise to sunset. In the summer, the levels change more quickly at either end of the day, but very little for the hours around noon.

The thickness of the atmosphere makes a difference to the intensity. At higher altitudes, for example, the light levels are higher because the more particles that are in the air, such as from dust and pollution, the more light is absorbed. The atmosphere has another important effect on sunlight: it scatters different wavelengths selectively. White light from the sun reaches the earth only after passing through the molecules that make up the atmosphere, and these are small enough to have a scattering effect on the shortest wavelengths.

As these are at the blue end of the spectrum, there are two visible effects. One is that, away from a direct view of the sun, you can see the scattered wavelengths in the form of a clear blue sky. Looking directly at the sun, the colour of the light depends on how much of the blue wavelengths have been scattered and lost; when the sun is high, very little, but close to sunrise and sunset, when the light has to pass obliquely through a much greater thickness of atmosphere, the light is shifted towards the red end of the spectrum. The lower levels of the atmosphere have the greatest effect on sunrise and sunset, and as these vary locally quite a lot, the colours can differ from place to place and from day to day, between yellow and red.

It may help to think of the scattering effect as performing a kind of large-scale division of the spectrum. The light source remains white, but it reaches us in a split

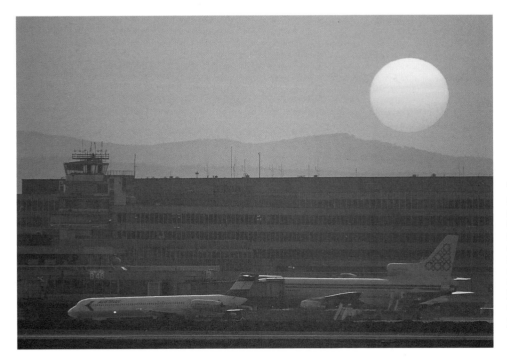

The atmosphere scatters sunlight, and has its greatest effect when the sun is low. As the shortest wavelengths scatter the most easily, and these are at the blue end of the spectrum, what remains when we look at a low sun is red or orange. The soft shadows on these airport buildings are lit by the scattered, bluish light.

form. In the middle of the day, this is predictable, but at the two ends of the day, less so. The next time you watch a red sunrise or sunset in a perfectly clear sky, look first towards the sun, and then away from it. The blue-violet colour in the sky opposite the sun is what remains of the spectrum.

The effect of the blue sky, also known as skylight, is so much weaker than direct sunlight that it is felt only in the shade. If we make an analogy with a studio set, the sun is a naked lamp moving in an arc over the base, as in the diagram. The blue sky acts as a reflector, with little measurable influence close to the angle of the sun, but acting so as to tint shadows when opposite. The third lighting element on a clear day is the surroundings. These also act as reflectors, and so affect the shadows. Vegetation is usually quite dark in masses, and has little effect; buildings in a city, however, often reflect light quite strongly, particularly if they are made of glass or are pale in colour.

Project: Light levels
On a clear day, or on a succession of clear days, make a series of readings every hour, from sunrise to sunset. Ideally, use a hand-held meter set for incident readings, and hold the meter level rather than angling it to face the sun.

If you use the camera's TTL meter, aim it at an 18 per cent grey card or some other flat surface that you know to be a mid-tone. Make sure that the card fills the frame, and also that the position of the camera is the same for each reading. Compare the readings with the ones shown *below*. There may be variations due to haze and to the location; readings taken in an open setting may be half a stop or more brighter than ones taken surrounded by shade.

The basic elements of sun and blue sky are the two lighting components, with the ground having an occasional effect, if it is light. The blue sky opposite the sun acts as a coloured reflector to fill in the hard-edged shadows.

Except in winter in high latitudes, light levels rise quickly at the beginning of the day and fall rapidly at the end. This is very marked in the tropics, where light intensity reaches a "plateau" of several hours. These readings were taken on ISO 100 film, at 1/125 second.

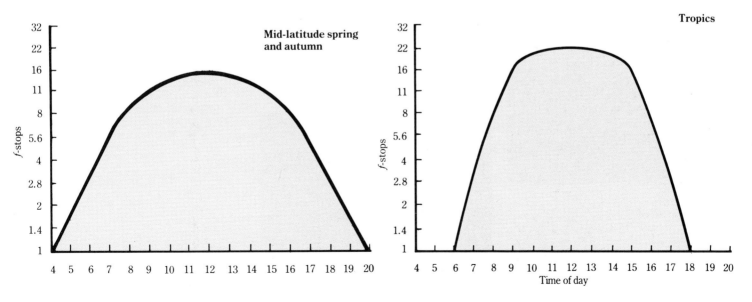

Mid-latitude spring and autumn

Tropics

Time of day

Project: Anticipating the sun's movement

The angle at which the sun rises and sets varies considerably according to the time of year (and also to the latitude). In both instances, the arc of the sun's passage becomes higher or lower. In the summer the angle is steeper, and the position of sunrise and sunset further apart.

When planning a photograph for the best light, particularly when the sun is low, it is important to know what path the sun will trace. This is easier when you are photographing in a familiar area than when travelling in a foreign country. In any unfamiliar place, where the sunrise and sunset times are different than at home, the essential first step is to find out when they are (the times are usually published in a local newspaper) and where on the horizon they occur (this you can only check out by seeing it for yourself).

The most difficult prediction of all to make is an exact alignment of the sun and the subject. If the subject is large, such as a cliff or mountain on the horizon, even small changes in the alignment will need movement over a considerable distance between camera positions. As the apparent movement of the sun is greatest close to the horizon, last-minute changes may not be possible. Sunset is easier to anticipate than sunrise, because the path can be seen. If you are waiting for sunrise, remember that the pre-dawn glow is *not* where the sun will appear; the glow will move south if you are in the northern hemisphere and north if you are in the southern hemisphere. This anticipation is something that can only be learned through practice.

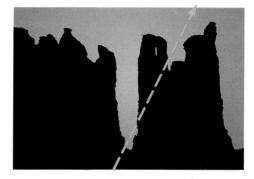
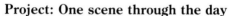

In order to catch the sun just as it rises into the notch between two cliffs in Monument Valley, the camera had to be set up before dawn. The sun rose diagonally, as shown by the arrow, and the camera position allowed for this. About half an hour later, the sun had reached the position shown in the photograph *below*.

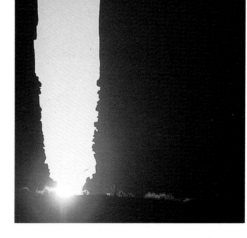

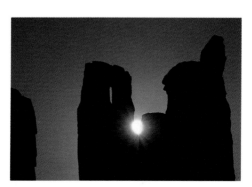

Project: One scene through the day

The short version is to shoot the identical scene two or three times during the day. If you can spare the time, however, a more useful project is to shoot the scene from dawn to dusk, every hour or two hours.

Even if you are accustomed to one changing view, such as from a window at home, it is normal for the eye to adapt to the variations in lighting and colour balance so that you remember it as appearing more consistent than it really is. The usual result of this project is that the strip of film will display a quite surprising variety of lighting qualities.

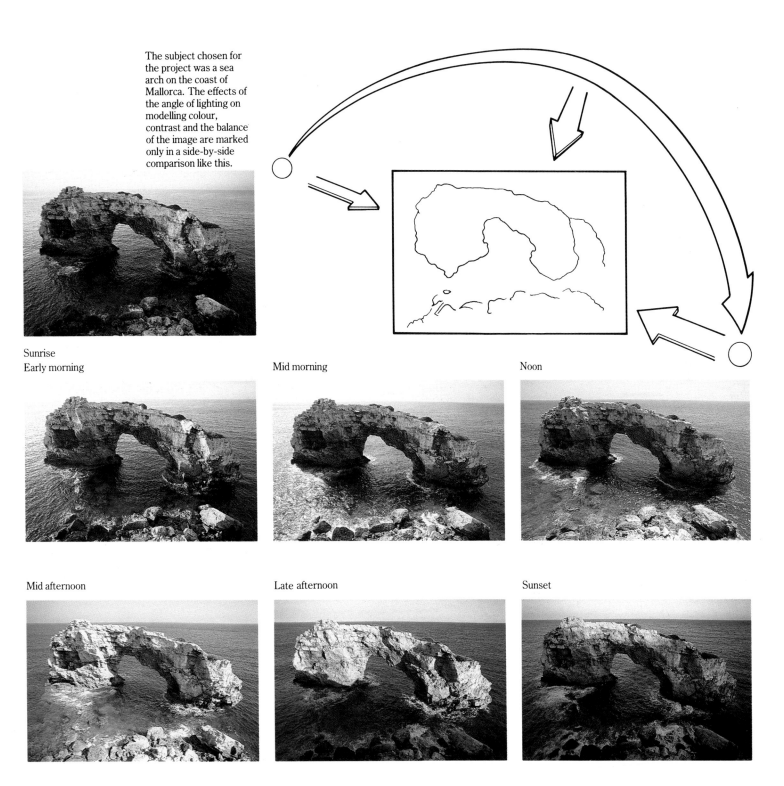

The subject chosen for the project was a sea arch on the coast of Mallorca. The effects of the angle of lighting on modelling colour, contrast and the balance of the image are marked only in a side-by-side comparison like this.

Sunrise
Early morning

Mid morning

Noon

Mid afternoon

Late afternoon

Sunset

Project: Sunrise and sunset

The most concentrated period for working with the changing angle of the sun is the beginning and end of the day, within an hour either side of the sun crossing the horizon. Every quality of the light changes: direction, diffusion, colour, intensity. It is, in addition, usually unpredictable because of atmospheric effects and the possibility of clouds, which reflect the light.

The circumstances of this example were a river mouth on the east coast of the Malay Peninsula, with a convenient camera position: a bridge. The view was checked out one afternoon, but because of the position, shooting took place the following dawn. Sunrise in the tropics is close to 6 o'clock in the morning and the sun moves very rapidly, so that the period of photography was relatively short, from about 45 minutes before sunrise to about 20 minutes after.

This is a more realistic project than the one on page 27 in that the idea is to respond to the changing conditions by altering the framing, focal length, format – even the viewpoint to a limited extent. The essential requirement is to find a good basic camera position that gives a comprehensive view of a potentially attractive scene. The only way of doing this is to research the location during the day, and this in itself calls for good judgement. I say "potentially attractive" because one of the lessons to be learned from this project is just how different the scene will look between a visit at midday to check it out, and at the actual time of shooting.

Whether you shoot at sunrise or sunset will probably depend on the location. You can expect the greatest variety when you shoot into the sun, and few scenic locations offer a 180° choice of direction. Ignoring the actual direction of shooting, which is obviously vital in making the photographs, the differences in lighting quality between sunrise and sunset are indistinguishable to another person looking at the photographs. In other words, if you do not recognize the location, you will not be able to tell just by looking at the photographs whether they were taken at the beginning or end of the day. During shooting, however, they feel quite different. Fewer people are familiar with sunrise, which is in itself a good reason for doing at least one project at this time.

Special needs of dawn photography are that you will need to be in position at first light, which means travelling during darkness. Also, because of the increasing light, the possibilities of the view tend to reveal themselves slowly, but because the eye is already well adapted, you will find that the light levels look much higher than they are. If there is any movement in the scene that needs a reasonable shutter speed, you may have to wait longer than you expect to be able to shoot. This, in fact, happened in the example shown here.

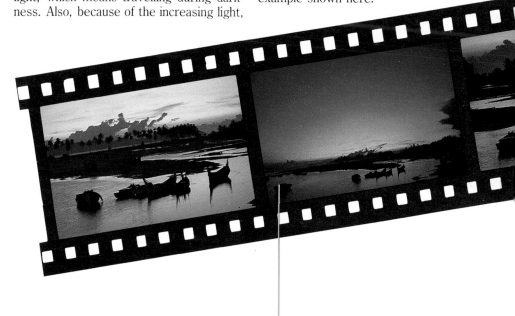

The range of colours in the sky, from deep blue to orange, is at its greatest here, more than half an hour before sunrise. A 20mm wide-angle lens gives the clearest view of this.

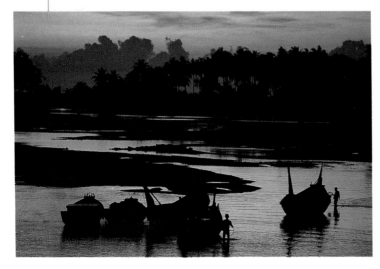

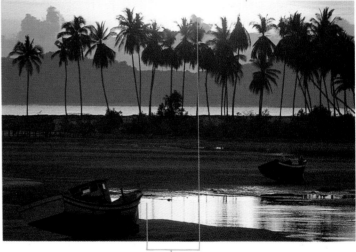

A problem with a medium telephoto view (180mm lens) is the movement of fishermen and boats; only at this point, about 20 minutes before sunrise, is there enough light for a shutter speed to freeze most of the movement: $1/15$ second.

About 15 minutes after sunrise, the sun breaks through the low line of clouds. Immediately, the contrast rises rapidly. No more worthwhile shots are possible after this one. Already the sun and its reflections are showing signs of overexposure.

The Sun's Angle

All the possible variations of lighting direction cover a sphere surrounding the subject. In the studio, any of them can be used, but apart from unusual reflections, sunlight operates only over a hemisphere, as shown. There are, in fact, two directions to consider at the same time: the sun's angle to the camera, and its angle to the subject. Together, they make too many permutations to classify sensibly, and we will concentrate here on the direction that has the main influence on the quality of illumination: the angle to the camera.

Quality of illumination is primarily responsible for atmosphere and the overall image qualities. The angle of the sun to the subject is mainly important for those subjects that "face" in a particular direction, and in revealing plastic qualities such as shape, form, and texture (these are dealt with later, on pages 158–65). The lighting sphere is included here to make a deliberate comparison with studio lighting.

Naturally, the directions shown are related to the time of day and season. By far the majority of outdoor photographs are taken with a camera angle that is close to horizontal – at least within 10° or 20°. For these, the lighting sphere diagram holds true. The exceptions are extreme verticals, either up or down. Upward vertical shots, in any case, tend to produce disorientation, and this usually overwhelms other image qualities, such as lighting direction. Nevertheless, back lighting is a common condition of shots like this (the technical recommendations are those on pages 36–9). Downward verticals, particularly over a distance, such as from high buildings and aircraft, are usually of a flat surface: the ground. Lighting considerations for this kind of picture are usually similar to those needed for revealing texture (see pages 164–5).

Suitability and aesthetics apart, the fairly high angle of the sun during the middle hours of the day has a reputation for being standard. This has much more to do with everyday experience than whether it looks attractive. As described on page 24, the

Lighting directions
The direction of light, which outdoors can be from anywhere above the horizon, can be grouped into zones. This "lighting sphere" is segmented to show the main directions, which are dealt with in greater detail on the following pages.

middle hours are the most consistent in light level, quality and colour. On balance, they are probably also the principal times of day for most human activity.

Aesthetically, there are some problems with a high sun. Probably the chief one is that it is over-familiar, and certainly not inherently exciting. The preconceptions that create this feeling are important to consider, although the conclusions are not so obvious. For an audience, there is an undeniable visual premium on interesting and unusual lighting. Indeed, the title of this book may lead you to expect that this is what it will teach – how to find and create rare qualities of lighting, including the most spectacular ones.

On the whole, all this is true, but it is important not to go overboard with the idea of spectacle. Dramatic lighting effects are only powerful in comparison with a variety of other conditions, and it would be wrong to think that a midday sun is good for nothing. Two of the three photographs here illustrate the less good qualities of a high direct sun, yet all in fact work well. The positive qualities are a crispness and detail that are bright and definite. As long as the shadows contain nothing important, these are good opportunities for making highly representative photographs. In general, subjects with a strong intrinsic form – i.e. shape or colour – do well in this light. If the air is clear, the precision of the image is

Highlight *f* 32

Although the contrast range is high in this shot of a Pathan craftsman – about 6 stops – the man's white clothes are such an important part of the image that they control the exposure setting; overexposure would be unacceptable. This gives deep shadows, but the viewpoint was chosen to keep these small.

Average tone (and incident reading) *f* 16

Shadow *f* 4

In a typically successful use of high, stark lighting, the subject already has strong features. The main entrance to the Forbidden City in Beijing has definite shape, line and colour, all of which are shown clearly by a high, slightly frontal sun, and by a carefully aligned wide-angle lens.

Bright, clear weather adds to the complexity of this street corner in Jaipur, India, by throwing extremely dense shadows. The stark, graphic effect produced is in itself visually interesting, however, and worth the photograph.

heightened, as it is in all these examples.

One of the principal difficulties is in the way the shadows fall. The higher the sun, the more they fall underneath. In a facial portrait, this lighting is unsuitable as the shadows tend to conceal the eyes. It is also unflattering, which becomes a problem if the photograph is intended to be a pleasing portrait, rather than a piece of reportage. On many other subjects it simply reduces the modelling effect that might have been useful for showing form and volume (hence the success of strong shapes and colours which can make this unnecessary). Flat, horizontal subjects, like level landscapes, suffer as much as any; shadows are at a minimum, showing little of texture.

Typical meter readings in these conditions are around ¹⁄₂₅₀ second at *f* 11 on ISO 100 film.

Frontal lighting

All the remaining directions of sunlight are those of a relatively low sun. Low in this case means no more than about 30° above the horizon, and in most of the examples shown, no more than about 20°. In a mid-latitude summer, this is before 6 o'clock in the morning and after 6 o'clock in the afternoon. All four types of lighting – frontal, side, back and rim – can be found at the same time, with the same position of sun. Here lies the practical value of a low sun: a choice of three or four major varieties of lighting quality at once.

First, frontal lighting, with the sun directly behind the camera. If you use it well, this can be very powerful, particularly with colour film, but it needs certain minimum conditions. In fact, the difference between success and an unremarkable image is more delicate and less predictable than with the other varieties of low sunlight. Being frontal, the sun in this position throws shadows away from the camera, and if the viewpoint is exactly along the lighting axis, they will be invisible. As shadows are responsible for modelling and texture, and help with perspective, the character of frontally sunlit shots tends to be flat and two-dimensional. Now, this is nearly a prescription for a rather dull effect, but what can make the difference is the colour and tone of the subject, and the intensity of the sunlight.

Go back to the photograph of the entrance to the Forbidden City on page 31. The lighting is fairly high, but behind the camera, and the most immediate quality of the picture is the strength of the colours. With real frontal lighting, this effect is even stronger, with the addition that the colour temperature is lower, and the light more yellow-orange. Hence, the contrast of both colour and tone is high, and if these are already inherently powerful in the subject, as in the picture of the Japanese girl shown on this page, the combined effect is very strong indeed.

When the sun is almost on the horizon, and provided that it remains bright, shadows begin to appear, and can very quickly cover everything. A practical point here is that your own shadow will appear. In most circumstances, this will not contribute usefully to the photograph, and there are just two solutions. One is to alter the shape of the shadow you cast, so that it appears natural and indistinguishable (for example, withdraw your arms, duck your head, or cover over tripod legs). The other is to move so that the lighting in the picture is not exactly frontal. This is what happened in the case of the photograph of the cemetery *below*. Slightly off-axis lighting can, as here, produce graphically strong shadows that edge the lit shapes and can be used in the design of the image.

Project: Frontal lighting

For this frontal lighting project, first find a viewpoint that will allow clear shooting of a subject opposite the sun, either at sunrise or sunset. It is important that no shadows will fall across the subject at the last moment. Large things, such as buildings and mountains, are obviously more reliable in this respect.

The examples here are of downtown Perth, in Western Australia, in the 45 minutes before sunset. The viewpoint is a well-known site. Apart from the annotated details accompanying the pictures, the principal lesson here is the unreliability of very low sunlight. This might seem a point that could be made without illustration, but it has a particular importance for frontal lighting.

Here, the narrow but hard shadows from a setting sun almost behind the camera play an important graphic part in a view of a Shaker cemetery near Albany, New York. The camera needed to be positioned carefully to avoid its shadow appearing in the image.

The contrast between the black silk and gold embroidery is already strong. Frontal lighting enhances this by illuminating the embroidery as strongly as possible.

The difference between the brightly-lit shot and the last, clouded, version is remarkable. In an instant, all the richness and interest was gone. The lighting direction remained frontal, but weak and diffused. Back lighting and side lighting conditions can often continue to work reasonably well when the light is weakened by clouds, but frontal lighting really needs the intensity of a direct sun and, ideally, clear air. Without this intensity, many frontal sunlit pictures become pointless.

In this kind of daylight, with the sun direct and high frontal, there is a formula that usually works well, and is useful to know in an emergency, such as meter failure:

$$\text{Exposure} = \frac{1}{\text{ISO}} \text{second at } f\,16$$

So, if you are using Kodachrome 64, the closest setting will be 1/60 second at f 16 (or an equivalent, such as 1/125 at f 11).

As the sun moves sideways, its reflections in the plate glass windows of one set of office blocks intensify. A long-focus lens (400mm) makes the most of this effect by cropping in tightly on the reflections.

In this frontal lighting project, a series of photographs of downtown Perth were taken as sunset approached. The most important lesson from this demonstration is that the sunlight must be strong and direct for the full effect of this type of illumination. Clouds drifted across the sun at the end, and the last shot shows how much is lost in the image.

Side lighting

Of all the types of direct sunlight, side-lighting is probably the most useful when modelling and texture are important characteristics in the subject. Shadows are the most important feature of side-lighting, and it is these that show the relief of surfaces and objects. As the diagrams *below* show, shadows appear longest to the camera and most distinct under side lighting. The other condition under which the sunlight is at right angles to the camera's view is when the sun is overhead, but in this case, the ground limits the extent of the shadows, and also tends to act as a reflector to fill them in.

The shadows from side lighting have three effects. The first is that the shadow edge traces the shape of the front of the subject, and so has a modelling effect. You can see this in the photograph of the two women sitting in the park. The second effect is on surface texture. Shadows are longest under side lighting, and so the small ridges, wrinkles and other fine details of a surface show up in the strongest relief. (See the texture project on pages 164–5.)

The third effect is on the contrast in a scene. If the sky is clear, and there is nothing nearby to reflect the light, such as buildings, the contrast between light and shade will be high. Moreover, as the diagrams *below* show, it needs very little to change a lit background into a shaded one, and a dark setting will help a side-lit subject to stand out very clearly. The photograph of the two women on page 35 shows both of these points.

There is an alternative camera position: overhead. In this case, the contrast is usually much less, because of the ground, or whatever surface the subject is resting on, but the texture remains strong.

Light measurement and exposure depend on the shape of the subject. If a major part of it faces the sunlight, this will be the most important tone to expose for. Take a direct reading of this, or an incident reading with the meter's dome receptor facing the sun. If, on the other hand, there is no prominent surface facing the sun, or if what you can see of the subject is virtually flat and facing the camera (as in the picture of the vegetables), the most appropriate reading will probably be of this mixture of light and shade. For an incident reading, aim the dome directly towards the camera, and so

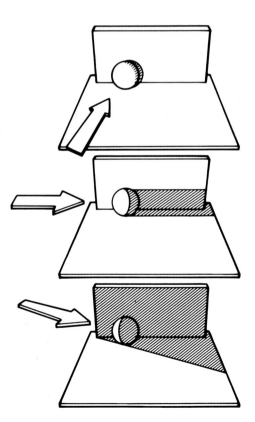

Side lighting produces the most distinct shadows. This sequence shows what happens as the direction of sunlight moves from frontal to back. The shadows are smallest from the camera's viewpoint in frontal lighting, and in back lighting shadows dominate to the extent that there are few sunlit parts to give local contrast. The maximum light/dark contrast within the subject is when the sun is at right angles to the camera.

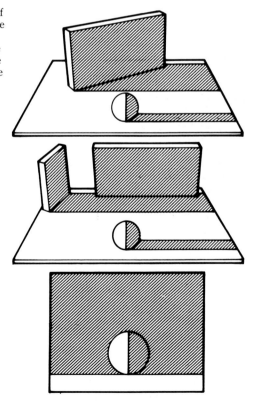

High contrast is typical of many side-lit scenes. The lighting is at right angles to the view, and thus the shadows are also, As the diagrams show, a surface needs to be angled only slightly away from the sun, or be shaded by quite a narrow obstruction, to give high light/dark contrast.

that it is partly shaded. You can see the differences involved by making similar measurements as part of the texture project below. The variations in light levels shown are typical, but depend on the amount of shadow fill opposite the light.

Project: Texture

Choose a subject with a curved surface, and shoot it with side lighting from a direct sun, as in the example here of a Japanese paper lantern. What this one picture will give you is a continuous variation of angle, from brightly lit to shadow. If the surface is textured, as it is here, it will stand out most strongly when the shadows of the texture are longest. This will be where the surface is almost in line with the direction of the sunlight and face-on to the camera.

f 16 *f* 11 *f* 4

Maximum texture detail

Project: Texture
The angle of this Japanese lantern's paper surface changes gradually left to right, and this affects the amount and distribution of shadow. The strongest impression of textural detail is when the sunlight grazes the surface at a very acute angle. Broadly speaking, there are three areas in the picture, as shown in the diagram.

One of the most effective uses of side-lighting to outline a subject depends almost entirely on the camera viewpoint. Ideally, as here in a Montreal park, the sun is at right angles to the view, and the background is in shadow; this is the equivalent of the second diagram on page 34.

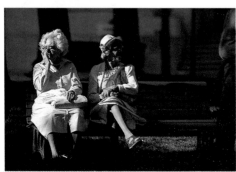

In this downward shot of a plate of vegetables, side lighting establishes the texture, an essential quality in food photography, where any tactile sensation helps to stimulate taste. A white card on the side of the dish opposite the late afternoon sunlight opened up the otherwise strong shadows.

Back lighting and rim lighting

Shooting into the sun gives some of the best opportunities for atmospheric and abstract images. The hallmark of direct shots is the silhouette, in various forms; this can be powerful if you take care to show a clear shape and expose appropriately. Off-axis shots, with the sun only just out of frame, can give a more interesting and unusual range of images, which draw very much on the texture of surfaces to produce their effects. As a class of pictures, back-lit photographs are intrinsically dramatic and exciting, although as with any other distinctive technique, their strength also lies in being applied sparingly. If, for example, you are making up a portfolio of your best pictures, in a sheet of twenty transparencies one or two such images will probably be the limit.

First, the lighting conditions. There are essentially four. One is a direct shot into the sun, another a direct shot into a reflection of the sun. The other two are off-axis shots, one normal, usually with the horizon visible, the other a slightly special condition, with a dark background that throws up the lit edges of the subject in sharp contrast. It is possible to use enough fill lighting or reflection to give reasonable shadow detail in such a case, but as this is only practical in close-up, we deal with it under Portable Flash on pages 108–9.

With a direct shot into the sun, the contrast will almost certainly be very high indeed. Even accepting that any subjects in the foreground or middle distance will be very dark, you will usually have to lose legibility at both ends of the brightness scale. The photograph of the beached fishing boat *below* is fairly typical of a wide-angle shot that includes both the sun and a main subject. Here you can see what

is being lost in the distant light tones and in the foreground shadows. The brightness of the sun causes a loss of richness in the colour; the boat lacks full detail. Note that these are technical points and not necessarily damaging to the overall effect of the picture; in fact, the atmosphere generated by the back lighting is very successful. There is one ameliorating condition: the light clouds on the horizon, which have weakened the intensity of the sun. In addition, two actions were taken to reduce the top-to-bottom contrast. One was simply to wait until the sun was low enough on the horizon. The other was to use a strong neutral graduated filter, sliding it up in its mount in front of the lens until the soft edge of the dark tone was aligned with the horizon.

If instead you choose a viewpoint that produces a silhouette, hiding the sun, there is no need to bother about reducing contrast. The parameters of the image have

There are four basic kinds of effect when shooting towards the sun, depending on the height of the sun and the camera position. Shooting directly into the sun produces a hard silhouette against a concentrated area of brightness. A higher angle into a reflective surface, such as water, also gives a silhouette,

but the bright background will be larger. When the sun is higher and out of frame, some shadow detail can be retained. With rim lighting the background is dark enough to show the brightly lit edge of the subject.

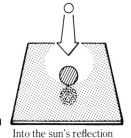

Directly into the sun

Into the sun's reflection

Slightly off-axis

Rim lighting

Clouds weaken sunlight

Shot timed for low sun position

Strong graduated filter gives 4 stops less exposure to top of image

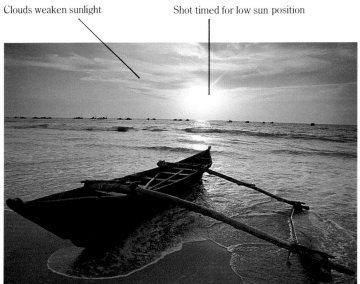

been changed completely. Silhouettes work *because* of high contrast, and depend on shape and the co-ordination of two principal tones, black and the light background. Beyond establishing a dark silhouette and sufficient brightness behind it, there is not a great deal that the exposure can do for the image, as the project should demonstrate.

Silhouettes taken directly into the sun normally hide the image of the sun itself, as the photograph of a dock-side crane loading a crate on this page shows. In a clear sky, the brightness around the sun is highly localized, so that severe underexposure, particularly with a wide-angle lens, will make the sky quite dark towards the edges of the frame. This will lose any silhouette outline away from the center. If the silhouette is small in the frame, and you use either a telephoto lens or a macro lens, then it is possible to outline an object against the sun's disc itself, as in the close-up photograph of the caddis fly.

Perfect silhouette
With the sun directly behind the subject – in this case a crate being loaded onto a ship in Piraeus harbour – there are no stray highlights to confuse the outline. As long as the composition is kept simple, with no irrelevant shapes in the foreground or background, and the exposure is short enough, the silhouette will be clean and recognizable.

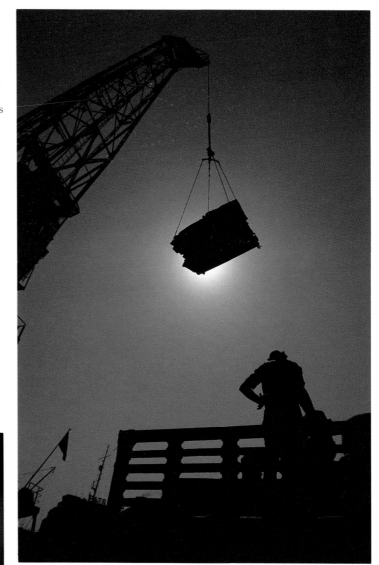

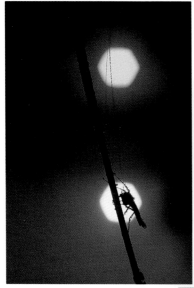

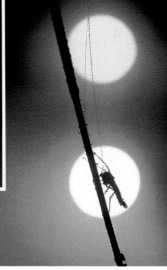

Silhouette against the sun's disc
Using a macro lens at $\frac{1}{2} \times$ magnification, the image of the sun is relatively large in the frame – big enough to provide a disc of back lighting to silhouette a caddis fly on a leaf. A precaution here is to shoot with the lens wide open; at a smaller aperture, the shape of the diaphragm blades deforms the sun's image.

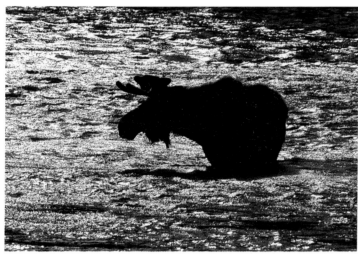

The sun's reflection

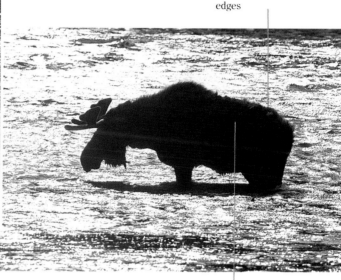

Loss of definition at edges

Loss of density without gaining detail

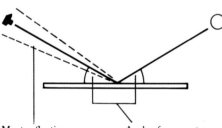

Most reflections cause some diffusion of the sunlight, and so a slight spread of reflected light. The result is a broader area of bright background, as in this example

Angle of camera to surface must be same as angle of sunlight. The two possible controls are changing the height of the camera and waiting for the sun's position to change

Exposure
Silhouettes show little detail, so the exposure can vary and still be acceptable, within limits. Overexposure, however, gives a flared effect, as shown in this example of a moose backlit against a river.

The other type of silhouette is against the sun's reflection, usually in water. There are two advantages to this situation. One is that, unless the water is perfectly calm and flat, it will have a slight diffusing effect on the sunlight. Instead of a concentrated patch of brightness, the background is larger and more even. With a telephoto lens, as used in the photograph of the moose in the river, this background can fill the frame, and the outline of the silhouette appears clean, sharp and obvious. The other advantage is that the necessary higher camera viewpoint gives a view slightly down, and it is often easy, as in this example, to isolate the image of the silhouette completely. This is usually more legible than having the silhouette merge with an equally dark ground-level base.

Off-axis back lighting can give considerable atmosphere to a photograph, with a glow softening the high contrast. This glow is in fact a mild flare, and so needs to be kept under control. Flare, although technically a fault, is by no means always something to avoid, but you should be certain that the effect you get is really what you want rather than a lowering of image quality. The special condition of off-axis lighting is rim lighting. This needs a dark or fairly dark background to show up the edges of the subject. Compare this with the construction of similar illumination in a studio on pages 180–1.

Project: Silhouette exposure
For this project, make all the practical light readings that you can for a silhouette shot,

and then bracket the exposure widely, shooting several frames. The normal criteria for judging exposure do not apply here. In a high-contrast silhouette shot there is no mid-tone area that needs legible exposure. The subject is the silhouette, and so the clarity of the outline is the standard.

The absence of a mid-tone actually gives a certain freedom of choice in the exposure, which is why you should bracket very widely, over at least 5 stops, possibly more. You will probably find that more than one exposure looks acceptable. The upper limit on exposure is usually when the density of the silhouette weakens noticeably into grey and when the edges of the outline begin to lose definition due to flare. The lower limit is when the background becomes dim, obscuring the silhouette's outline. These are the standards, but you might find that, for instance, overexposure in some situations gives an attractive impressionistic effect.

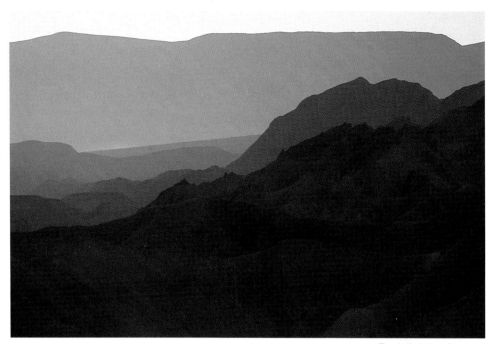

Back lighting flare
Lens flare is a constant problem in backlit shots such as this telephoto view from Zabriskie Point overlooking Death Valley. This photograph illustates the loss of contrast and image quality when the lens is left unshaded.

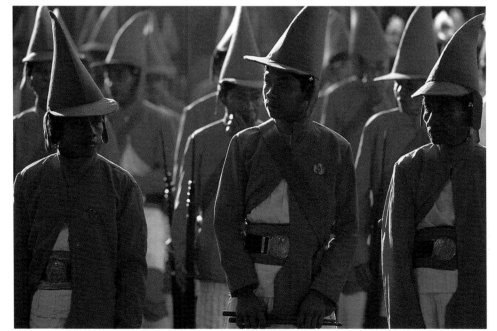

Rim lighting
At a very low angle, almost into the picture frame, the sun can produce this rim lighting effect. How brightly the edges appear depends strongly on the texture of the subject, here the cloth helmets and uniform of a Javanese ceremonial guard.

Choosing the moment

There are many occasions, particularly in landscape photography, when the shot can be anticipated, the camera set up in advance, and what remains is to judge the best time to shoot. The timing almost always depends on the lighting. If, as here, we restrict the project to clear weather, the question of the timing becomes simpler, although by no means predictable, as the examples show.

Project: Timing the shot

Find a landscape location with a reasonably definite subject. First select the viewpoint, and then decide what the preferred angle of the sun should be. In this example, the subject is Delicate Arch in Utah, the view one that shows the arch clearly with illumination that varies during the afternoon from side-lighting to lighting that is nearly frontal. The potential for a rich colour to the rock is an important factor in deciding to shoot late in the afternoon, just before sunset, as is the possibility of interesting shadows. As first seen, an overall view of the arch looked as the first, horizontal photograph **1**. This was about two hours before sunset.

What was expected was that the intensity of colour would increase until shortly before the sun touched the horizon; around this point atmospheric effects would dim the light. It was not known how the shadows would fall across the scene. In principle, it was clear that they would creep forward, but the exact lines could not be predicted. In this kind of situation, it is sometimes necessary to shoot at different times, just in case the best moment passes without the photographer realizing in time. In this case, the principal two shots were taken on 4×5 inch film, the others, which needed to be taken quickly, on 35mm film.

As it turned out, there were two good moments for shooting. The first was based on the shadow lines that gave the best view of the curving sweep of rock below the arch, a feature that was wanted in the picture but which could potentially conflict with the details of the arch itself. The second shot was based on the reddest light, just before the intensity of the sunlight began to weaken.

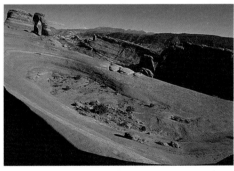

1 From a distance, two hours before sunset, a wide-angle shot shows the arch perched on the edge of a rock bowl. Although interesting, it was decided to change the shot for a closer view, as the rock bowl would be completely shaded well before the arch.

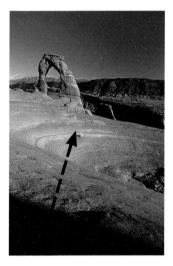

2 About half an hour before sunset, the foreground shadow appeared, moving in the direction shown.

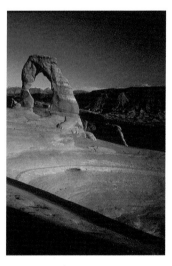

3 The first moment for a principal shot. The shadow has reached the ledge and, for a few moments only, there is an interesting double shadow line. Part of the sweep of the rock bowl is as prominent as it can be.

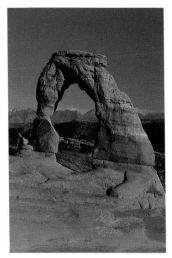

The shadow is now moving quite quickly upwards

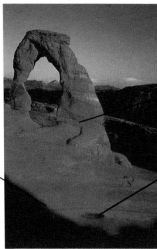

The colour is about as intense as it will get

This mark in the rock makes a convenient point for timing the shot. In any case, the shadow should not cut into it

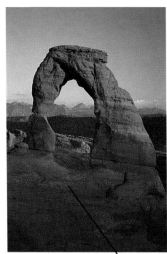

Colour weakening

4 With most of the bowl in shadow, the lens was changed from wide-angle to standard. The effect now sought is the richness of colour.

5 The shadow appears again in the foreground. The second principal shot must be taken before it reaches the base of the arch.

6 In fact, before the shadow reaches the arch, the colour and light intensity begin to weaken at the bottom of the picture. The sun is now on the horizon.

Shadow path
In the last hour or so of the afternoon, the sun's path across and down caused the shadows in the picture area to move as shown. These shadows were cast by rocks behind and to the right of the camera, and for the timing of the photographs there were two important breaks in direction. The first was caused by the ledge in front of the camera making a break in the shadows. The second was the point at which the shadows began to move up the arch.

7 Within seconds, the loss of direct sunlight becomes obvious below the arch. The moment for shooting has already passed.

Direct sunlight has disappeared from below here

41

Skylight

Skylight, as we have already seen on page 11, is blue because of the scattering of short wavelengths in the atmosphere. The blueness varies with the weather conditions and the altitude (more blue in the thinner air of mountains). Its effect is weakened by clouds and by any bright surrounding object, such as a white building, that reflects sunlight. Although skylight is what remains on a sunny day when the direct sunlight is blocked, it behaves, from the point of view of taking pictures, as a light source in itself.

Skylight is most important when a photograph is being taken entirely in shade. What happens in this circumstance is that, because there is only one kind of illumination visible and it is consistent, the eye expects it to be neutral in colour; in other words, white. Occasionally it is, but more often it is not, and then the problem is to work out exactly how blue it is. A colour temperature meter is the only certain method, and as this is not standard equipment, skylight in shadows is not a reliable source if colour accuracy is important.

Nevertheless, you can at least improve your judgement by means of the project here. When you are using skylight, make a practice of turning right round to see exactly what makes up the illumination. If it is mainly reflection from surroundings, and blue sky occupies only a small part of this view behind the camera (a quarter or less), then you probably need to use nothing stronger than a 81B filter.

Project: Judging colour

The eye is a poor judge of the colour temperature in shade, and the only method of training it is to compare processed results on colour reversal film with your assessment of the view at the time of shooting. As a basic project, take a scene in which you know that the shadows will be a prominent blue (under a clear sky and with few reflective surroundings). Do your best to judge the colour temperature – and so the necessary filtration – from the colour temperature table on page 10 and by looking behind the camera at the sky. Bracket the filtration, using different strengths of amber colour conversion filters.

More straightforward projects that you can fit into normal shooting involve simply making an estimate of the colour temperature of shaded areas in certain photographs. Keep a note of these, and check your accuracy with the developed slides. To do this, as with the first project, place amber colour conversion filters over the slides when you examine them on a light box to find which value produces a neutral result. Only colour reversal film is of any use for these tests, as the colour casts are impossible to see in a colour negative and are likely to be overwhelmed in colour printing.

The colour temperature of skylight covers approximately this range. In the first panel, the atmospheric conditions are clear and dry; the intensity of the blue depends on altitude, season, position of the sun, and which part of the sky you look at (normally, the higher, the more intense). In the second panel, the blue is diluted by increasing amounts of haze. Broken cloud in the third panel reduces the overall colour temperature; this varies with how bright the clouds are and how much of the sky they cover. Finally, the surroundings may obscure some or most of the skylight, and if they are pale in colour and sunlit themselves, they can virtually take over as the light source.

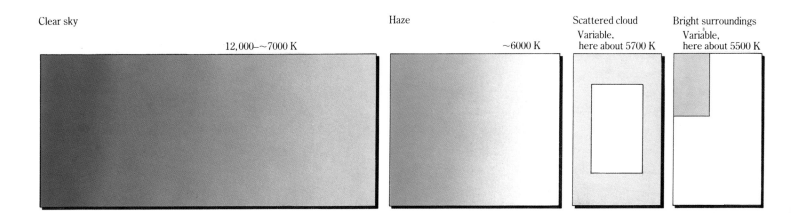

Clear sky
12,000–~7000 K

Haze
~6000 K

Scattered cloud
Variable, here about 5700 K

Bright surroundings
Variable, here about 5500 K

14,000 K, 74 mired

5000 K, 200 mired

10,500 K, 95 mired

85C, +81 mired

81EF,
+53 mired

81D, +42 mired

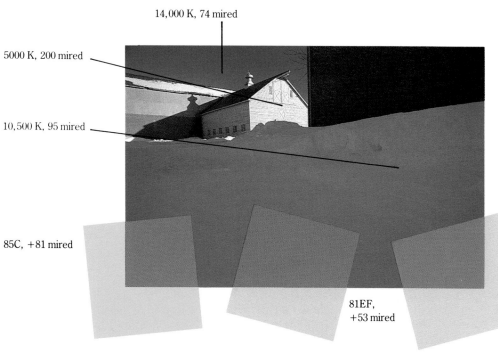

Filter project
Using the colour temperature table on page 10 as a guide, find a shade situation under an intense blue sky, and shoot several frames with successively stronger amber colour conversion filters. Avoid shaded areas that receive reflected light from buildings and other surroundings – the idea is to work with a strong blue skylight.

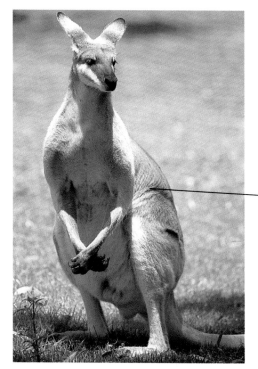

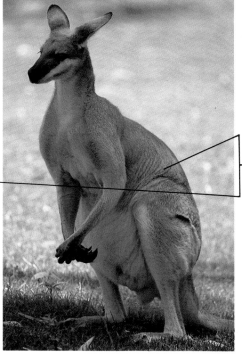

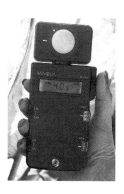

This pair of photographs, taken within minutes of each other, shows the typical difference in light level and colour temperature between sun and shade on a bright day. To the eye, the colour of the wallaby when it had moved into the shade seemed neutral; in the film, we can see the distinct blue cast from the skylight.

Colour temperature difference: about 1500 K

Light intensity difference: about 4 stops

Twilight

Like normal daytime skylight, twilight is a reflected light source, but rather more complex in its effects. It is the light that remains once the sun has set, and in the opposite direction before sunrise. In a clear sky, the intensity shades smoothly upwards from the horizon, where it is brightest, and outwards from the direction of the sun. The studio equivalent is a light placed on the floor, aimed up towards a white wall, and this used as back lighting for a shot taken on a raised surface – as in the photograph on page 176. The sky in the direction of the light acts partly as a diffuser, partly as a reflector. The actual light levels vary considerably, from a maximum when the sky is completely clear immediately after sunset or before sunrise.

These settings are from an incident reading: what you would need if you were taking a photograph by twilight, facing more or less in the opposite direction. A much shorter exposure can be used if the photograph is being taken *into* the twilight, making a silhouette of the horizon and subjects. In this kind of backlit shot (the photograph *below* is a good example), the shading of the sky from bright to dark gives some choice of exposure, particularly with a wide-angle lens. Less exposure intensifies the colour and concentrates the view close to the horizon. More exposure dilutes the colour in the lower part of the sky, but shows more of the higher, bluer parts. In other words, increasing the exposure extends the area of the subject within the frame. A range of exposures is acceptable, depending on what you want from the picture.

It is not only the intensity which shades from the horizon upwards, but the colour does also. The exact colours depend on local atmospheric conditions, and the different light scattering effects that we looked at on pages 24–5 are combined in a twilight sky. At a distance from the brightest area – opposite and above – the colour temperature is high, as it would be during the day. Close to the horizon in the direction of the light, however, the scattering creates the warmer colours at the lower end of the colour temperature range: yellow, orange, and red. These all merge in a graded scale of colour.

Added to this basic lighting condition, clouds are fairly unpredictable in their effect. If continuous, they usually destroy any sense of twilight, but if broken, they reflect light dramatically: high orange and red clouds create the classic "postcard" sunset. The project on pages 28–9 includes twilight, and one of the things that becomes clear after a number of occasions is that clouds at this time of day often produce surprises. The upward angle of the sunlight from below the horizon is acute to the layers of clouds, so that small movements have obvious effects. On some occasions, the colour of clouds after sunset simply fades; on others, it can suddenly spring to life again for a few moments.

The gradual shading of light and colour can be extremely valuable for some shots. At a particular angle, it produces a broad reflection of light in water or other shiny

Even gradation
A clear sky at dusk or dawn acts as a smooth reflecting surface for the sun below the horizon. The light shades smoothly upwards from the horizon (as shown in the diagram *right*). This effect is most obvious with a wide-angle lens, which takes in a greater span of sky.

84° angle of view with 20mm wide-angle lens

11° angle of view with 180mm telephoto lens

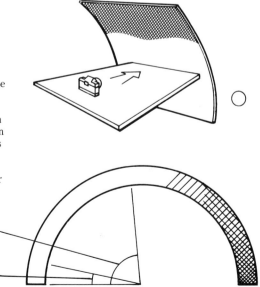

surfaces, but one that has no distinct edge. This can be a very simple and attractive illumination for reflected things, and has its equivalent in studio lighting, as you can see on pages 130–3.

Project: Twilight shooting

In clear twilight, shoot with both wide-angle and telephoto lenses. The wide-angle view, by including more of the height of the sky, will contain a range of colour, from approximately orange to blue. The telephoto shots, with a narrower angle of view, can only take in a small part of this; perhaps only a single colour. You can see something of this difference in the sunrise project sequence on pages 28–9.

To demonstrate the effect of smoothly-graded light on a reflected surface, photograph a car at twilight, facing the brightest part of the horizon and under a sky that is reasonably free of clouds. For the clearest lighting effect, shoot from a slight elevation; enough so that the image of the roof of the car remains a little below the horizon.

Blue twilight
Red and orange sunrises and sunsets depend very much on the condition of the atmosphere. When they do not occur, an overall blue cast is typical, as in this view of a New England church in winter.

Choices of exposure
Following the meter reading exactly will give an exposure that often resembles a daylit rather than a twilit scene. For a better impression of evening, in this view of downtown Toronto the second photograph was underexposed by 1 stop.

Clouds

Clouds are the most visible component of weather. In outdoor photography they are by far the most important controlling factors in daylight. As you can see from the photographs on these pages, the variety of cloud effects is enormous, and the usual simple formula given in film tables for adjusting exposure is really not enough for any sophisticated approach to natural light.

To make a comparison with studio lighting, clouds act as variable diffusers over the scene, and as reflectors at the same time. Imagine that the full range of these diffusers includes ones of different thickness, texture, extent, at different heights, and capable of being arranged in a number of layers, moving at different rates: the permutations are infinite. The simplest conditions, and the closest to having predictable effects are when the cloud cover is continuous. Overcast skies just diffuse the light, and if they are sufficiently dense that there is no patch of brightness to show the position of the sun, the light is as soft and shadowless as it ever can be. The table on light levels on page 50 gives an indication of how an overcast sky affects exposure.

Medium-to-heavy overcast skies have a reputation for bringing dullness to a scene. To an extent this is true, but not exclusively so. Light comes more or less evenly from the entire sky, so the only shadows are those caused by objects being close to each other; this lack of shadow reduces modelling, perspective and texture. Most things appear to have less substantial form, and large-scale views appear flat. There is virtually no modulation of light, and the sameness of illumination in all directions makes conditions less interesting. There are none of the lighting surprises that bring so much of the pleasure of photography in changing weather.

That said, however, overcast skies are good for certain subjects. The chief characteristic of this kind of lighting is that it is extremely uncomplicated. Hence it is good for giving clear, legible images of subjects that are, for one reason or another, complex. Things with intricate shapes, for example, are prone to appear confusing when direct sunlight adds a pattern of shadows. Reflective surfaces make clearer, more legible images under diffuse lighting: the reflection of a broad, even light source will cover all or most of any shiny surface.

By contrast, in clear weather, the sun appears as a small, bright, specular reflection.

The value of shadowless, overcast lighting, therefore, is in its efficiency rather than in its evocative qualities. It helps to clarify images. We will come across this distinction again when we look at ways of using photographic lighting, particularly in highly controlled studio conditions: efficiency versus character. Much depends on what you see as the purpose of the shot. If the photograph has to remain faithful to the physical, plastic qualities of the subject, this sets certain criteria. Then again, it is possible to say that certain directions of lighting, types of diffusion, and so on, are better than others. Clarity in the image takes precedence over more expressive qualities.

In landscapes and other views that include the horizon, a 100 per cent cloud cover alters the tonal relationship between sky and land. Without cloud, the difference

Clouds are principally diffusers of sunlight, and to a lesser extent reflectors. The amount of light that they reflect is difficult to isolate; it is strongest from low white cumulus, and adds something in the region of ½ a stop to direct sunlight.

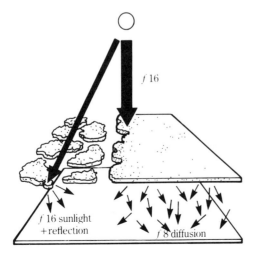

f 16

f 16 sunlight +reflection

f 8 diffusion

Portraits
One valuable property of cloudy light is that shadows are very weak and soft-edged. This is often an advantage with portraits – particularly with a richly textured face such as this.

Indistinct clouds and haze

While clouds that have recognizable outlines, such as woolly cumulus or wispy cirrus, become a visual element in a landscape, indistinct clouds and haze are important mainly for what they do to the lighting. As well as changing the light level, they also alter the brightness range.

Dark

Medium

Light

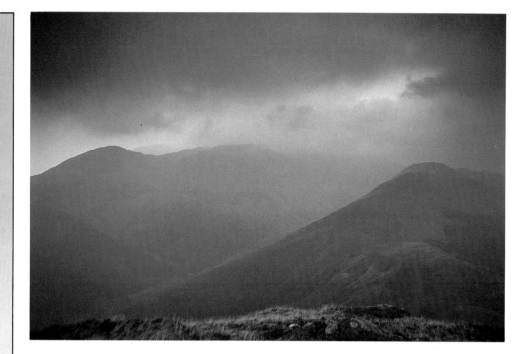

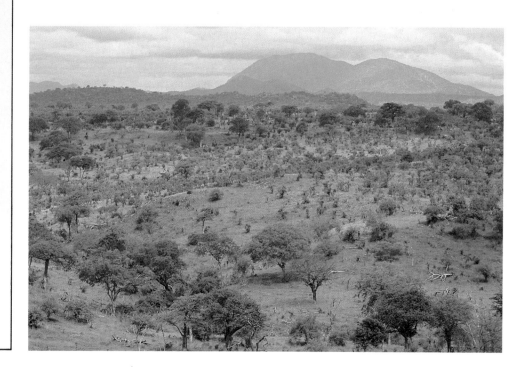

in brightness between the two is usually fairly small; quite often, the subjects are lighter in tone. This is not so when cloud extends all over. As the diagram *top right* shows, the cloud cover *is* the light source and, if contained in the view, raises the contrast so high that if the scene includes the horizon, some detail will be lost either in the sky or in the ground. This is particularly true with colour reversal or transparency film, which has less latitude than negative film. If the subjects or ground are properly exposed, the sky will be white, without any visible texture to the clouds.

The usual answer for this is to use a neutral graduated filter over the lens, aligning the soft edge of the filter's darkened area with the horizon line, so that the sky is made darker. If the final result is a print, another way of adjusting the tones is by different exposures during enlargement (more exposure to the sky if you are printing from a negative, less if from a transparency). The lighting conditions are more complicated and less easy to anticipate when the clouds are broken, so that there is a mixture with blue sky (in fact, the complexity extends to situations where there is more than one layer of broken cloud, each different in type). The diagram on this page gives an impression of the range of possibilities; even simplified like this, it shows how the intensity, quality and colour of light can vary. On a windy day, these conditions change rapidly, not only from cloud to direct sun, but from one type of weather to another. Watch what happens when a cold front passes over. Between scattered and partial cloud cover, the most noticeable effect is the fluctuation of the light; at the left and right of the scale, conditions are most consistent.

If you are trying to take a particular shot that you have fixed in your mind, scattered cloud on a windy day can be frustrating, to say the least. The light changes up and down, delaying the shooting. However, the sheer variability of broken cloud can produce some of the most interesting, and

Distinct clouds
Some idea of the visual complexity of definitely-shaped clouds is given by this chart, which plots brightness of individual clouds (mainly a matter of how thick they are) against the degree of cloud cover. Naturally, the less the cloud cover, the more the blue of the sky has an effect. Three examples are shown.

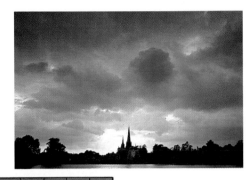

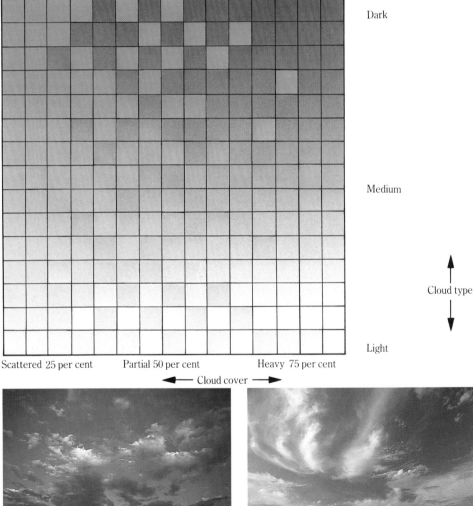

Dark

Medium

Light

Cloud type

Scattered 25 per cent Partial 50 per cent Heavy 75 per cent

← Cloud cover →

▲ Light and shade
Clouds passing over a landscape create a kind of chiaroscuro effect: a tonal overlay to the scene. The effect is most successful at a distance and from a high viewpoint, here an aerial view of a southern Philippine port.

In cloudless weather, the light levels of the ground and the blue sky are usually quite close. In very clear weather, the landscape can, not uncommonly, be brighter than the sky. On a normally overcast day, the sky is much brighter, and so the contrast between the two parts of the scene high. Visually, the effect is as shown in the diagram: the light source appears in view.

1
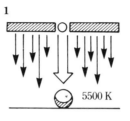
5500 K

2
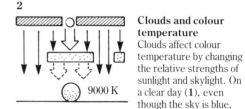
9000 K

3
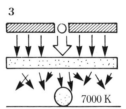
7000 K

Clouds and colour temperature
Clouds affect colour temperature by changing the relative strengths of sunlight and skylight. On a clear day (**1**), even though the sky is blue, the sun is so much stronger, that it overwhelms the higher colour temperature from the rest of the sky; only the shade, typically 3 or 4 stops darker, is bluish. When scattered clouds cross in front of the sun (**2**), they reduce its strength, leaving the blue skylight relatively more important. When the entire sky is cloudy (**3**), the colour temperatures of the two light sources, sun and skylight, are thoroughly mixed; as a result, the colour temperature of the diffused light reaching the ground is raised slightly overall.

	Sunrise/ sunset		Noon summer				
Sun in clear blue sky	4000	4500	5000	5500			
Hazy sky		4500	5000	5500	6000		
Thin cloud (visibly brighter in direction of sun)			5000	5500	6000	6500	
Overcast (completely diffuse)				6500	7000		
50 per cent scattered clouds (sun blocked)				7500	8000	9000	
25 per cent scattered clouds (sun blocked)				9000	10,000	11,000	12,000
Skylight alone					12,000–20,000		

Colour temperature, clouds and time of day
The height of the sun affects the colour temperature, as does the degree of cloud cover. Each bar in this diagram shows the typical range, in kelvins, from sunrise and sunset at the left to a high midday sun at the right.

even dramatic, lighting. To take advantage of it, however, you will need to react quite quickly. Familiarity with the different light levels in any one situation will help; if you have already measured the difference between cloud and sunlight, you can change from the one setting to the other without having to use the meter again. Under heavy cloud with a few gaps, this may be particularly useful, as the sunlight is likely to move in patches across the landscape, and be difficult to measure quickly.

Clouds and light level

Although light levels are reduced when clouds block the sun, the amount depends very much on the type of cloud. If the clouds are indistinct and spread across the sky, the light loss is on a simple scale from a light haze (as little as ½ a stop less than clear sunlight) through thin high stratus to dark grey low clouds (up to 4 or 5 stops darker, and more in exceptionally bad weather). With distinct clouds, however, such as scattered fair-weather cumulus, the light levels can fluctuate rapidly, particularly on a windy day. Light, white clouds usually cause a simple fluctuation of about 2 stops as they pass in front of the sun from bright to shade in one step. Dark clouds with ragged edges, or two layers of moving clouds, cause more problems, as the light changes gradually and often unpredictably. In the first case, two light measurements are all that is necessary – one in sunlight, the other as a cloud passes – and once this is done, you can simply change the aperture from one to the other, without bothering to take any more readings. In the case of more complex moving clouds, constant measurement is essential, unless you wait for clear breaks and use only these.

Colour intensity
In this pair of photographs of a church steeple in Montreal, there is a marked difference between direct sunlight (*left*) and even a light cloud (*right*). The cloud reduces the intensity of the red, changes the hue by raising the colour temperature, and lowers the contrast. Also, note the effect on the reflections.

Light loss: even cloud cover							
	Clear sun	Light haze	Heavy haze	Thin high cloud	Cloudy, bright	Moderately overcast	Heavily overcast
f-stops	0	−½	−1	−1½	−2	−3	at least −4

Projects: Different cloud conditions

The first project is an exercise in imagination. Overcast weather is generally thought of as being dull and uninteresting for photography, and this in itself is reason enough for working a little harder than usual to find ways of making it work. Look for subjects that have the kind of complexity of form that would look confusing in direct sunlight, and for those with important details that would otherwise be in shadow. Use subtractive lighting (see pages 64–5) for portraits to create modelling. Also, look for subjects that have shiny surfaces and use an overcast sky to give an even, simple reflection.

A more basic project is to shoot pairs of frames to contrast the effects of direct sunlight with those of cloud. The easiest times to do this are when the clouds are moving and there are gaps. Adjust the exposure as necessary, but make a note of how many stops the difference is. Compare the various pairs; notice in particular the effect on colour temperature, on colour intensity and relationships, and on modelling. When shooting landscapes, make a point of looking for interesting patterns and modulations of clouds, and use them in the composition.

Modelling
Clouds can either help to reveal the form of a subject or make it less obvious, depending on the type of surface. The copper roof of the Secretariat building in Kuala Lumpur shows its shape better on a dull day, while the brickwork below, not being so reflective, does better under direct sunlight.

Colour temperature
Because clouds combine the colour temperature of the sun and sky above, the effect is a slight raising of the colour temperature, as can be seen in this pair of photographs of a peacock. The exposure was adjusted for the cloudy version *right*, but the colour is unmistakably more blue.

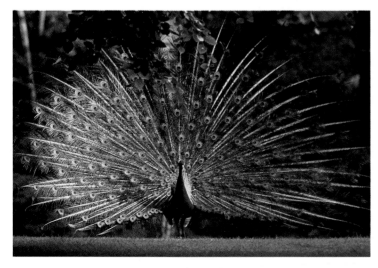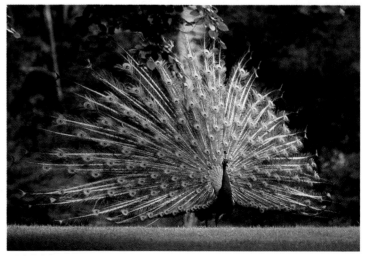

Rain and Storms

Rain

The speed at which it falls, and the slow shutter setting needed in what is usually poor light, results in rain looking much like mist in most photographs. To get some impression of the actual raindrops, the best conditions are back lighting against a dark background, and this is uncommon in rainy weather. The best sense of raininess often comes from the subjects – people with umbrellas, drops on leaves and car wind-screens, and so on – rather than from the light. The levels are usually very low: rain and cloud together easily reduce the light by 4 or 5 stops.

Lightning

As one of the most dramatic features of a storm, lightning can add considerably to the power of a landscape. It is insufficiently strong to take pictures *by*, but you can include it as a subject, provided that the conditions are dark enough. There is no way of synchronizing lightning flashes with the shutter, and the only certain technique is to leave the shutter open in anticipation of a strike. Fortunately, the electrical conditions that produce one lightning flash usually produce a number, often more or less in the same place. At the height of a storm, you should not have to wait longer than about 10 or 20 seconds for the next flash, and it is more likely to be in the direction of the last few flashes than in any other. Nevertheless, lightning in daylight is very difficult to shoot without overexposure. If there is still light in the sky (this is likely to make a more interesting picture), estimate the average interval between flashes, and adjust the camera settings to allow a time exposure longer than that.

Ordinarily, the exposure depends on the intensity of the individual flash, whether it is reflected from surrounding clouds, and how far away it is. You can estimate the last, at least through a group of flashes: count the

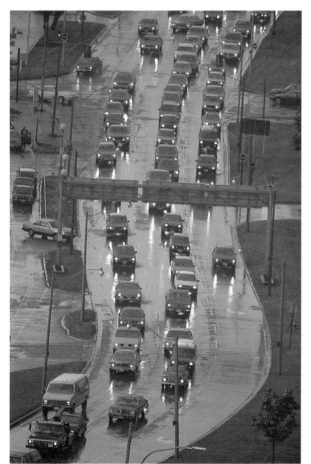

◄To establish "raininess", some visual clues are necessary. Here the reflections of car headlights in the wet surface of a Toronto freeway make the point.

►**Lightning**
Distant lightning over Rangoon and the delta of the Irrawaddy was photographed at dusk with an exposure of 30 seconds – long enough to catch a few cloud-to-cloud strikes and one cloud-to-ground. The afterglow of sunset and city lights help to establish the setting. The aperture was *f* 2.8 and the film speed ISO 64.

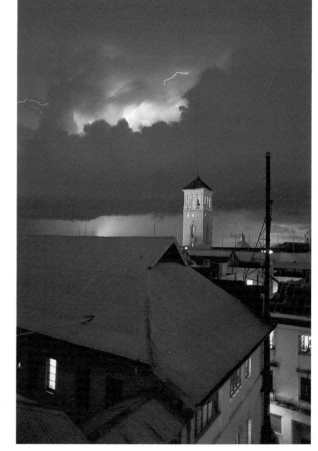

number of seconds between the flash and the accompanying thunder, and apply the following:

Interval	Distance to storm	Film speed (ISO)				
		25	50–64	100	200	400
Under 10 secs	Under 2 miles (3 km)	f 8	f 11	f 16	f 22	f 32
10–45 secs	2–9 miles (3–15 km)	f 4	f 5.6	f 8	f 11	f 16
Over 45 secs	Over 9 miles (15 km)	f 2.8	f 4	f 5.6	f 8	f 11

The difference between flash and thunder is the speed of sound.
5 seconds=1 mile (1.6 km)

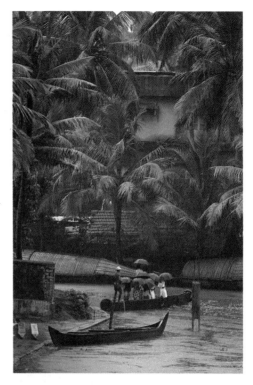

Other obvious indicators of rain in a photograph are umbrellas and people sheltering. In this view of a canal in Kerala, India, during the monsoon, the rainfall itself appears little different from a dull haze, despite the heavy downpour.

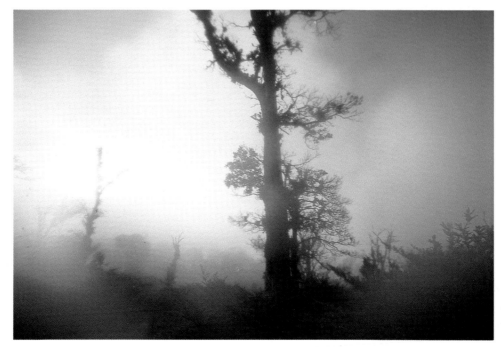

Storm
Sometimes the most effective impression of stormy weather is by impression and minimum detail, as in this view of swirling clouds and driving rain on a Central American mountain.

Haze

Haze is the scattering of light by particles in the atmosphere. Fine dust and pollution produce it (the latter can create much worse haze), as does high humidity. In fact, haze varies considerably, not only in how heavy it is, but in the wavelengths that are affected. The finest particles scatter the short wavelengths more than most, and produce bluish ultraviolet views over a distance. The haze from humidity, on the other hand, has a neutral colour effect, and looks white over a distance.

Visibly, there are two main effects from haze. One is on the view itself, the other is on the quality of light. The effect on a landscape is to make it appear paler at a distance; this is progressive, so that contrast, colour and definition gradually drain away from the foreground to the horizon. This effect is strongest when the sun is in front of the camera (but not necessarily low), and is what contributes most to aerial perspective – the impression of depth due to the atmosphere. To make this work strongly, however, you would need to shoot in such a way that there are at least a few obvious planes of distance in the scene; simply a long view, with no foreground or middle ground, appears pale.

The effect of haze on the lighting is to soften the hard edges of sunlight. The extra scattering reduces contrast and helps to fill shadows. The effect can be an attractive balance between sunlight and diffusion, particularly when the sun is a little in front of the camera, as in the photograph *opposite*. The amount of haze varies, and in its visible effect, strong haze merges with light continuous cloud.

Project: Reducing haze

Although haze can add to the atmosphere of a view, it can also be unwelcome by hiding detail, colour and crispness. The following are ways of reducing it; try them out in one location on a hazy day.

- *Ultraviolet filter* This works on the short wavelengths only, so the effect is unlikely to be total. In addition, with black-and-white film, an orange or red filter has a stronger haze-cutting effect.
- *Polarizing filter* This works most strongly at right angles to the sun (in side lighting) and produces a noticeable overall improvement.
- *Frontal or side lighting* Either of these are preferable to back lighting, which should be avoided.
- *Avoid distant views* The closer you shoot, the less atmosphere, and so the less haze. For this reason, a wide-angle lens may be an improvement over a telephoto.

When haze has a noticeable effect on film, as in this telephoto view across Canyonlands National Park, Utah, filtration can make a substantial improvement. In the unfiltered version **1**, the haze appears a pale blue; both contrast and colour saturation are weakened. Adding an ultraviolet filter **2** improves this, while a polarizing filter **3** has the strongest effect of all.

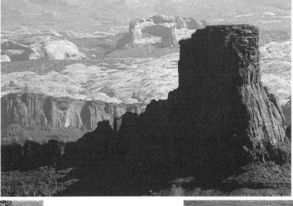

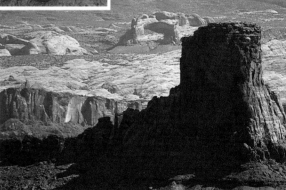

Project: Permutations of lighting

So far, the lighting projects have been limited to just one or two variables: direction, colour temperature, or the contrast between light and shade, for example. At some point, however, undertake one project in which you combine a number of these. Take one location and one basic view; shoot it under a variety of lighting conditions, including different times of day, seasons and weather.

As well as doing this with one identical view, shoot whatever seems to be an appropriate image for any particular condition, changing the lens and framing as seems necessary. The identically composed series should help demonstrate the combinations of lighting effects; the less constricted views show that different lighting conditions exert their own influence on the design of photographs.

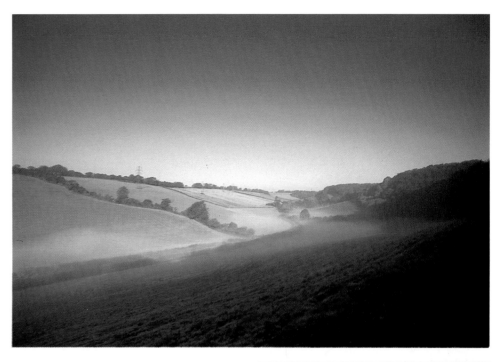

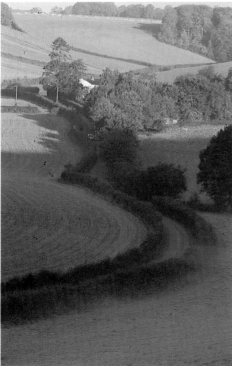

The project setting here is in a small valley in the Chilterns, northwest of London. The two vertical shots are part of a longer series, photographed over a period. In the horizontal view, a clearing early morning mist suggested the use of a 20mm wide-angle lens: at this scale, the pastel colours of sky and fields make an attractive combination that would be lost in a more tightly-cropped version.

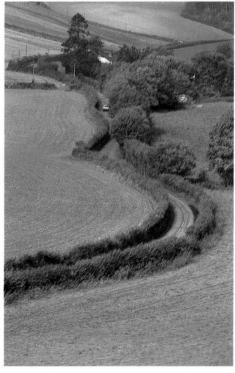

Mist, Fog and Dust

The most extreme effects on the atmosphere are those of mist, fog and dust. All can be so dense as to make even nearby things difficult to see. The droplets or particles are so large that there is no selective scattering of wavelengths, just an overall diffusion (dust, though, has its own colour, and tinges the view yellow, light brown, or whatever). There is really no point in thinking of these as problem conditions: they clear eventually (and usually quickly) and there is very little that can be done to change their basic character. In any case, they are generally not so common, and offer opportunities for a number of interesting images. When you come across them, make use of them.

When a fog is dense, or when the sun is fairly high, there is little if any sense of direction to foggy light. If you choose the distance at which you shoot carefully and close to the limits of legibility, the colour and tonal effect will be extremely delicate. Against the light, depending on the density, these conditions produce some form of silhouetting. Close to the camera, the subjects are likely to stand out quite clearly, with good contrast. At a distance, the silhouettes and setting will be in shades of grey. As the conditions shift, thicken or clear, the nature of the images changes significantly. Dust in particular is a very active condition: it needs wind or movement to remain in the atmosphere. Backlighting gives the best impression of its swirling and rising, but there are obvious dangers to the equipment.

There are two ways of creating an impression of mist and fog when neither exist. One, simple but mild in its effect, is to use what is known as a fog filter. This is a graduated filter on the same principle as the neutral graduated filter shown on page 67, but it shades from clear to diffused. If you use it at a fairly wide aperture, so that the edge between the two halves remains vague, and the diffused area is above, the effect is that of the atmosphere thickening with distance. The second method, involving much more trouble, is to produce artificial smoke, either from smoke flares or by hiring an oil-based smoke machine. Even a medium breeze is enough to dissipate the smoke as quickly as it is produced, however.

Project: Effects from fog
On a foggy day in one location, try and create as big a variety of images as possible. As well as looking for different subjects and viewpoints and using different focal lengths, wait until the fog begins to clear to take advantage of the following shifting effects:
- delicate colours in directionless lighting.
- depth of view with subjects at different distances from the camera, fading progressively towards the distance.
- strong silhouettes against the light.
- pale silhouettes.
- clearing, shifting fog. A wide-angle lens is often the best for showing different thicknesses of fog in one image.
- a view from a high point of a sea of fog with clear air above, ideally with the tops of trees or buildings standing out.

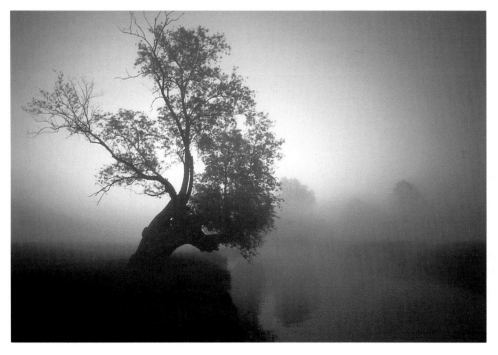

Silhouettes
Shooting against the light in an early morning fog silhouettes a riverside tree. The fog conceals the background, and the strength of the silhouette can be controlled by the camera position. In this instance a wide-angle lens was used so that the shot could be taken only a few yards from the tree.

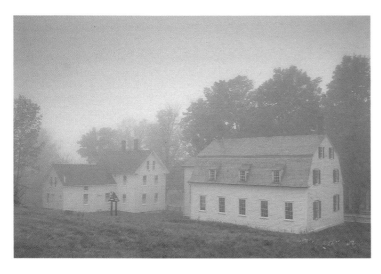

Delicate tones and colours
Morning mist gives an overall softness to a Shaker village in Maine. In a situation like this, with a clear view and a choice of camera positions, the distance can be selected to give a certain degree of softness, changing the focal length of lens as needed.

Dust
Although very damaging to cameras, dust has special qualities that can add considerable excitement and atmosphere to a photograph. Here, swirling clouds of dust churned up by an earth-mover give it a looming presence; back-lighting from a setting sun makes the most of this.

For comparison, see how the same subject photographed *right* appears in different lighting conditions. These earthmovers *below* were shot on three occasions; from left to right, in the early morning, the middle of an overcast day, and mid-afternoon. As an extension to the project described *opposite*, photograph the same scene or subject under a variety of conditions.

Snowscapes

A fresh fall of snow is the ultimate in bright surroundings. The studio equivalent is an overhead light and a bright white curved base: the kind of still-life set that you can see in the photographs on pages 172–5. When photographing local subjects in a snowscape, such as a portrait, the two most noticeable effects are powerful shadow-fill, particularly from beneath, and frequently bright backgrounds. The reflection that fills the shadows reduces contrast, which is no bad thing for many subjects under a direct sun. Bright backgrounds can create flare, and efficient lens shading is usually necessary. Landscapes and other overall views vary considerably with the quality of the daylight. Contrast is low under cloud, skylight and twilight, but can be high in direct sunlight, particularly with back lighting.

Exposure is, on the whole, more critical in a snowscape than in most other landscapes. Between a white that reproduces as a muddy light grey and one that is featureless and washed-out, there is very little latitude in the exposure setting, and neither over- or underexposure looks particularly good. The eye is quick to appreciate a pure white, and equally quick to discover it wrong in appearance. Measurement and exposure need care, but are usually not quite such problems as they are often claimed to be.

The essential thing to remember is that if you take a direct, reflected light reading of white, flat, sunlit snow, you will need to add 1 or 2 stops to the exposure. Reflected readings show how to reproduce the tone they measure as grey. As long as you remember this, there are no great problems, except that the final result is delicate, and it is often wise to bracket exposures, if only by ½ a stop up and down. Incident readings with a hand-held meter are not affected, of course. The project below offers more suggestions on exposure.

As snow is an efficient reflector, colour or temperature differences in the sky are mirrored, and seem more prominent. Look, for instance, at the illustration for the skylight project on pages 42–3. In scenic views, this strength of colour is by no means unpleasant, particularly if combined with other colours in the picture.

Project: Variations in lighting

This depends, naturally enough, on the availability of a good covering of snow; something which may be certain in some locations and impossible in others. Nevertheless, the ideal conditions are the day after a fresh snowfall, and clear, bright weather. Cloudy weather offers much less variety of lighting, and so of images. The example here was a winter's day in the north of England, on Hadrian's Wall, beginning at dawn.

1

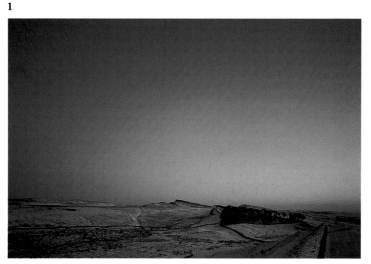

2

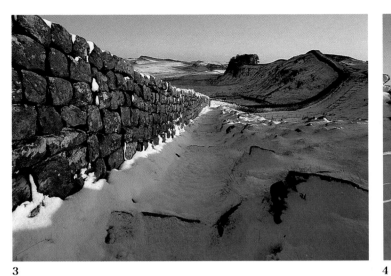

3

4

5

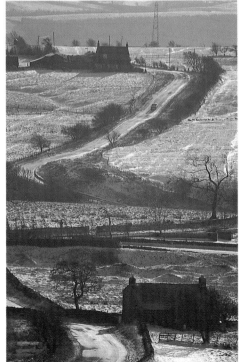

6

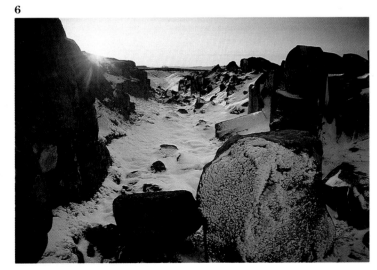

All of these photographs were taken on a single day in one general location – Hadrian's Wall – and are shown in order of shooting. The first photograph was taken just before sunrise, the last at sunset. Part of the exercise here was to catch as much visual variety as possible from the lighting conditions, and in particular using the reflective qualities of the snow. White snow picks up colour more readily than anything else in landscape photography, from the strong blue of a clear sky to the pinks and oranges of a low sun.

Mountains

The height of mountains creates some of their special conditions of light; their relief produces the others, through the frequently rapid changes in local weather. One of the most memorable conditions is the clear, crisp air in sunlight that gives high visibility to long views and fine detail. This, however, is only one of a variety of types of lighting. The air is thinner at altitude, and so clearer, provided that the weather is fine. Being thinner, there are fewer particles to scatter light into the shadow areas, which can thus be very deep. Local contrast, as a result, is often very high. The skylight in shade is a more intense blue than at sea-level. As usual, this is difficult to estimate without a colour temperature meter, particularly as the values are often unfamiliar.

The thin air is a less effective screen against ultraviolet rays, and there is a higher component of these short wavelengths. This produces an unusually large difference between what you can see and what colour film will show. Unless you want to make use of the blue cast to demonstrate the distance, use strong ultraviolet filtration. Remember also that, in reacting to the ultraviolet wavelengths, the film receives more exposure, and the distant parts of the scene will look paler than to the eye.

So much for the thinner atmosphere. The interesting part of mountain light comes from the weather, and this is controlled strongly by the relief of ridges and valleys. In particular, clouds become a part of the local lighting, as the project examples show.

Project: A variety of conditions
Essentially, the idea here is to explore the variety of lighting conditions in one location by working at different times of day, and from a variety of viewpoints. The two extremes of viewpoint are a high peak in the middle of the mountains, and sea-level from a distance.

Contrast
At 7000 feet (2000 meters) in the Colombian Andes, the thinner atmosphere gives a high contrast range close to the camera (haze reduces this at greater distances). The range here is about 7 f-stops, giving an almost lunar quality to the rock-strewn landscape.

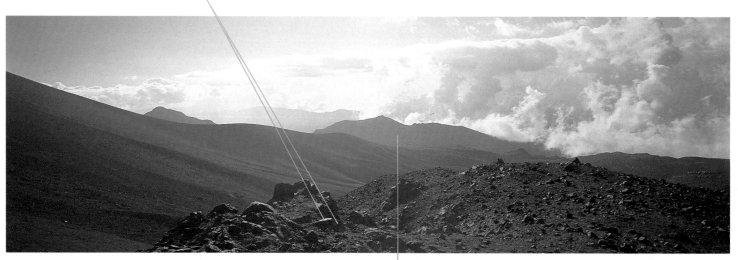

Ultraviolet haze
The thinner atmosphere also means less screening of ultraviolet rays. The sensitivity of film to ultraviolet gives a pronounced pale blue cast to distant parts of the landscape. The lens was unfiltered.

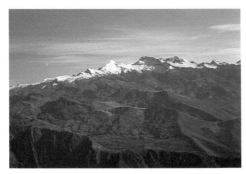

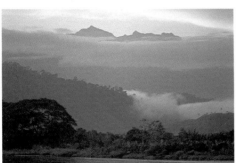

All the examples on this page were taken in the Sierra Nevada de Santa Marta: an isolated part of the northern Andes. The two photographs *below*, both taken at dawn (on different days), show the difference between a sea-level view and one from a 9000-foot peak. The other photographs, all of the same central peaks, were shot during the morning, from sea-level (*left*) a nearby peak (*right*), and from the air (*above left*).

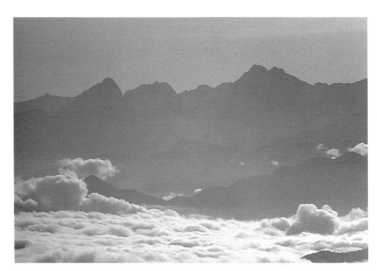

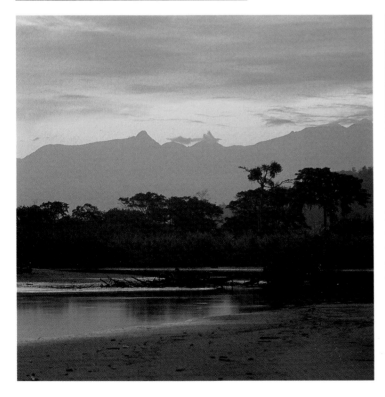

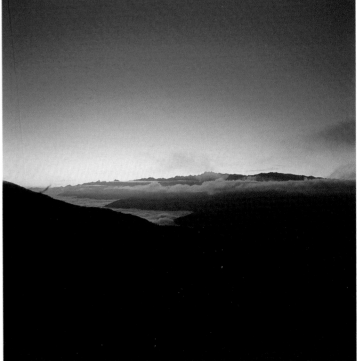

Tropics

Tropical light is characterized by the height of the sun and its consequences. At some time of the year at least, the sun is directly overhead in the middle of the day, and its effect on the distribution of light and shade is unfamiliar to most photographers. If you live in the middle latitudes – in New York, say, the Mid-West or Europe – your idea of a high sun is probably around 60° above the horizon. This gives the kind of conditions that we looked at on pages 30–41: distinctly high, but with enough direction to make a visible difference to the appearance of the shadows if you walk around the subject, or turn it to face another way.

For about two or three hours a day in the tropics, however, there is no sense of front, back or side to the sunlight. Shadows lie directly underneath things. Roofs and awnings cast deep shadows, but under many subjects, such as people or cars, the shadows are very small. Anything more or less level, like most landscapes, appears without any significant shadows at all. It is easy to say this overhead light is unattractive, and by conventional standards it probably is for many subjects; however, it would be too dogmatic to dismiss it as being generally unsuitable. If this is typical of the tropical scene, then it can play a part in conveying the atmosphere of the tropics. A high, intense sun at least has natural associations with heat.

However, to return for a moment to the conventions of lighting quality, portraits and landscapes are the two subjects that suffer most on the scale of attractive-unattractive. A face directly under the sun will have prominent, deep shadows under the eyebrows, nose and chin; moreover, eyes carry much of the expression in the face, and these will be fairly well hidden by shadows. The lighting problem for landscapes is almost the opposite: a lack of shadow. There is, as a result, less sense of shape and texture to the landscape, and consequently a weaker perspective.

Whether this matters or not depends on the reasons for the photography. In the case of the portrait, if you are trying to make it look attractive, then this lighting will be a problem; if you treat it as reportage, not necessarily. The general solution is to shoot earlier or later in the day; an immediate answer for a portrait is to shoot in open shade, but avoid facing a large area of blue sky (which will raise the colour temperature).

If you go back to page 25 and the diagrams of the sun crossing the sky, you can see that above a certain height there is not so much difference in the light level. In the tropics, the sun remains above 40° for much longer – around five or six hours. Effectively, this means for much of the day the light level remains consistent. Unfamiliarity and heat may make you think that it is brighter than it really is, and it is important that you measure the light, and follow the meter reading.

The sun rises and sets more or less vertically, which at least makes it easy to predict its position for aligning subjects with sunrise and sunset (see page 26). However, rising and setting like this, it appears to move quickly: dusk and dawn are short. If you are used to the time that is normally available in a temperate climate for preparing a shot or changing position, you may be caught out when you first photograph the tropical version.

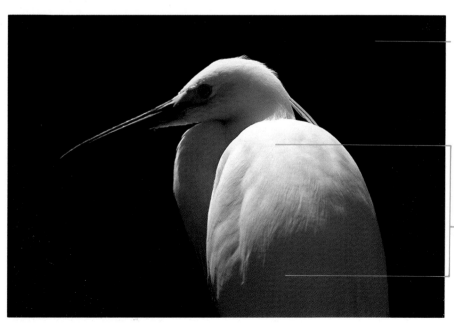

Shadows
Because of the high position of the sun, even small overhangs and projections can cast strong background shadows.

Contrast
The overhead sun gives high contrast and this kind of distribution of light and shade: highlights above, shadows beneath. On ISO 100 film, direct spot readings of the plumage on this egret were *f* 32 and *f* 4.5 respectively.

On open ground and over a distance, the heat causes quite a lot of movement in the air close to the ground; the shimmering effect creates blur in a telephoto image. This is most obvious at midday and during the early afternoon, and so is strong ultraviolet scattering also.

Project: Using tropical lighting

Avoiding the high, overhead sun that is typical of tropical lighting is relatively straightforward; simply a matter of shooting early or late in the day, and not really worth a special project. Instead, on the next occasion that you have to visit a tropical country, take the challenge of shooting in the middle of the day.

Look for scenes that convey the impression of heat, images with stark contrast, patterns of light and shade that are distinctive to the tropics – for instance, long, downward-pointing shadows on a bleached wall; a face completely shaded by the brim of a hat and so on. In other words, look for images that say "tropics" through the quality of lighting as much as through the subject matter.

High-relief subjects tend to be full of contrast, while flat subjects like this beach landscape off the coast of Borneo appear quite the opposite. There is nothing here to cast a shadow under the vertical lighting, and the contrast range is remarkably low.

Just as umbrellas are used as protection against rain, people living in the tropics usually shelter from the sun, and this can be used as one visual symbol. Here, a municipal worker in Manila is heavily masked, despite the heat.

Natural Light: Equipment

Under normal conditions, outdoor daylight photography needs very little in the way of equipment to handle the lighting. Over a distance, no real control is possible. The basic equipment comprises a limited range of filters, a means of shading the lens from direct sunlight, and meters. For most purposes, the camera's TTL metering system is sufficient, provided that you are familiar with the ways of compensating for abnormal lighting conditions, such as back lighting and high-contrast views that feature a small bright subject against a large dark background. A hand-held meter is valuable, but you can do without it. A colour temperature meter is even more of a luxury, but for shadowed settings under a strong blue skylight, it will save the film you would normally use in bracketing filtration (see page 43).

Real manipulation of daylight is, however, possible on a local scale. Portraits in particular have a relatively small subject area, and can benefit from lighting control. The principal options are diffusion, reflection and blocking. The equipment shown here was custom-made to the photographer's specifications from collapsible aluminium tubing and sail cloth, but any suitable material that is fairly tough will do, provided that you can find ways of rigging it in position. There are also proprietary screens available, which fold and are mainly designed to be held by an assistant. Daylight screens are mechanically extremely simple, however, so if you need them you might as well make your own.

The screens shown here double for use with all kinds of location lighting. Their main use is to modify sunlight. Depending on the density of the translucent material, diffusing screens will soften harsh lighting, and are particularly valuable for close portraits. Reflectors are used for shadow fill to reduce contrast, but a sheet of mirror-like mylar (it does not have to be large) can be used to redirect sunlight that may be blocked by an obstruction. This redirected sunlight can then be diffused if wanted.

Finally, blackout material can be used for subtractive lighting techniques. These include blocking light from one direction in order to favour another, and darkening one side of a subject to increase the modelling effect on overcast days when the lighting is directionless.

As sunlight usually strikes the subject from overhead, a secure method of suspending a screen is essential if you are using diffusing material. Loose, unsupported fabric can be rigged with lines to nearby supports, but as these are not always available, a collapsible frame is valuable. With a large sheet, the wind may cause problems in an exposed location; for this, use guy-lines.

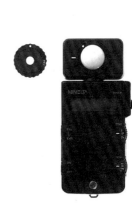

Subtractive lighting
An alternative method of adjusting the modelling effects of daylight is to reduce the light from one direction. This is particularly effective on dull, cloudy days. Here, black material stretched over a frame subtracts reflected light from the left of the subject.

Hand-held meters
For the most precise exposure control, a hand-held meter (*left*) can be used with an attachment for incident light (fitted) or reflected light (separate). A colour meter (*right*), though expensive, makes it easy to adjust filtration for blue skylight.

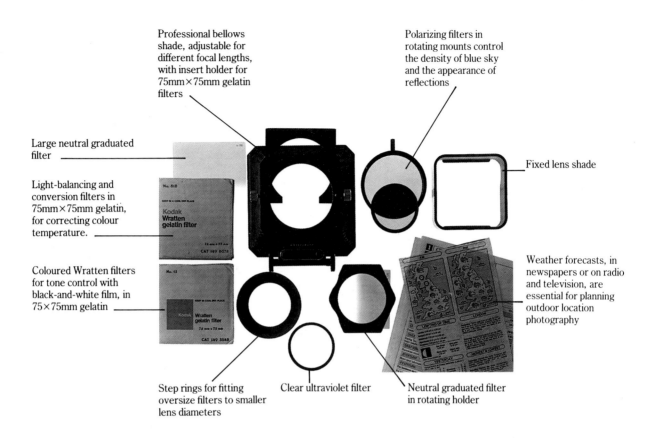

Professional bellows shade, adjustable for different focal lengths, with insert holder for 75mm×75mm gelatin filters

Polarizing filters in rotating mounts control the density of blue sky and the appearance of reflections

Large neutral graduated filter

Fixed lens shade

Light-balancing and conversion filters in 75mm×75mm gelatin, for correcting colour temperature.

Coloured Wratten filters for tone control with black-and-white film, in 75×75mm gelatin

Weather forecasts, in newspapers or on radio and television, are essential for planning outdoor location photography

Step rings for fitting oversize filters to smaller lens diameters

Clear ultraviolet filter

Neutral graduated filter in rotating holder

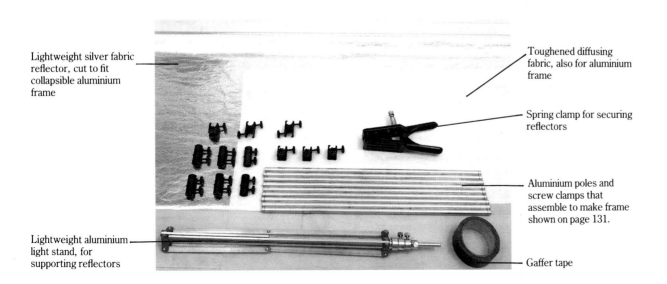

Lightweight silver fabric reflector, cut to fit collapsible aluminium frame

Toughened diffusing fabric, also for aluminium frame

Spring clamp for securing reflectors

Aluminium poles and screw clamps that assemble to make frame shown on page 131.

Lightweight aluminium light stand, for supporting reflectors

Gaffer tape

Natural Light Indoors

The most valuable quality of daylight indoors is its evident naturalness – the lighting appears to be just as it is found, not altered or set up by the photographer. If, in addition, it works well for the subject, this is an extra bonus. Although there are some technical difficulties with light level, contrast, and the uncertainty of the colour balance, the quality of the light from a window is often very attractive and useful. The most commonly used form of still-life lighting equipment is, in fact, based on this effect: boxed-in area lights of the type shown on page 127 are designed to imitate the directional but diffuse natural lighting from a window.

Although interiors vary in design, the typical source of natural light is a window set conventionally in a wall. Which way it faces and the view outside control the amount and colour of daylight entering. As with the skylight project, look carefully at the view out of the window to determine whether or not there is likely to be a major rise or fall in colour temperature. The walls of neighbouring buildings may have a much greater effect than the sky.

If there is no direct sunlight (or if this is diffused by net curtains, for instance), you can treat the window as the source of light. This has an important effect on the intensity, as the light, instead of being constant at any distance, falls off rapidly, almost according to the Inverse Square Law (see page 16). So, if you are taking a portrait by the diffused light from a window, how close your subject stands to it makes a considerable difference to the exposure. If you are photographing the room as a complete interior, the level across the picture may be so great that it needs some remedy to reduce the contrast.

The distinctive feature about light from a window is that it is a mixture of being highly directional, but broad. The shadow is therefore even, simple and soft-edged. The combination of qualities makes diffuse window light almost unequalled for giving good modelling, and can be particularly

successful for portraits and full-figure shots, as the photograph *below* shows. For comparison, look at the examples of studio lighting on page 160. This modelling effect is strongest when the window is to one side of the camera's view; the density of the shadow, and thus the contrast, will depend very much on what happens on the other side of the room: whether there are other windows, how big the room is, and whether it is decorated brightly or not. If the shadow side of the picture is dark and you want to preserve some detail, you should consider adding reflectors.

Shots facing away from and towards the window produce very different effects. With your back to the window, the lighting effect is likely to be very flat, unless beams of sunlight modulate the view. Into the light, the contrast will naturally be high, but flare from the edges of the window can produce a more atmospheric image.

If, however, you feel it is important to be able to see what is going on outside the window as well as the interior of the room, there are only a few special techniques that will help. One is to add lighting to the interior to balance it to the daylight outside,

Daylight through open windows often has an attractive, studio quality; as a fairly large, diffused sidelight, it can be particularly suitable for full-length figure shots, as in this photograph of a group of young Filipinos at an official function in Manila.

and we deal with this later, on pages 72–95. A second technique, which needs no other lighting, is to take two exposures on one frame. The first is timed to record the outside scene through the window, then the window is blocked with black cloth or card and the second exposure made using the light from other windows or doorways to record the interior details. A third technique is for use only with prints: shading and printing-in controls are used during the enlargement to hold back the outside view. This is easier with a black-and-white negative than with colour.

Graduated filter
The side-to-side range of brightness in this room is typical of interiors lit only by one window (*left*). A neutral graduated filter rotated to shade from right to left was the easiest solution.

Printing controls
In the first print (*far left*), a single exposure was given, without manipulation, to show the inside of this unusual window frame; the exterior view is completely washed out. In the second print (*centre*), the shorter exposure was timed to suit the view outside; the interior has become too dark. The third print (*left*) is a mixture of the two exposures, using shading and printing-in techniques to give each area its best exposure.

Blocking the light source

In this interior of a Shaker barn in New York, the only light source was the single window visible here. An adequate exposure for this was too short to reveal any of the interior, so, in addition to this short exposure, a second was made, much longer, with a sheet of black velvet hanging several feet in front of the window; this allowed reflected light to illuminate the beams.

Double exposure to balance outdoor and indoor light

Using only daylight so as to preserve a natural feeling, the problem in this shot was to balance two very different exposures on the same frame. The first was set for the exterior level of lighting – a short exposure. The second was made with the visible window blacked out by a sheet of black velvet, using light from another window to record the details on the desk.

Equipment

The selection of equipment shown here gives considerable control over the distribution, quality and colour of indoor lighting without having to use extra lamps. There are two basic groups of equipment: those things necessary for measuring the existing light and controlling the way it reaches the film, and the materials for altering the light that actually falls on the scene.

Both exposure and colour temperature meters are more important in this kind of lighting situation than in almost any other.

Normal experience makes it relatively easy to judge levels outside, but the sheer variety of rooms, the way they are decorated and the arrangement of windows, makes it necessary to rely on measurement. A hand-held meter is certainly necessary; a colour temperature meter less so provided that you bracket the filtration and are prepared to accept colour temperature variations in the picture. In either case, with or without a colour temperature meter, a comprehensive set of filters is essential. This includes neutral graduated

filters to allow the exposure to be altered across the picture area; the straight edge of the graduation limits their use a little, but they are an effective way of dealing with the fall-off from a single window across a room.

These comprise the basic equipment. To go one step further, the light itself can be manipulated at its source – effectively, the windows and doors. It can be blocked, diffused and filtered for colour. If the room has more than one source of daylight, such as opposed windows, the balance of light from each can be altered totally.

Modifying window light

Two basic techniques for controlling the amount and quality of daylight entering a room are to hang black cloth (*below*) or translucent sheeting (*bottom*) over windows that are out of shot. Black cloth alters the proportions of lighting; the translucent sheeting diffuses direct sunlight.

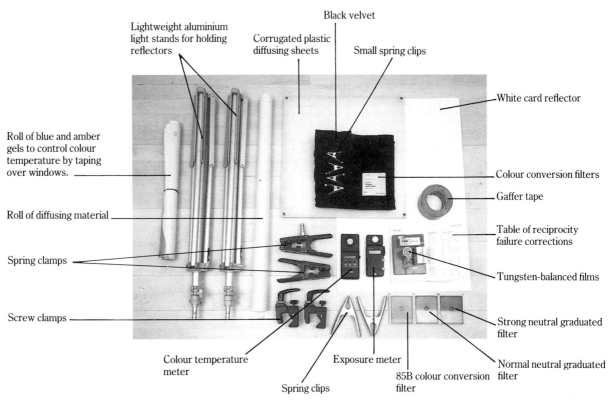

Lightweight aluminium light stands for holding reflectors

Corrugated plastic diffusing sheets

Black velvet

Small spring clips

White card reflector

Roll of blue and amber gels to control colour temperature by taping over windows.

Colour conversion filters

Gaffer tape

Roll of diffusing material

Table of reciprocity failure corrections

Tungsten-balanced films

Spring clamps

Screw clamps

Strong neutral graduated filter

Colour temperature meter

Exposure meter

Normal neutral graduated filter

Spring clips

85B colour conversion filter

Moonlight

Moonlit landscapes are possible for photography, but difficult. The moon does no more than reflect sunlight, so that, in principle at least, a moonlit scene should look and photograph like a dimmer version of the same view in daylight. In practice, it looks different, and photographs taken by moonlight have some distinctive qualities.

To the eye, moonlight seems to lack colour, with perhaps a slightly cool cast. This is because the light level is too low for the retina's colour-sensitive receptors. Instead, a rather less detailed and monochromatic image is formed. In any case, the light level is still too low for a normal view, even with a clear full moon, and night-time landscapes simply look dark.

Photographing by moonlight needs very long exposures, even with fast film, as the intensity is in the region of 20 stops less than daylight. The readings are beyond the range of ordinary meters; the exposures, which may need to be many minutes, or even an hour or two, will certainly cause reciprocity failure in the film. During a long exposure, the position of the moon will change, and there will be a slight blurring to the edges of shadows as they move.

Specifically, a bright full moon is about four hundred thousand times less bright than the sun. This, however, is only a starting point for working out the exposure. The clarity of the atmosphere makes a bigger difference than it does with the sun, and the phase of the moon has a predictable effect. On top of this, the exposure time may need to be doubled or quadrupled (at least) to compensate for the reciprocity failure; this varies considerably with the make of film.

From all of this, the only sensible method, which you should try for yourself, is to shoot only under a bright full moon, use settings between four minutes and fifteen minutes at f 2.8 with ISO 100 film (or equivalent) as a start, and bracket widely. Such long exposures make it tempting to use fast film, but if you are shooting a landscape or building, the grainy appearance will not be ideal. Reciprocity failure information supplied by film manufacturers does not usually cover time exposures of more than a few minutes, so use the direction of the colour shift in the published figures as a guide.

Photographing the moon itself is much less difficult, although it may still be a problem to measure its brightness except with a hand-held spot meter or a spot reading facility in the camera's TTL meter-

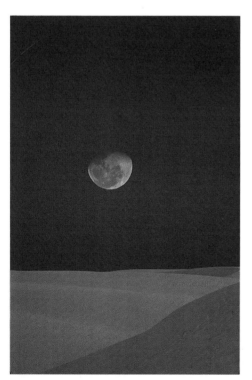

Double exposure
In this evening view of White Sands, New Mexico, the moon was actually higher in the sky than it appears here. To suit the composition, two exposures were made: one for the sand-dunes and a second of the moon. Grid lines in the viewfinder were used to position both elements.

Moonlit scenes
Illuminated only by a full moon in a clear sky, this farm in California's Napa Valley needed an exposure of 30 minutes at f 3.5 on ISO 64 Kodachrome. Much of this long exposure time was taken up by reciprocity failure.

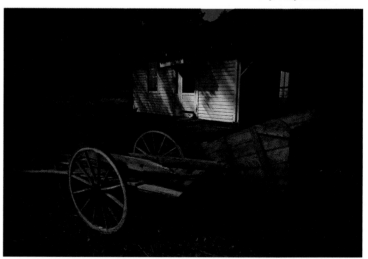

ing system. Again, the brightness depends on atmospheric conditions and on the phase. A bright, full moon needs an exposure on ISO 100 film in the region of $\frac{1}{250}$ second at f 8, but it is sensible to bracket exposures with this as the shortest.

For the moon to appear at a respectable size in the frame, a powerful telephoto is necessary, and as the maximum aperture of the lens is likely to be relatively small, bracketing exposures usually has to be done by altering the shutter speed. The limit to the slowest shutter speed is the movement of the moon's image in its orbit around the earth. The moon appears to move its own diameter in two minutes. For a 400mm lens on a 35mm camera, an exposure of one second or longer will cause blurring.

Even if the moon is not close to the horizon, it is possible to combine it with a landscape view by means of double exposure. This is fairly common practice – perhaps too well-used. Photograph the moon at a position in the frame that you can remember. As an aid, a grid-etched focusing screen would give you reference points; or if the camera's prism head can be removed, use a marker on the screen. Then, if the scene you want to combine it with is visible at the same time (such as a flood-lit building in a different direction), simply reposition the camera. Use the double exposure lever fitted to many cameras before you operate the film advance lever, or alternatively depress the rewind catch, which has the same effect – that of disengaging the take-up spool.

If there is no scene immediately available, try this: shoot a number of frames at the beginning of the roll, first having marked the film leader so that the film can be reinserted to give exactly the same number of frames that have been exposed prominently on the film leader. If the film is not marked in this way, the framing may change slightly between the first and second exposures, as few cameras advance film the same amount after each picture (one notable exception is the Pentax LX). To be sure that its image does not overlap subjects on the ground, keep the moon in a fairly open area of sky when taking the second set of exposures. Expose the additional scene normally; it does not have to be under a completely dark sky. Two precautions if you want to preserve realism: use the same focal length for both moon and landscape, and remember that if you set the moon in a dusk sky, a full moon is always in the opposite part of the sky to the sun.

Focal length
The moon, even when full, appears insignificant except through a fairly powerful telephoto lens. Here, in a photograph of London's Tower Bridge, a 400mm lens was used. The greater the magnification, the faster the apparent movement of the moon – ½ second was the longest possible exposure time to avoid blurring the image.

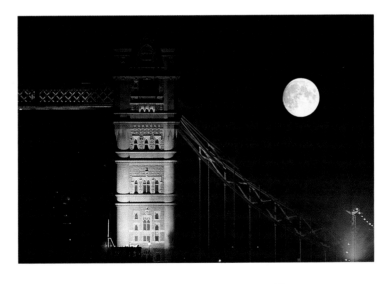

The time taken for the moon to appear to move this distance is 2 minutes.

In a standard 35mm picture frame, the moon appears at these sizes with different focal lengths of lens.

300mm

400mm

500mm

600mm

800mm

AVAILABLE LIGHT

In the family of light sources used in photography, the mixed bag of artificial lighting found in houses, offices, city streets and public spaces is the poor relation. From a practical point of view, daylight is the natural source of light. Most films are balanced for its colour, and it is strong enough to allow convenient shutter speeds and apertures with medium-speed film and an average lens. Photographic lighting, which we come to in the next section of this book, is purpose-built and so also designed for camera and lens settings that are close to ideal. What remains – artificial lighting that is *not* designed for photography – is often far from ideal, and makes special measures necessary.

One of the most common terms for this collection of light sources is available lighting; another is existing lighting. Neither is a perfect description, and could just as well embrace ordinary daylight, but they are accepted as including the tungsten, fluorescent and vapour discharge lamps that are used for the normal lighting that we live by at night and in interiors. Photographic film is less adaptable to differences in lighting than is the human eye, and it is still not possible to make it anywhere near as sensitive to poor illumination. As a result, lighting that serves us quite well is often far from ideal for photography.

There is little point in passing any kind of judgement on the appearance of available lighting. Whether it looks attractive or not in any particular situation is usually beside the point: it is as it appears, and there is normally little that can be done to alter it. If you want to take natural-looking photographs under these conditions and are not able or willing to make careful additions with photographic lamps, then you must adapt your techniques, equipment and materials as necessary to suit the situation.

The principal difficulty is that the levels of lighting are considerably lower than normal daylight, as you can see from the comparison on page 10. This puts a premium on any equipment or film that helps exposure. A tripod is one essential item for most types of shooting; fast lenses and fast film are also useful. What characterizes working with available light more than anything else is that, in one way or another, the photography is close to the limits of acceptability. High-speed film brings with it graininess, which strains image quality, as do the odd colour effects of some light sources. The generally low light levels may call for slow shutter speeds and wide apertures, and these have attendant problems. Technique is more critical in this kind of lighting than in either daylight or photographic lighting.

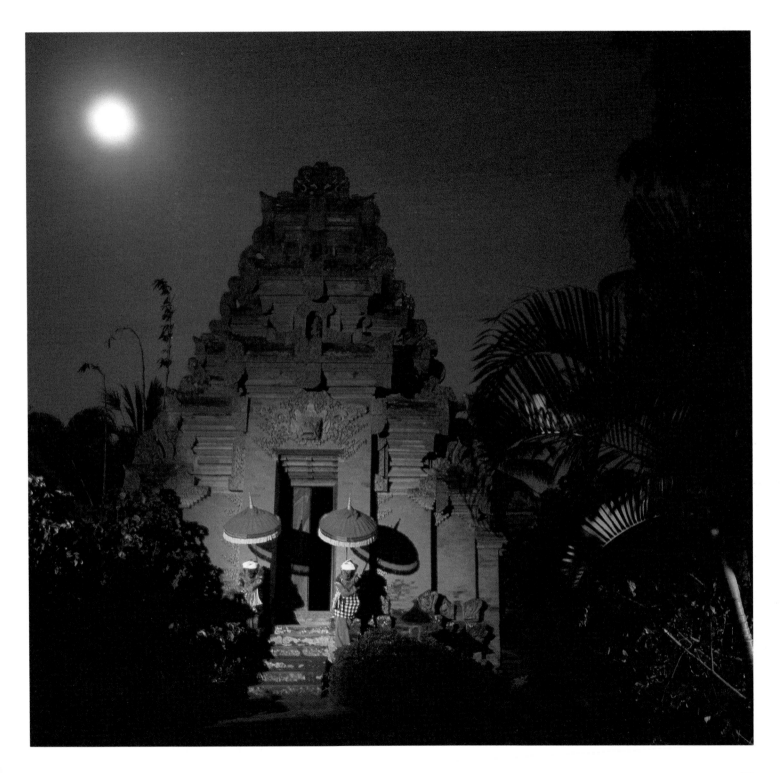

Incandescent Light

Tungsten lamps are the standard, traditional form of lighting domestic interiors, and this is where nowadays you are most likely to find them. Outdoors, and in large interiors used by the public, they have mainly been replaced by fluorescent and vapour lighting. A tungsten lamp is incandescent – it shines by burning – and its brightness depends on the degree to which the filament is heated. As this in turn depends on the wattage, you can get an idea of the brightness, and the colour, from the rating of the lamp. The colour range, which is between orange and yellow, depends on the colour temperature (see pages 10–13).

Colour temperature is perhaps the first thing to think about when shooting by available light in houses. If you enter a shuttered, tungsten-lit room straight from daylight, you can immediately notice how orange it looks. Usually, however, we see tungsten light at night, and it does not take the eye long to adapt and to see it as almost white.

The first time you photograph a tungsten-lit interior, uncorrected and on regular colour film, you may be surprised at the orange result: not what you remembered. If you have never done this, take the opportunity now. As a reminder of the colour temperature scale that we looked at on page 10, the table *below* gives the colour temperature values for the usual ratings of domestic lamp, and the filters that you would need to make the lighting appear neutrally white on film. Note that these are for either tungsten-balanced film or daylight-balanced film that has already been filtered to give it the same 3200 K balance.

The temperature of 3200 K is still closer to white than the light from any domestic bulb, but it makes a sensible start. This

Tungsten light source	Colour temperature		Filters with Type B film or daylight with 80B filter	Exposure at 3 feet (1m) ISO 400 film with filter attached	*f*-stops weaker than midday sunlight
	kelvin*	mireds*			
Candle flame	1800	555	80A+80B	3 seconds at *f* 2	About 12
40-watt domestic lamp	2760	362	82C	¹⁄₁₅ second at *f* 2.4	About 8½
60-watt domestic lamp	2790	358	82C	¹⁄₁₅ second at *f* 2.8	About 8

*These figures are readings taken from particular light sources and may vary slightly according to the age and manufacture of the lamp and the voltage applied to it.

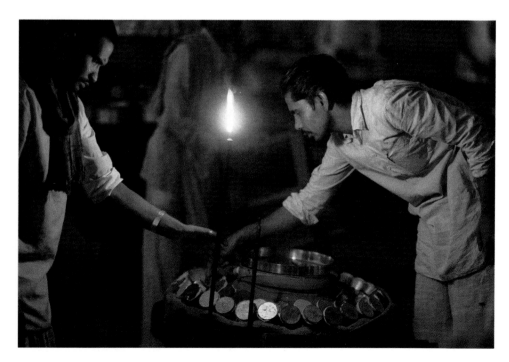

Naked light
A typical lighting situation with tungsten, flames and other incandescent lamps is when the light source appears in shot. In this case, it is best to overexpose the lamp so that the illuminated parts of the scene record adequately. Bracketing exposures is good insurance.

In this shot of a young Indian girl receiving the finishing touches to her stage make-up, just before a performance given by a dancing school in Trivandrum, Kerala, an important part of the visual interest is in the mix of lighting – daylight behind, but strongly tinted tungsten from the right. It is not always necessary to correct colour differences.

colour temperature, as we will see in the section on photographic lighting, is normal for photographic tungsten and tungsten-halogen lamps. In its visual colour effect, 3200 K goes almost the whole way to correcting the colour cast. However, as with so many things in photography, the complete answer is not a purely technical one. The ultimate criterion is what *looks* right, not what measures perfectly. The project on the next page is designed to help you work out the necessary compromise.

Another important consideration for the colour temperature is whether the tungsten lighting covers the entire picture area, or whether it is isolated in a scene that has other illumination. This consideration applies to all kinds of available light, and is bound to affect decisions on filtration and correction. Here, we will treat local lighting

as a distinct situation, and deal with it a little later, as mixed lighting on pages 88–91.

The intensity of light available is always a problem, as with all non-photographic artificial lighting. This deserves qualification, but in terms of the mixture of image quality and ease of taking pictures, the ideal standard would allow you to use a fine-grained film, say ISO 64, at shutter speeds of around $\frac{1}{125}$ second with a choice of apertures around the middle of the range for a standard lens: something in the order of $f\,8$. Give or take a couple of stops of light, this constitutes the lighting conditions for trouble-free hand-held photography. Available tungsten lighting falls short of this by several stops, and so needs extra care and camera-handling skills in almost every technical area of shooting. We could deal with these almost anywhere in this section

of the book, but the problem affects fluorescent and vapour lighting also, and will be covered on pages 88–95.

Unlike daylight, tungsten and all other forms of artificial lighting operate under the Inverse Square Law (see page 16). Bear this in mind when making calculations about the light level: the further the lamp is from the subject, the much weaker the intensity. This effect is even stronger with domestic tungsten lamps than with other kinds of artificial lighting, because the light source is so concentrated, and explains the pooling effect of lamps in a room. Most domestic interiors are far from evenly lit; each lamp tends to create a pool of light around it, with intervening darker shadow areas. The eye senses this less than film because human vision adapts rapidly to different light levels, even in one scene.

Project: Worth correcting or not?

This question comes up again with other kinds, and so colours, of available lighting. The convention regarding colour temperature is that white is right and all others need correction. This can hardly be so: one example quoted earlier in the book is of sunset, which would look distinctly peculiar if white. Yet at least one major camera manufacturer recommends using its equivalent of an 80B bluish filter to do just this – which demonstrates that following the numbers does not necessarily produce acceptable photographs.

For this project, make it a practice for the first few tungsten-lit conditions you encounter to shoot with and without correction (if you are trying to make an accurate reproduction of something, like a copy of a picture, this does not apply, but then in such a case photographic lighting really is necessary). To do this, you might change films, from Type B to daylight or use both of these films, each in a different camera body. Another method is to use only daylight film, adding and taking off an 80B conversion filter. Fine correction is not really important, at least for this project, so do not bother with the exact filter recommendations in the table on page 74.

In the example shown here, the subject was a Javanese classical dance, and the lighting was tungsten flood-lights with a colour temperature of about 2900 K. How you judge the results of this and your own shooting will depend on your taste. In this example, my own feeling is that either version is acceptable, and that the filtration, although separating the colours better, adds little to the overall effect. The colour difference is immediately obvious when compared side by side, but if you cover up

Both of these photographs were taken under the same tungsten lighting, at a classical dance in Yogyakarta, Java. The picture at left was taken on tungsten-balanced film, the other on daylight-balanced film. The value of correcting the colour temperature is here open to personal taste.

The rich orange glow of a laboratory oven heating platinum cups is a dominant element in the image. Correcting the colour temperature would be pointless.

the corrected version, the other does not appear to be quite so red. Practically, the lack of filtration in this case made it possible to use a shutter speed twice as fast which, under the circumstances of the shooting, was much more important.

Sometimes, the orange cast of uncorrected tungsten light can be attractive, giving connotations of warmth and comfort. This may be worth bearing in mind. As an interesting aside, traditionally butchers' shops and meat markets have used tungsten lighting (many still do), for the simple reason that the meat looks a little redder. By contrast, imagine how unappetizing it would look by green or blue light.

Project: Bracketing exposure

As we have already discussed, a tungsten-lit scene characteristically has pools of light, and so exposure is not so easy to judge in a broad view. Take a scene in which this occurs, as in the photographs on this page, and take a range of exposures in several shots. Start with an exposure based on the light level close to the lamp, and increase successive exposures. There is often a (small) range of acceptable results, and they will usually depend on what you consider to be the most interesting or important part of the picture.

Bracketing
This pair of photographs of a stonemason at work in the Holy Sepulchre, Jerusalem, is part of a series of different exposures. There is a full *f*-stop difference between the two shots, yet both are, in different ways, acceptable. Lengthening the exposure increases the visibly illuminated area.

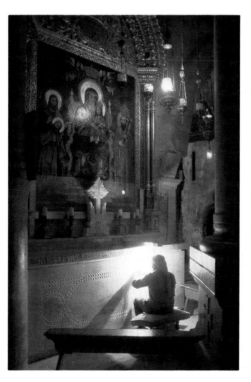

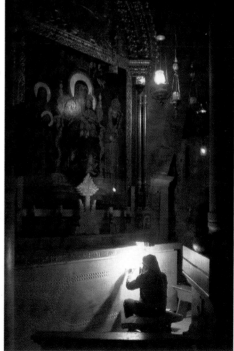

Fluorescent Light

Fluorescent lamps have a discontinuous spectrum, as already mentioned on page 8. This is by no means as extreme as that of sodium and mercury vapour lamps, but is still sufficient to give a greenish colour cast. A fluorescent lamp works by means of an electric discharge passed through vapour sealed in a glass tube, with a fluorescent coating on the inside of the glass. These fluorescers glow at different wavelengths, and have the effect of spreading the spectrum of the lamp's light. Visually this is an improvement over vapour lamps because the spectrum can be evened out to appear more like that of daylight, but the deficiencies that remain are usually enough to affect photography.

If these deficiencies were consistent, it would be a simple matter of using one standard correction filter. However, as the tables and graphs on these pages show, fluorescent lamps vary in the visual effect that the manufacturer tries to produce. Some are slightly green when photographed, others very much so. The practical difficulty is in telling how much of a green cast will appear just from looking. The descriptions of the different types of lamps are, as you can see from the recommended filtration, meaningless for photography; a result of the difference in response between the eye and film to different wavelengths.

In shooting by available light, the usual response of most photographers is to want to correct the green cast to a neutral white illumination. A large part of the problem aesthetically is that an overall bias towards green is considered unattractive by most people, except in special and occasional circumstances. If you go back for a moment to the section on tungsten lighting (pages 74–7), you can see how a shift to orange is tolerated. The same is not true of green. Whereas orange is a colour of illumination that is within our visual experience (e.g. firelight, rich sunsets) and has, on the whole, pleasant associations of warmth, green is not a natural colour of light.

Nevertheless, although this is a fairly good reason for wanting to make corrections, you should, as a first step, think about whether you can make some use of the green cast, or indeed, whether the colour will make any important detrimental difference to the image.

One reason why it may not be too important to make a correction is sheer familiarity. Fluorescent lighting is used so much in large interiors, like supermarkets and offices, and so many uncorrected and under-corrected photographs are regularly published, that viewers are to an extent accustomed to seeing the greenish cast. For this reason alone, it is rarely a disaster. Another reason is that, in scenes that combine differently-coloured light sources, the green of the fluorescent lamps will be localized. Offset by, for example, the orange of tungsten lighting, it will not dominate the picture.

Indeed, the positive side of mixed lighting is that the colour combinations can be intrinsically attractive, and contribute to the image. Then again, the unattractive associations of green light may be exactly what you need if you intend to convey a particular kind of atmosphere. Institutional settings, such as the emergency reception area of a hospital, a seedy bus terminal or subway, are likely to look more effective if the fluorescent lighting is left uncorrected. This is something you can test for yourself.

If, however, you do want to correct the lighting, there are several options open. (For reference, these are summarized in the check-list on page 83.) The simplest and most usual technique is to use a filter of the opposite colour over the lens. This is straightforward provided that you know the strength and exact hue of the colour cast. If you have a three-way colour temperature meter, you can measure this directly and immediately, but it must be the type of meter that will measure colour shifts outside the strict amber-to-blue range of colour temperature.

These meters are, however, something of a luxury. Without one, the most accurate alternative is to try and identify the type of lamp, and use the filters recommended in the table on page 80. Be warned, however, the manufacturing standards as regards the spectrum are not particularly consistent, and that in any case age can change the colour of the lamp. Moreover, one interior may have different types of lamp.

Covering the full range of the visible spectrum, from violet to red, these bar charts show the different emissions from different types of fluorescent lamp. The visual effect is approximately the total of what you see here.

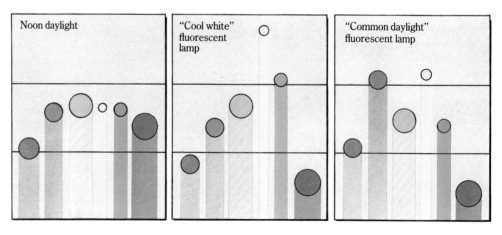

Fluorescent lighting filters
This range of filters from one manufacturer (Rosco) corrects the greenish light from the most common types of fluorescent lamps for photographic use under varying conditions. Other manufacturers have similar ranges.

¼ plusgreen adds partial green (equivalent to CC 075 Green lens filter) as the other varieties of plusgreen *right*. 92 per cent transmission.

½ plusgreen adds partial green (equivalent to CC15 Green lens filter) to daylight and lamps used as full plusgreen. 90 per cent transmission.

Plusgreen/windowgreen (equivalent to CC30 Green lens filter) is used over a window (5500 K daylight) or flash-head to match the green colour cast from US Cool White or Daylight type fluorescents. A magenta filter must then be used over the lens. 76 per cent transmission.

Plusgreen 50 converts 3200 K tungsten lamps to match US Cool White and Daylight fluorescents. A magenta correction filter is then used over the lens. 45 per cent transmission.

Fluorofilter converts the greenish light from US Cool White or Daylight type fluorescents to 3200 K. Matches photographic tungsten lamps. 36 per cent transmission.

Minusgreen (equivalent to CC30 Magenta lens filter) placed over US Cool White or Daylight type fluorescent lamps to match photographic daylight. 55 per cent transmission.

½ minusgreen (equivalent to CC15 Magenta lens filter) reduces the green cast from fluorescents. 71 per cent transmission.

¼ minusgreen reduces fluorescent green cast, but less than the filter *left*. 81 per cent transmission.

However, if you compare the different filter recommendations, you can see that most are quite close to one basic value: CC30 Magenta. If you have neither the time nor the means to find out exactly what the filtration should be, using either a Kodak Wratten CC30 Magenta or its equivalent will usually work. At the least, it will make an improvement. Specialist filter manufacturers produce a specific fluorescent light correction filter in glass or plastic which is virtually the same, but more convenient for quick use if you buy it in a screw-mount to fit your lenses. Certainly, as the table shows, the lack of red in fluorescent lighting is closer to the colour balance of regular daylight film than it is to either Type B or Type A films.

In a planned location shot with preparation time available, a professional photographer would normally test the colour cast well before time by photographing the setting on the type of film to be used, varying the filters on different frames. You may wish to use the recommended filtration in the table as a starting point, and filters could be added and subtracted in strengths of CC10. The processed film would then show which single filtration to use for the principal photography. Even without going to this effort, you could borrow from this technique and bracket the filtration as you shoot: CC10 Magenta, CC20 Magenta, CC30 Magenta and CC40 Magenta versions will improve the chances of one corrected image. Incidentally, none of the Polaroid colour films are of any use for testing fluorescent lighting: they all react differently from normal colour films.

The film you choose will, in any case, make a difference. Colour reversal film produces its final image in one step, so the filtration you select at the time of shooting must be accurate if you are going to use the results as slides. Colour printing, however, gives one more chance to adjust the filtration. If you are using colour negative film, filtering at the time of shooting is less critical. You will, however, have no reference for adjusting the print unless you include a standard colour chart in one of the shots (see page 128); the print enlargement will have to be filtered by eye, and if you leave this to a colour laboratory, you should send the negative with specific instructions.

A final alternative which does not involve adding any lighting of your own is to filter the fluorescent lamps at source. The problems of assessing the colour shift are the same as with choosing a filter for the lens, and each tube must be filtered. Use lighting filters of the type sold for stage lighting and cinematography, available in sheets and rolls in non-flammable material. This is normally effective only if the fluorescent tubes are concealed. The special advantage of this technique is when the fluorescent lighting is mixed with other sources, such as daylight, tungsten or photographic lamps. A reliable but difficult alternative to this is temporarily to replace the existing tubes with fluorescent lamps that are specially corrected for photography. The difficulty here is in matching the size of the fittings.

The intensity of fluorescent lighting is relatively weak, and the filters will reduce the exposure even further. On ISO 100 film, the typical level in a supermarket, for instance, would be $f\,2.8$ at $1/30$ second without any filtration or plus $2/3$ stop with a CC30 Magenta filter. In any case, you should try to keep the shutter speed no faster than $1/30$ second, because of the way a fluorescent tube works. It is a pulsating light source; in an old lamp you can often see the flicker. If you move a pencil rapidly backwards and forwards in front of a fluorescent light source (such as a light box) you can see a strobe effect which corresponds to the cycle of the lamp.

The other technique for balancing fluorescent lighting is to use photographic

Recommended filters for fluorescent light

Type of fluorescent lamp	Daylight-balanced film	Type B film	Type A film (Kodachrome 40)
Daylight	40M+40Y +1 stop	85B+40M+40Y +1⅔ stops	85B+40R +1⅓ stops
White	20C+30M +1 stop	60M+50Y +1⅔ stops	40M+30Y +1 stop
Warm white	40C+40M +1⅓ stops	50M+40Y +1 stop	30M+20Y +1 stop
Warm white de luxe	60C+30M +2 stops	10M+10Y +⅔ stop	No filter
Cool white	30M +⅔ stop	60R +1⅓ stops	50M+50Y +1⅓ stops
Cool white de luxe	20C+10M +⅔ stop	20M+40Y +1⅓ stops	10M+30Y +⅔ stop

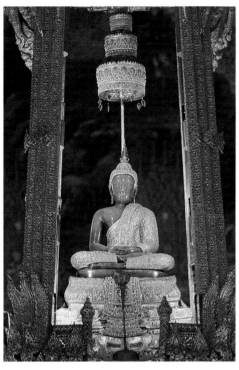

◄ Vertical striplights cast the usual greenish light, but in this instance they enhance the colour of the Emerald Buddha in Bangkok's Wat Phra Kaeo. Filtration would have had the effect of making the green statue appear duller.

▼ Used as illumination for the façade of a building, the colour of the fluorescent lighting is by no means as important as in an interior: here there are no skin tones or other critical subject colours.

▲ Given sufficient time, it is always possible to make full correction for fluorescent lighting, provided that it is the only light source. The safer method is prior testing on film. Here, in the London Stock Exchange, a test of different filters showed that the CC30 Magenta used here was the best. Filtration, however, reduces the light reaching the film and a tripod is often necessary.

lamps. The standard location for fluorescent lamps is overhead, in the ceiling, and this can create shadow difficulties with portraits and some foreground areas in an interior view. This alone may make it worthwhile introducing fill lighting. One method is to use the same type of fluorescent tube, but close to the camera, and filter as above. A more portable alternative is to add a greenish gel filter over the head of a portable flash to give it the same colour as the ambient light; again, filter as before.

Another lighting possibility makes use of the colour opposition between fluorescent and tungsten lamps. Green and orange are not exactly opposite, but in its general visual effect, the combination of the two is acceptably normal in most circumstances. A neat technique, therefore, is to aim one or more tungsten lamps directly up into the fluorescent lamps. The tungsten lighting adds some of the missing spectrum. To do this, you must be able to hide the tungsten lamps, their stands and cables, from view.

Projects: Correcting and using colour cast

Practice basic correction by bracketing filtration. The importance of choosing the precise filters depends to a large extent on what results you are prepared to accept. Make a test from CC10 Magenta to CC30 Magenta or CC40 Magenta and decide for yourself from the processed film whether or not the differences seem important. Use only transparency film for this project. After

photographing a number of scenes lit by fluorescent lamps, ideally on one type of film, compare the uncorrected frames of each. This will give some idea of the range of colour casts.

Another project is to find ways of using the colour cast of fluorescent lighting to enhance the photograph. Try this with scenes that could benefit from appearing shabby, unfriendly or deserted. See also the projects for mixed lighting sources.

Project: Correcting by adding tungsten
The overall green cast of fluorescent light can be neutralized by adding an opposite colour. For this project, take a low-ceilinged interior such as this gold trading office. Aim one or two photographic lamps up towards the striplights on the ceiling, from concealed positions. Note that, while there will be local patches of green and orange from the two light sources, the combined effect will be approximately neutral.

A warm glow is produced where the tungsten lighting strikes the ceiling directly

Daylight through window remains neutral and unaffected

Desk top receives direct illumination from fluorescent strips, reproduces green

The combined effect of the fluorescent and tungsten lamps is neutrally-coloured light

3200 K tungsten lamp placed on floor, concealed, and aimed up towards ceiling

Basic correction
Although the exact tint of green depends on the type of fluorescent lamp, most interiors under this kind of illumination can be made to appear approximately neutral by adding a magenta filter of about CC30 strength.

This pair of photographs of the restoration of the aircraft that dropped the A-bomb illustrates the difference. The corrected version was shot with a proprietary filter. Note the pinkness near the far door of the hangar, lit by daylight.

Checklist: Balancing fluorescent lamps

Method	Comments	
Filter on lens	Simplest is a CC30 magenta or proprietary 'FL' filter. More accurate is a filter carefully chosen according to type of lamp. More accurate still are prior testing on film and use of colour temperature meter. Bracketing filters are an additional safeguard.	
Change lamp	Use lamp specifically balanced for colour photography. Fittings vary, however.	Without extra lighting
Filter lamp	Tape sheet of magenta gel around lamp or fitting.	
Correct filtration during printing	Not always completely satisfactory, but works well when colour cast is only a mild green. Increase green filtration for colour negatives.	
Fluorescent fill light	Use the same type of lamp as in the existing lighting, and filter the lens as above.	
Filtered flash	Place green lighting filter gel over flash, and filter the lens as above.	
Filtered tungsten	As for flash (above), but also add an 80B equivalent blue gel.	Photographic lighting added
Add tungsten lighting locally	Aim tungsten lamps directly at the fluorescent lamps; the orange cast will compensate approximately for the green of the fluorescent.	
Overwhelm with flash or tungsten	Feasible in small spaces and for close-ups.	

Vapour Discharge Light

Vapour discharge lamps are much less common than fluorescent or tungsten, but being more powerful, are often used for large public areas, particularly outside. The three principal types of lamp are sodium, which looks yellow in photographs, mercury, which looks bluish-white and photographs between that and strongly blue-green, and multi-vapour, which is reasonably well-balanced for colour photography. Sodium lamps are typically used for street-lighting and for flood-lighting buildings, mercury lamps in large warehouses and industrial plants, and multi-vapour lamps in sports stadiums, where television cameras need good colour balance.

The emissions of vapour discharge lamps peak strongly in very narrow bands of the spectrum, and are completely lacking in many wavelengths. Only multi-vapour lamps produce a colour quality that is close to normal, and being able to distinguish them from mercury vapour sources is not always possible. As a guide, however, all sports stadiums that have television coverage will almost certainly have multi-vapour lighting, for this reason.

Without the benefit of a coating of fluorescers to spread the output over other parts of the spectrum, the effects of vapour discharge lamps are very difficult to control by filtration. Sodium lamps are notorious for

this, emitting only in a yellow-green wavelength. The only substantial effect that filtration has is to make the image darker. Mercury vapour lamps have more than one peak, and can benefit from red and orange filters, but results are difficult to predict. Test first if you can.

The only realistic advice is to accept the colour that you get. If you are shooting in close-up, and more balanced colours are really necessary, provide photographic lighting that will overwhelm the existing vapour lamps; this means either relatively powerful tungsten lamps used close, or, with less difficulty, flash at the highest synchronization setting.

In an oil refinery in East Malaysia the site lighting is all vapour discharge, as in most industrial plants. The blue-green lights are mercury vapour, the yellowish sodium. From this distance, colour correction is not worth even considering, as the lights occupy only a small part of the picture.

Mercury vapour
Unfiltered mercury vapour lamps in a hangar used for assembling the Space Shuttle's main fuel tank has a typical blue-green cast. Compare this with the fluorescent-lit hangar on page 81. Some correction is possible, using the table opposite, but the discontinuous spectrum prevents a completely neutral result.

Recommended filters for vapour discharge lamps

Type of lamp	Daylight – balanced film	Type B film	Type A film (Kodachrome 40)
G.E. "Luca"	70B+50C +3 stops	50M+20C +1 stop	55M+50C +2 stops
G.E. "Multi-vapour"	30M+10Y +1 stop	60R+20Y +1⅔ stops	50R+10Y +1⅓ stops
Clear mercury	80R +1⅔ stops	90R+40Y +2 stops	90R+40Y +2 stops
De luxe white mercury	40M+20Y +1 stop	70R+10Y +1⅔ stops	50R+10Y +1⅓ stops
Sodium	NR	NR	NR

Multi-vapour
This type of powerful vapour discharge lamp is used principally in sports stadiums where television cameras are used, and is normally close to neutral without filtration. The Jai-Alai fronton in Miami, Florida, shown here is a typical location. Note, however, that while the overall effect is acceptable, the colour balance is not perfect: there are some greenish shadows, while a row of additional tungsten lamps gives an extra yellowness to parts of the scene.

Sodium vapour
These yellow lamps are basically uncorrectable. One way of making the best of the wrong colour cast is to keep flesh tones and other key subject colours small in the picture, as in this photograph of champagne tanks in California's Napa Valley. A close portrait would show an unhealthy-looking face.

Effect of correction filters on other light sources

	Tungsten	Fluorescent	Sodium vapour	Mercury vapour	Daylight and flash
Daylight film, no filters					
Corrected for tungsten: add blue					
Corrected for fluorescent: add magenta					
Corrected for mercury vapour: add red					

Note that the strength of the colour shift on other lighting depends on whether or not the sources themselves are visible. With a fluorescent-correction filter, for example, daylight from a window will have the same magenta colour as the filter, but a direct view of the window will show it as white fringed with pink.

Outdoors at Night

The light sources available outside at night are the same types as those we have just looked at, but in different proportions. Vapour lamps are used much more extensively outdoors than indoors, because of their higher output; this is particularly true of street lighting and flood-lighting. Tungsten as street lighting is increasingly less common, but can be seen in shop and other windows and as car lights.

Although the light sources are the same as those used to illuminate interiors, their effect is very different. The scale of the usual type of outdoor shot is greater, and the surroundings do not give the same degree of reflection as do interior walls and ceilings. As a result, there is much more pooling of light: in a typical scene there are many lights, and they are localized. Only very rarely are there enough lights in a concentrated area to give the impression of overall illumination. This happens, for instance, in the busiest part of a downtown night-club district, some open-air night-markets and, as you might expect, in stadiums. In most night-time city views,

however, there is either one well-lit area, such as a flood-lit building, or a pattern of small lights.

In many ways, this causes fewer difficulties than an interior, and there are fewer occasions when you might need to decide on the principal light source and correct the colour with filters. The impression of a colour cast occurs when most of the picture area is affected; when there are other lights in the image, colour balance becomes much less important.

The localization of the light sources

Subject	ISO 64–100	ISO 160–200	ISO 320–400	ISO 800	ISO 1000	ISO 1600
Normally lit street	½–1 sec, f 2.8	¼–½ sec, f 2.8	⅛–¼ sec, f 2.8	1/15–⅛ sec, f 2.8	1/15 sec, f 2.8	1/30–1/15 sec, f 2.8
Brightly lit street	1/15 sec, f 2.8	1/30 sec, f 2.8	1/60 sec, f 2.8	1/60 sec, f 4	1/60 sec, f 4.5	1/60 sec, f 5.6
Downtown nightclub/theater district	1/30 sec, f 2.8	1/60 sec, f 2.8	1/60 sec, f 4	1/60 sec, f 5.6	1/60 sec, f 6.3	1/60 sec, f 8
Neon sign	1/30 sec, f 2.8	1/30 sec, f 4	1/30 sec, f 5.6	1/30 sec, f 8	1/30 sec, f 9	1/30 sec, f 11
Shop window	⅛–1/30 sec, f 2.8	1/15–1/60 sec, f 2.8	1/30–1/125 sec, f 2.8	1/30–1/125 sec, f 4	1/30–1/125 sec, f 4.5	1/30–1/125 sec, f 5.6
Floodlit building	½ sec, f 2.8	¼ sec, f 2.8	⅛ sec, f 2.8	1/15 sec, f 2.8	1/15 sec, f 3.5	1/30 sec, f 2.8
Subject under street light	½–1 sec, f 2.8	¼–½ sec, f 2.8	⅛–¼ sec, f 2.8	1/15–⅛ sec, f 2.8	1/15–⅛ sec, f 3.5	1/30–1/15 sec, f 2.8
Distant city lights	1–10 secs, f 2.8	½–5 secs, f 2.8	¼–2 secs, f 2.8	⅛–1 sec, f 2.8	⅛–1 sec, f 2.8	1/15–½ sec, f 2.8
Firework display over city	¼–2 secs, f 2.8	¼–2 secs, f 4	¼–2 secs, f 5.6	¼–2 secs, f 8	¼–2 secs, f 9	¼–2 secs, f 11
Aerial firework display	1–4 secs, f 4–f 5.6	1–4 secs, f 5.6–f 8	1–4 secs, f 8–f 11	1–4 secs, f 11–f 16	1–4 secs, f 14–f 19	1–4 secs, f 16–f 22
Lightning over city, 4–10 miles (6–16 km) away	Open shutter, f 5.6	Open shutter, f 8	Open shutter, f 11	Open shutter, f 16	Open shutter, f 19	Open shutter, f 22
Flames, large fires	1/60–1/30 sec, f 2.8	1/30–1/15 sec, f 2.8	1/60–1/30 sec, f 2.8	1/125–1/60 sec, f 2.8	1/125–1/60 sec, f 3.5	1/125–1/60 sec, f 4
Subject lit by fire	¼–½ sec, f 2.8	⅛–¼ sec, f 2.8	1/15–⅛ sec, f 2.8	1/30–1/15 sec, f 2.8	1/30–1/15 sec, f 3.5	1/60–1/30 sec, f 2.8
Floodlit stadium	1/30–1/15 sec, f 2.8	1/60–1/30 sec, f 2.8	1/125–1/60 sec, f 2.8	1/250–1/125 sec, f 2.8	1/250–1/125 sec, f 3.5	1/250–1/125 sec, f 4
Open-air rock concert	1/30 sec, f 2.8	1/60 sec, f 2.8	1/125 sec, f 2.8	1/125 sec, f 4	1/125 sec, f 4.5	1/125 sec, f 5.6
Car headlights/tail-lights on motorway (streaked)	10 secs, f 11–f 16	10 secs, f 16–f 22	10 secs, f 22–f 32	5 secs, f 22–f 32	3 secs, f 22–f 32	2 secs, f 22–f 32
Subject lit by car headlights at 20 feet (6 m)	½ sec, f 2.8	¼ sec, f 2.8	⅛ sec, f 2.8	1/15 sec, f 2.8	1/15 sec, f 3.5	1/30 sec, f 2.8
Oil refinery	2 secs, f 2.8	1 sec, f 2.8	½ sec, f 2.8	¼ sec, f 2.8	⅛ sec, f 2.8	1/15 sec, f 2.8

makes measurement difficult. A spot meter is the most useful meter to have, but the table on page 88 is more practical under a variety of conditions. Use it as a guide rather than as a completely accurate recommendation, and bracket exposures around the figures given. For many night-time scenes the accuracy of the exposure is not, in fact, very critical. However, one thing that often makes overall cityscapes unsatisfactory is that the large number of lights does little to show up the setting, and remains as a pattern of dots. For this reason it usually helps, in making this kind of shot, to take the photograph at dusk, when there is just a little residual daylight.

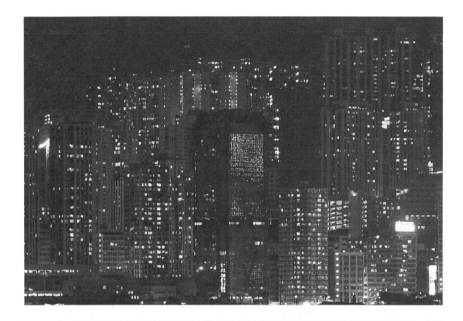

A high contrast ramp is typical of many floodlit buildings. For this shot of the Federal Reserve Building in Washington DC, a spot meter was used, and the exposure based on the reading from the darker of the two outspread wings.

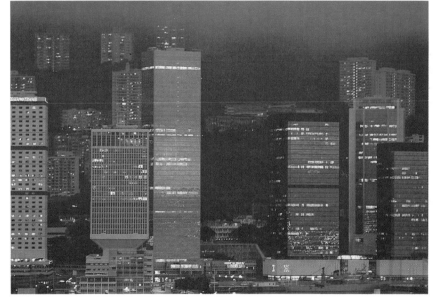

In this pair of night-time city views, both taken in Hong Kong, it is residual daylight that makes the difference. In the first picture *top*, taken well after dusk, the exposure is as good as it can be, but the shape of the buildings is lost. The second view *above* was taken towards the end of dusk, and reads much more clearly, while still having the appearance of a night view.

Fireworks

Firework displays, like lightning, make their own exposure. Light intensity apart, there is little point in trying to use a fast shutter speed; the effect of a bursting firework display is created by the streaking of the lights, even to the eye. A short exposure simply shows less of the display. Conversely, provided that the sky is really black, leaving the shutter open will *not* cause over-exposure, but instead add more displays to the image. Two things to be careful of are the clouds of smoke from the fireworks that sometimes drift across the view, and the lights of buildings if you include the setting in the shot. Both of these set limits to the over-exposure.

For the best effect of the bursts, exposure times are usually between half a second and four seconds, but you can judge this for yourself by watching the initial displays and timing them from the moment the rockets reach their bursting height. This allows fairly slow, fine-grained film to be used successfully: f 2.8 is a reasonable aperture with ISO 50 or ISO 64 film. In any case, the exposure is not critical: try making a variety of exposures to determine this for yourself.

For a view that includes the setting, as in the photograph *right*, lock the camera firmly on the tripod, and make sure that the framing and focal length are right for the height of the displays. Check this and the location of the fireworks by watching a few through the viewfinder before shooting. For a close view of a single burst, try this technique: use a medium telephoto lens and the tripod head partially loosened (enough so that you can move the camera, but still sufficiently tight to hold it when you stop). Pan upwards to follow the rocket as it ascends, and as soon as it bursts, stop and open the shutter.

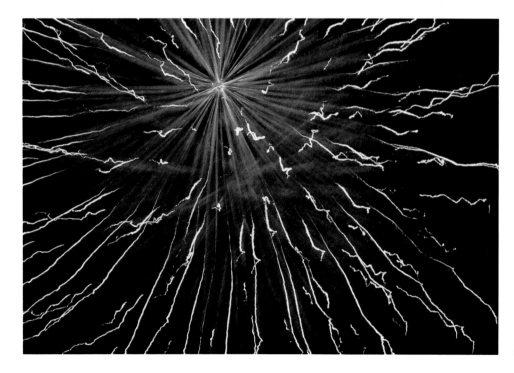

For close shots of a bursting firework, use a medium telephoto lens (here 180mm) and a tripod. Follow the trail of the rocket upwards. As it slows down, lock the tripod head and open the shutter. Close the shutter when the lights fade.

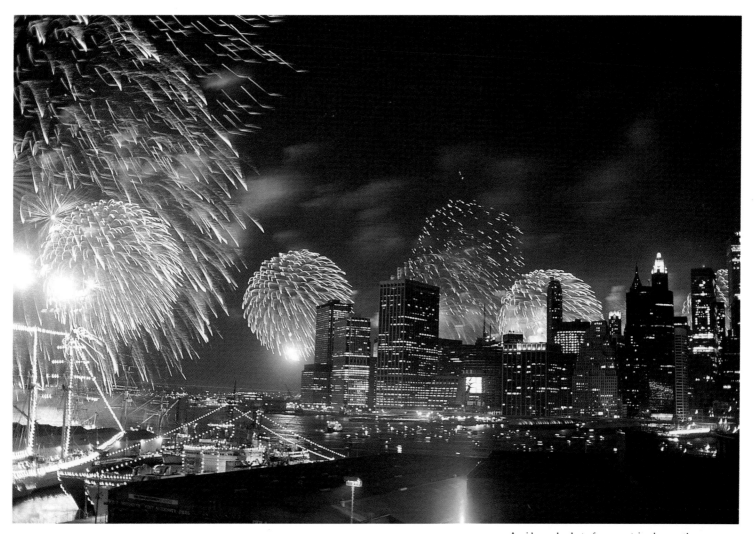

A wide-angle shot of fireworks in a setting needs more careful preparation. Use the beginning of the display to judge the height and position of the bursts; frame the picture according to these. With the camera locked on a tripod, vary the exposure times to include single and multiple bursts. This photograph was taken in New York at the centenary celebrations of the Statue of Liberty. The lens focal length was 35mm, and the aperture f 2.8 with ISO 64 film.

Project: City lights

Find a viewpoint that gives a reasonable overall view of the downtown of a city – one where you can set up a tripod and wait. Arrive around sunset, and take a sequence of identical shots, beginning at the time when the majority of the city lights are switched on, and continuing until there is no light left in the sky.

For the earlier shots, bracket the camera's settings so that one gives a "normal" exposure and the others are darker. Under what remains of the daylight at dusk, you should find that the exposure setting has an important effect on the atmosphere of the scene. A full exposure may not even look much like evening, but like a dull day instead. For the impression of early evening or night, the lighting from the sky usually needs to be just visible and no more.

Later in the evening, when there is no more residual daylight, long time exposures are possible. One effective use of these is to record the streaks of headlights and tail-lights. Exposure settings are not critical from the point of view of the film, but the shutter should be open long enough for the traffic to cover a good distance on the road.

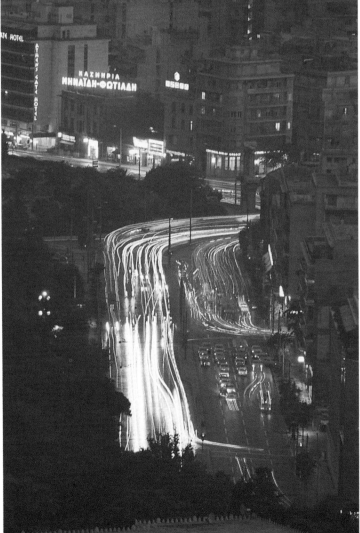

Twilight just after sunset is an important element in an overall view of a city – it is usually the only overall illumination that gives definition to the buildings.

Project: Neon displays

Although these are fluorescent lights, the colours of the displays overwhelm the typical greenish colour cast (see pages 78–83). There is usually little point in trying to make any compensation with filters. For this project, find a suitably interesting and attractive display, and set up the camera on a tripod. Most displays are high up – well above street level – and the easiest technique is usually to stand back, across the street or further, and use a telephoto lens. For one exposure, use a CC30 Magenta or fluorescent-correction filter, just to be able to see what difference it makes. Apart from this, take a series of different exposures, using the figures recommended in the table on page 80. As you are using a tripod, fast film is not necessary, and in any case you will need to keep the shutter speed at ⅟₃₀ second or slower, to compensate for the tendency of fluorescent lamps to pulsate.

Which exposure looks best is usually a matter of taste, and the range of what is acceptable is quite wide. In comparing the results later, you should notice that short

For backlit displays like this sign outside a Las Vegas hotel, read the light level of the sign, and then reduce the exposure by 1 or 2 stops.

exposures give more intense colours, reproduce the tubes as thin lines, and show nothing or very little of the surroundings. Longer exposures give a thicker appearance to the display, which appears paler in colour also.

Bracketing exposures
Although this range of exposure settings covers 4 stops, each version is acceptable. Underexposure of neon displays emphasizes the sign itself; overexposure brings in the setting. The TTL meter reading was that used for the second lightest version.

Equipment

Night shooting needs a particular selection of equipment, and this depends on the style of photography you plan to do. There are three methods of working, each more or less distinct. Two of them use available light only – hand-held with fast film and time exposures with normal or slow film – and the third uses portable flash. There is some overlap between flash photography and available light photography, when the flash is used either for fill lighting or to illuminate just the foreground. Flash equipment is shown here in the equipment photograph, but its techniques are dealt with later on pages 100–111.

Camera controls in the dark
Not all viewfinder displays are illuminated. LED displays are the most visible in darkness, and some cameras with LCD displays incorporate a small light to illumin-ate them at night. It is more than useful to be able to set both the shutter speed and aperture by touch alone. On most cameras and lenses both have click stops to mark each full stop change; provided that you are familiar with the direction of rotation in which they increase and decrease, it is simple enough to work from one end. This is only a matter of familiarization. Apart from this, carry a small torch; if it has a clip so that you can fix it to your shirt or jacket, you will have both hands free.

Enhancing the light levels
Fast film and fast lenses are both options to consider, although neither is a perfect solution for every circumstance. Fast film is the only practical means of shooting without a tripod and producing unblurred images of moving subjects. Its drawback is graini-ness, and so it is probably inappropriate for static and scenic views that can be managed with a time exposure on a tripod.

Fast lenses are very valuable, but there is little point in using them at any setting other than fully open, as their substantial cost goes into providing the final extra stop or two of aperture. Depth of field is therefore limited, and this limits the type of view for which they are best suited. The most sophisticated have aspherically ground front elements, and this, among other things, corrects coma, so giving sharper, undistorted images of point light sources, which are common in night scenes.

An extra aid is a brightness-enhancing screen. Microprism grids are useful for low light level viewing, and there are also specialist treatment services which will apply a coating to focusing screens to make the view appear brighter. (See volume I, *Cameras and Lenses*, for more on this.)

A small torch is essential for working at night. It may be the only practical way of reading the meter with cameras not fitted with LED viewfinder display.

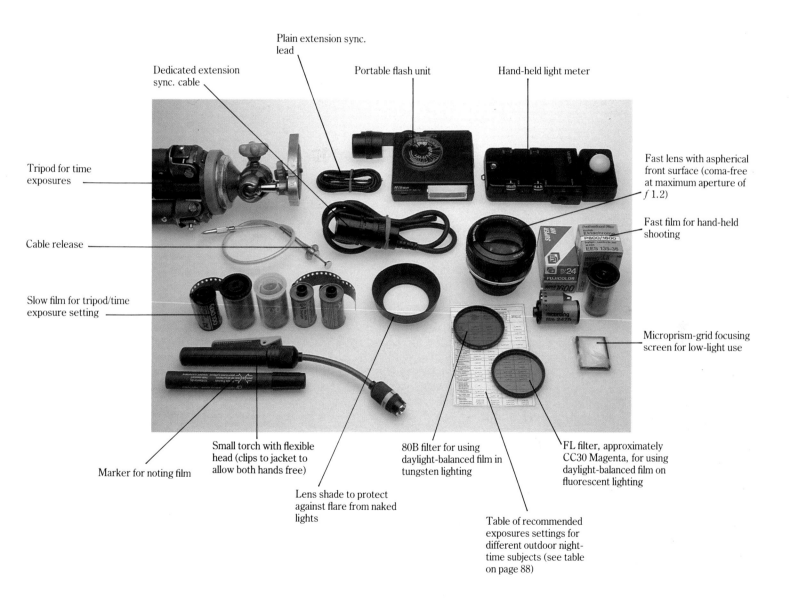

Plain extension sync. lead

Dedicated extension sync. cable

Portable flash unit

Hand-held light meter

Tripod for time exposures

Fast lens with aspherical front surface (coma-free at maximum aperture of *f* 1.2)

Cable release

Fast film for hand-held shooting

Slow film for tripod/time exposure setting

Microprism-grid focusing screen for low-light use

Marker for noting film

Small torch with flexible head (clips to jacket to allow both hands free)

80B filter for using daylight-balanced film in tungsten lighting

FL filter, approximately CC30 Magenta, for using daylight-balanced film on fluorescent lighting

Lens shade to protect against flare from naked lights

Table of recommended exposures settings for different outdoor night-time subjects (see table on page 88)

PHOTOGRAPHIC LIGHT

If you were to undertake a full range of lit studio and location photography, you would eventually find a use for all the sources of photographic lighting covered in this section of this book. However, for cost if nothing else, most photographers commit themselves to one type of lighting, at least to begin with. For reasons that we will come to on the following pages, portable flash falls a little outside this choice: it is essentially convenience lighting for hand-held shooting, and offers few possibilities to exercise full lighting control.

The majority of the photographs shown as examples in this section have been made with equipment that is mains-powered and designed for use not as naked lamps, but with fittings that change the quality of the light. Essentially, then, the choice of lighting equipment lies between mains flash and mains tungsten; a few other specialized sources are also dealt with for completeness, but basic photographic lighting falls into one of these two categories.

As with other photographic equipment, such as cameras, there are many competing systems, and these are often not compatible. This is particularly the case with mains flash, in which the power units, collectors and flash-heads cannot normally be inter-changed. Before buying anything, make all the comparisons you can, and anticipate your future needs. You might, for instance, eventually need several identical lamps, or a set of specialized lights – one for still-life main illumination, and others for back-grounds, and so on. Also, if you expect to shoot on location as well as at home or in the studio, the weight and transportability of the equipment will be important. Some makes of lighting system are designed with certain priorities in the type of photography – one well-known professional range, for instance, comprises flash-heads already fitted into different sizes of area lights expressly for still-life photography.

What will be stressed throughout this and the last section of the book is the import-ance of controlling the quality of lighting. This may seem an obvious point to make, but if you are used only to portable flash, for instance, the sheer quantity of materials, time and effort that go into full lighting control may be a surprise. In still-life shooting, studio portraits, room sets and other controlled situations, convenience and simplicity are low priorities. Precise lighting takes time to plan and construct, and can be untidy and complex when set up.

In terms of equipment, what must always come first is the means to produce as full as possible a range of directions, diffusion, concentration and all the other qualities that define a particular type of illumination. Often, this will take a lot of effort, and introduce you to a special class of lighting problem. This type of problem is that of compromising between conflicting lighting qualities. For instance, diffusing a lamp in such a way that it suits one object in a group may cause an unwanted spill of light onto another. The main light and background light may (and often do) conflict, and separating the effect of each on the other may call for some ingenuity in managing and placing the equipment.

The most important decision at this stage is the choice of the basic lamps. Although they can hardly ever be used satisfactorily alone as direct lights, most of the rest of the equipment you will need for modifying the light does not have to be bought – you can make it yourself. Indeed, some of the diffusers and reflectors shown later are not even available commercially. In terms of mechanical precision, light fittings do not compare with most other photographic equipment, and there is every reason to design your own to suit your tastes in lighting effect.

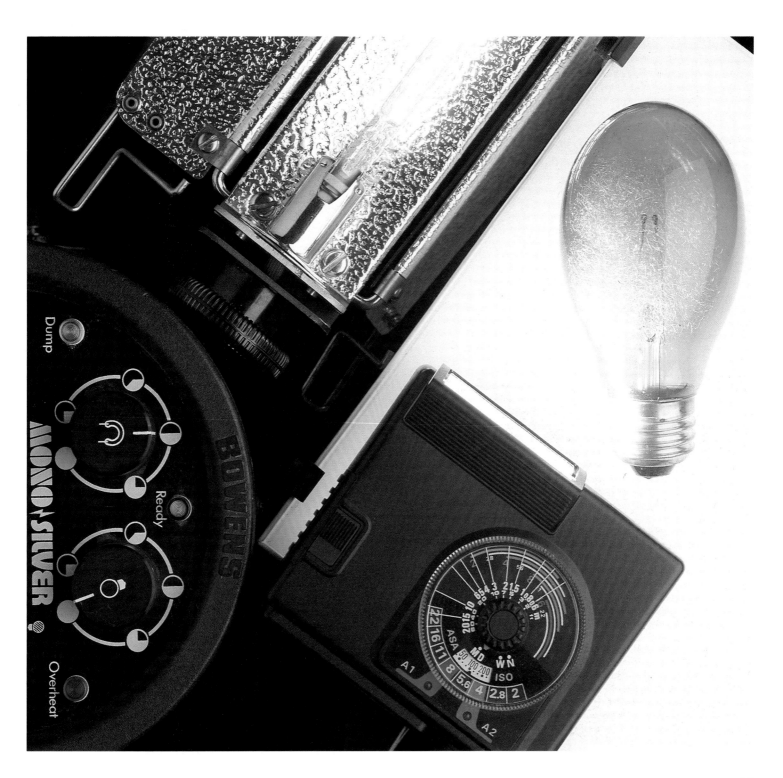

Flash versus Tungsten

The two principal types of photographic lighting are electronic flash and tungsten. There is very little other choice. As already explained, in order to use a full range of lighting controls, the choice is even more strictly defined: both must be mains-powered. An AC mains supply allows the use of lamps with a high output of light, and this is the key to managing its quality. Many of the diffusing and reflecting systems described on pages 124–33 absorb large amounts of light varying between a few and several stops.

At the end of all this modification, the intensity must still be sufficient to allow comfortable shutter speeds and apertures. What constitutes "comfortable" depends on the type of shot and on the camera format (good depth of field with a larger camera needs a smaller aperture). The light output of the unit can always be reduced either by switching down (in the case of flash) or by using lower wattage lamps or lower voltage (in the case of tungsten). Too much light is hardly ever a problem, and if it occasionally is, a neutral-density filter of the appropriate strength will solve it.

Mains flash and tungsten are good, and less good, in different circumstances. In terms of cost and manageability, flash systems tend to be more expensive and complex, although many basic units cost less than a good studio tungsten lamp such as a small luminaire. There is no perfect way of comparing the intensity of flash and tungsten lamps directly, because one is virtually instantaneous and the other continuous; however, the power that they draw gives something of a guide. The measurement is watts for a tungsten lamp and joules (watt-seconds) for a flash unit. The 800-joule flash unit illustrated on page 100 costs about twice as much as the 800-watt Arrilite tungsten lamp shown on page 113, and three times more than the less sophisticated 800-watt Totalite also on page 113. (These tungsten units can be fitted with different strengths of lamp, but 800–1000 watts is normally the maximum for this size.) In weight, the same flash unit is 7lbs (3.2 kg), compared with 7lbs (3.2 kg) and 4lbs (2 kg) respectively for the tungsten lamps. Complexity is important when things go wrong, and while most tungsten lamps are mechanically simple enough for you to repair yourself, flash units are not, unless you have a special interest or expertise in electronics.

Flash is balanced for normal daylight film, at 5500 K, which has some convenience if you prefer to stock only one type of film. It can also be mixed with daylight without filtration, although balancing the exposures

Lighting systems: Comparative checklist

	Flash		Tungsten		Fluorescent
	Portable	Mains	Mains	Battery portable	
Light output	Low; individual pulse sets limit	High, but individual pulse sets limit	Fairly high; no limit to quantity reaching film if time exposure is used	Low, but time exposure increases level	Low, but time exposure increases level
Compatibility with other sources	Colour-balanced for daylight, otherwise use filters. Mixed exposure calculations with ambient lighting a little difficult		Needs filtration to make compatible with any other source. Continuous, so easy to judge effect and measure exposure with other, ambient lighting		If tubes are those corrected for photography, colour-balanced for daylight. Exposure calculation easy with ambient lighting
Controlling quality of light	Few possibilities	The most possibilities: many fittings available, including enclosed boxes	Many possibilites, but cannot be enclosed without cooling fans	Limited	Limited, but excellent for diffused area light
Portability	Excellent	Difficult	Quite difficult	Good	Quite difficult
Weight and complexity	Lightweight	Heavy, complex, expensive	Moderately heavy, simple, moderately inexpensive	Fairly simple and uncomplicated, but battery needs care	Simple, uncomplicated
Heat output	Negligible	Little	High, damaging to some subjects	Low to moderate	Very little
Treatment of subject movement	Freezes action	Freezes all but the fastest action	Blurs action	Blurs action	Blurs action

Speed and aperture settings: Basic requirements

Type of photography	Camera format	Typical film speed (ISO)	Shutter/ flash speed	Aperture
Still-life	35mm 6×7 cm 4×5 inch	25 50 50	*Usually unimportant	f 22–f 32 f 32 f 32–f 45
Studio portrait	35mm 6×7 cm 4×5 inch	100 100 100	⅟₁₂₅ second	f 11–f 16 f 16–f 22 f 32
Interiors/ room sets	35mm 6×7 cm 4×5 cm	40 64 64	Unimportant	f 16–f 22 f 22–f 32 f 32
Fashion (with movement)	35mm 6×7 cm	100 100	⅟₂₅₀ second	f 11–f 16 f 16–f 22

Note that the speed requirements are only important as a consideration with continuous lighting. Flash is faster than virtually any studio equipment.

*Occasionally a very fast speed is needed: to record steam rising from a hot dish, for example, or a liquid being poured.

Over large lighting distances, such as in this car museum, the only way of increasing flash exposure beyond a certain level is to make several flashes. With tungsten lighting, as used here, increasing the time exposure is usually simpler and more straightforward.

is not so easy and needs a flash meter that will also measure continuous lighting. Most tungsten lighting is balanced for 3200 K Type B film (some for 3400 K Type A film). It can be used in balance with daylight if you either filter the lamp with a −131 mired blue gel or filter the daylight with a +131 mired orange gel. With daylight-balanced film, use an 80B filter over the lens.

To freeze action, flash has all the advantages; most flash tubes discharge more quickly than the fastest shutter speed. To allow shutter speeds in the order of ⅟₂₅₀ second and faster, a great deal of tungsten lighting would be needed, particularly if it is to be diffused or reflected. If, on the other hand, you want to convey motion with some blur, continuous light is essential.

The single discharge from a flash tube sets a limit of sorts on the exposure. To exceed this, the flash must be tripped several times (twice for an extra stop, four times for two extra stops, eight times for three extra stops, and so on), and this demands a static subject. The recharging time determines the ultimate comparison with tungsten lighting: under certain conditions, it takes longer to build up the necessary exposure with cumulative flashes than it does with a time exposure under tungsten lighting. This break-even point usually occurs when the exposure needed is between 4 and 5 stops greater than a single pulse can provide. Camera movement is also a danger when the shutter has to be tensioned and released more than once (the alternative, an open shutter in complete darkness, is not always possible) as is overheating the flash unit.

Flash units need a modelling lamp to preview their effect. This is not normally a problem – tungsten lamps are used for ring-flash tubes, fluorescent strip lights for linear flash tubes – although exact imitation may fail when, for instance, a tight, focused beam needs to be produced. The modelling lamp gives no indication of intensity. Tungsten lamps give exactly the lighting effect that you can see, and allow direct comparison with other light sources: a useful facility on location. In a studio, on the other hand, it is usually more comfortable to work with the weak modelling lamp of a flash unit than the full intensity of tungsten lamps. It is less of a strain on the eyes (normal practice is to close your eyes briefly as the flash is triggered).

Finally, flash lighting is cooler to use than tungsten. This is not simply a matter of comfort, although this itself is fairly important in fashion and portrait photography in an enclosed space. Heat spoils some subjects (many ingredients in food photography, for example) and a hot tungsten lamp cannot safely be enclosed in the kind of boxed area light fitting shown on page 127.

Studio Flash

If the only photographic lighting that you are familiar with is portable flash, the mains-powered units used in studios probably invite comparison. Although the process of creating the light is the same – a short high-voltage charge that ionizes xenon gas in a sealed tube – most other features are quite different. Size, bulk, complexity, technical management and, above all, the lighting possibilities are all on a different scale. Simply being able to draw continuously available power at a much higher voltage makes it possible to use capacitors that will discharge enough energy to meet virtually any conceivable demand in photography. The light can be diffused, reflected or redirected in all kinds of ways, and still reach the subject at a sufficiently high level to allow a small aperture and good depth of field. The table on page 99 gives an indication of ideal working apertures of different types of studio and other control-led photography; the range of mains flash units is sufficient to allow the choice of one that is suitable for whatever camera you use.

To make use of the extremely high output of the mains flash capacitors, the flash tubes are considerably larger than those in portable units. Instead of a short straight tube, the most common design for medium-power units is a circular tube. High output units use a spiral design to extend the size, and linear tubes are used in strip-lights and in large area lights. One result of the need for high output and larger tube sizes is that the peak flash duration is much longer than that of a portable flash unit. Instead of thousandths of a second, mains flash duration is measured in hundredths of a second: between $\frac{1}{200}$ and $\frac{1}{500}$ second is typical of units in the 200–800 joule range.

Given the light output possible just from a single flash tube – and that it is practically instantaneous – it is not surprising that mains-powered flash is the lighting equipment of choice in studios. Used outside a studio to light things larger than still-life sets and people, it does not have quite such a clear-cut advantage. The maximum dis-

charge through the flash tube marks the upper limit on a single dose of light output, and if this is still not enough for the photograph, the only alternative is to trip the shutter and flash again: serial flash, as it is sometimes known. While this is possible, and even almost normal in still-life photography, it is no use with an active subject.

Basically, a mains flash unit works as follows. As the power supply is in the form of an alternating current in a relatively low voltage, the first part of the circuitry is a transformer and associated rectifier (or more than one in the case of larger units). The transformer steps up the voltage and the rectifier converts the alternating current to a direct current (AC to DC). This unidirectional high-voltage source then supplies the capacitor (or banks of capacitors) which store the charge. On command, the high-voltage output in a capacitor is discharged through the flash tube.

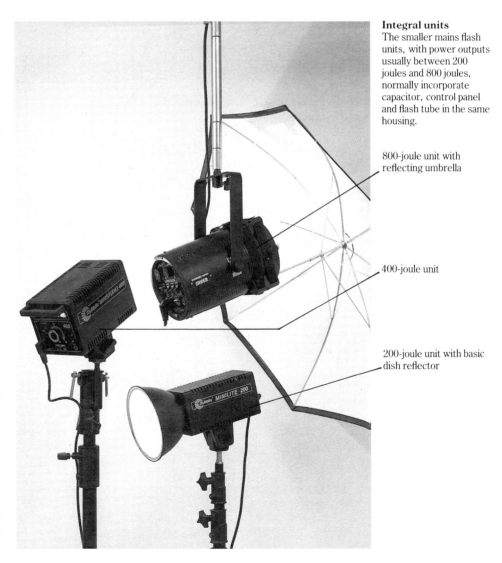

Integral units
The smaller mains flash units, with power outputs usually between 200 joules and 800 joules, normally incorporate capacitor, control panel and flash tube in the same housing.

800-joule unit with reflecting umbrella

400-joule unit

200-joule unit with basic dish reflector

Heavy-duty units
The most powerful studio flash designs, of 1000 joule output and upwards, tend to have flash heads separate from the power packs. The size of the capacitors makes this the only practical construction.

Coil flash tube head fitted with small area light on boom arm

Large area light containing two linear flash tubes, supplied with cantilevered support and fronted with translucent acrylic

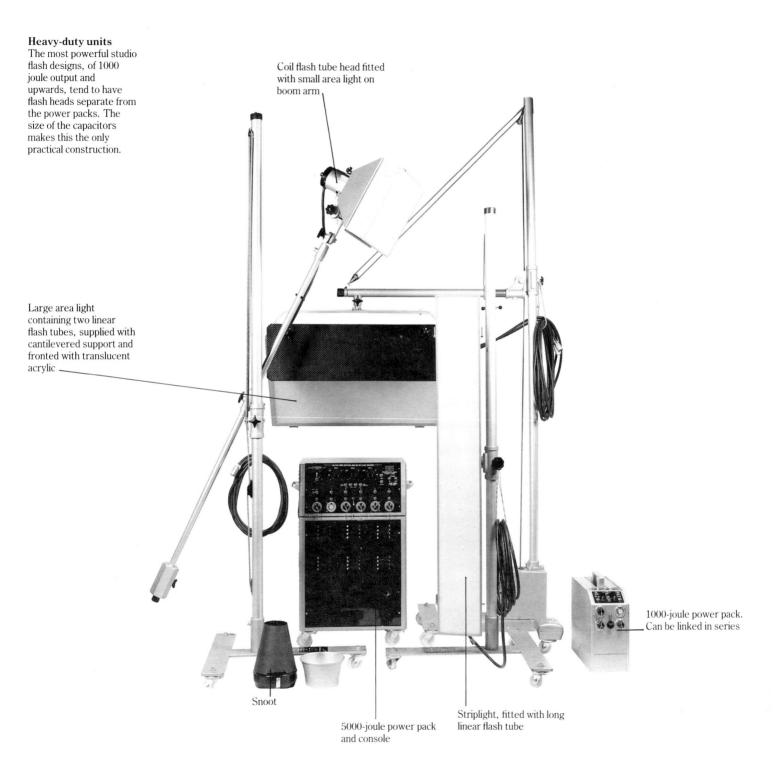

1000-joule power pack. Can be linked in series

Snoot

5000-joule power pack and console

Striplight, fitted with long linear flash tube

There are two main kinds of construction. In one, now reserved for high-output units, the power-pack and controls are in a separate housing, with the flash heads connected by cable. In this design, the power-pack has more than one outlet to supply different heads at the same time, and the power ratio can be varied between them. The second design is the integral unit, in which a single housing contains everything: controls, capacitors, flash heads, etc. Although individually heavier as a head, the integral design is simply to carry and use, and needs fewer cables.

The controls in this basic system are partly automatic and partly selected by the photographer. The main choice offered to the user is in output, and most units offer a selection of levels up to the maximum. For instance, a stepped control might offer quarter-power, half-power, three-quarter-power and full power, or the control may be stepless (the quarter-power to full power range is still the most common). Input from the mains is controlled automatically so that the capacitors store just the charge necessary for the selected output. The capacitor voltage tends to decay naturally, and in a typical flash unit an amplifier will cut in when the voltage has decreased by about 5 per cent, and top up the level.

In flash units that have the power unit and control console separate from the flash head, there is usually a facility for supplying several heads at the same time, and of selecting the amount of charge passed to each. Normally, this is in the form of a ratio selector, so that, for example, half the total output may be passed to one head and a quarter each to two others.

Once the flash has been fired, either by a triggering switch or by the synchronization cable attached to the camera, the capacitors are recharged automatically. Often this is arranged in such a way that there is an initial surge, which may last for a fraction of a second, until this is reduced by a limiting circuit to a lower current. With a large flash unit, you should check that the initial surge

does not exceed the fusing of the mains circuit. For example, the Strobe 5000 Joule Console shown *opposite* draws a peak current of 20 amps for $\frac{1}{2}$ second before reducing to about $7\frac{1}{2}$ amps until the capacitors are fully charged.

The time taken to charge up the capacitors is known as the recycling time, and this varies between makes. It also, understandably, depends on the output, and if you select a lower output, the flash will be ready for firing again in less time than if it is switched to maximum. Recycling times typically vary between $\frac{3}{4}$ second and 4 seconds at full charge. There is normally a visual signal (a light on the control panel) to indicate when the charge is full at the end of this recycling period. Some units also have an audible signal and on a few the modelling lights are quenched during recycling.

Switching up or down on the output control, or cross-switching between outlets on a separate power-pack, requires a change to the level of the charge stored in the capacitors. In switching up, there is a short delay while the amplifier tops up the level; in switching down, the extra unwanted charge must somehow be bled off. On some units a bleed circuit does this; on others, there is a dump switch, which effectively discharges a flash manually. Natural decay will, in any case, bring the level down eventually, although this may take between several seconds and anything up to a minute or two.

If you fire the unit repeatedly over a period, two problems may occur. One is straightforward overheating, which will happen faster if the head is enclosed in a box-type fitting (see pages 124–7). Most units have an internal thermostat to monitor this, and will switch off if the temperature rises too high. If this happens, the unit will not fire until the temperature falls to a certain level, which may take a few minutes. If you are planning to shoot with fast-repetition flashing, switching off the modelling lamp will help lower the temperature a little.

The second problem likely with rapid firing is overloading the flash tube itself. The danger sign is an after-glow in the tube. Check for this by firing the flash and then immediately looking at the tip of one of the electrodes inside. If you can see it glowing momentarily, let the tube cool down. The recovery period recommended for most tubes varies between about two and five minutes.

A final, and important, precaution is to be rigorous about safety procedure. The safety in this case is your own. Always earth the equipment correctly, and never, ever, make any connections or disconnections with the mains supply attached (for instance, if you need to remove the flash tube, or when plugging in and out of the outlets on a separate power-pack). It should also go without saying that it is dangerous to use water close to one of these high-voltage units, so that if you need, for instance, to spray a still-life set, take particular care to shield the power-pack and flash head.

Many units incorporate a safety circuit that bleeds off power once the unit is switched off at the mains, but if not, the circuitry inside can remain live for up to a minute, depending on the make of the unit. This alone is a good enough reason for leaving the works inside the housing. Unless you are completely confident of what you are doing, leave repairs to experts.

The speed of the flash discharge results in a low heat output; unless the flash head is fired rapidly and continuously, there is more heat produced by the modelling lamp than by the flash tube or internal electronics. The implications of this go well beyond being able to photograph ice-cream without melting it, and such like. The relative coolness of a flash head means that it can be used right next to almost any kind of material suitable for modifying the light quality. In particular, it can be enclosed, and this seemingly simple fact was responsible several years ago for a major revolution in studio lighting. The area light is a product of

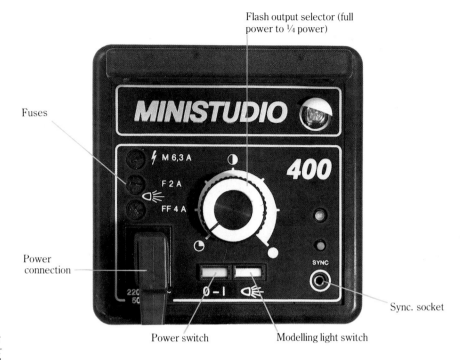

Flash output selector (full power to ¼ power)

Fuses

MINISTUDIO

⚡ M 6,3 A

F 2 A

FF 4 A

400

Power connection

SYNC

220
50

0 – 1

Sync. socket

Power switch

Modelling light switch

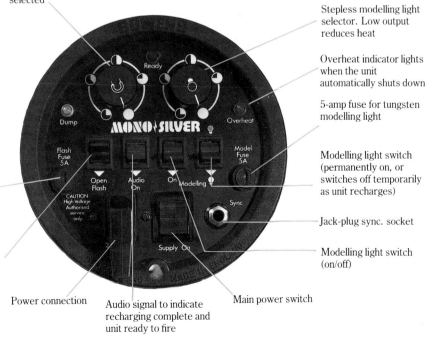

Stepless output selector for flash, from full power to ¼ power. Segmented circles indicate output selected

Stepless modelling light selector. Low output reduces heat

Overheat indicator lights when the unit automatically shuts down

5-amp fuse for tungsten modelling light

Ready

Dump

MONO▪SILVER

Overheat

Flash
Fuse
5A

Model
Fuse
5A

5-amp fuse for flash tube

CAUTION
High Voltage
Authorised
service
only

Open
Flash

Audio
On

On Modelling

Sync

Modelling light switch (permanently on, or switches off temporarily as unit recharges)

Supply On

Jack-plug sync. socket

Modelling light switch (on/off)

Manual trigger

Power connection

Audio signal to indicate recharging complete and unit ready to fire

Main power switch

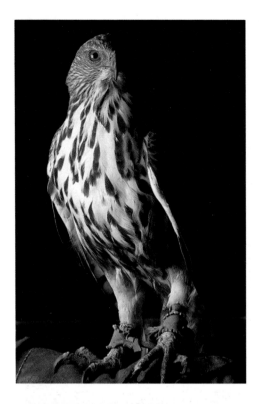

Used alone, with no shadow fill and against a black velvet background, a 2 foot square (0.6m) area light gives strong modelling to this hawk eagle. With a moving subject like this, flash is essential to avoid blur.

mains-powered flash, and from the late 1960s onwards changed the appearance of still-life photography. Area lights are precise diffusers, and dealt with as such on pages 124–7. At least one manufacturer, however, produces area lights not as attachments but as basic lighting equipment. These are the exceptions to the normal practice of building flash equipment as raw light sources.

If you compare the available ranges for flash equipment with those of tungsten lighting, you can see one noticeable difference in the heads. Although most of the tungsten units have built-in reflectors, often adjustable, most flash tubes are backed with the absolute minimum of reflective dish, usually no wider than the dimensions of the basic head. Essentially, flash units are made to be used with attachment fittings. While beam control is normal in tungsten lighting, it is not standard in flash.

There are two practical reasons why flash manufacturers avoid this. One is that the beam of the flash tube is never visible for long enough to judge by eye, and the nearest you can get to seeing what it will look like is the light from the modelling lamp. The second reason is that a flash unit is structurally more complex than most tungsten lamps, with integral units now more popular than ever. As a result, there are more complications in trying to make the flash tube move in and out of the housing to adjust the spread of light.

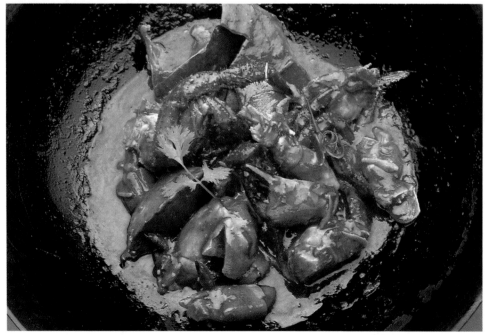

Food photography often involves movement, particularly if, as here, the cooking process is the subject. For this shot of chili crab being cooked, a 2½×3½ft (0.8×1m) area light was suspended overhead, so that its light would be reflected in the liquid.

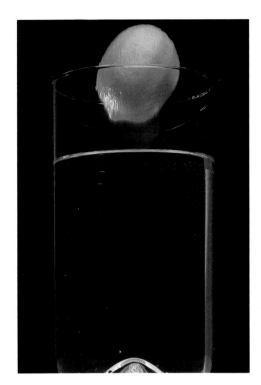
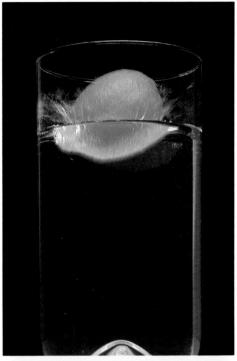
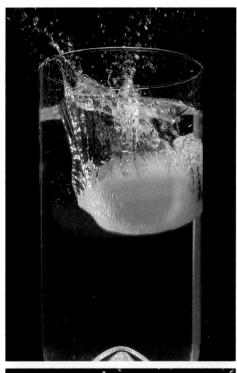

Project:
Synchronization
Rapid movement introduces two extra difficulties. One is synchronizing the exposure with the right movement in the action, the other is that the flash duration in a large flash tube is relatively long, and may not be fast enough to freeze the subject. In this project, a lemon is dropped into a glass of water. Try a similar arrangement, dropping the object and triggering the camera manually. Note the delay between pressing the shutter release and the flash discharge. On the developed film, see how much blurring there is.

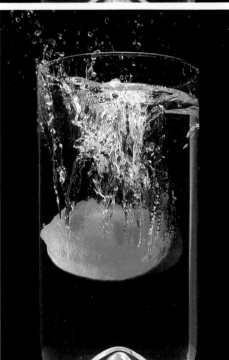

Basic equipment

This set of equipment is based on moderately-powered integral units, and is reasonably portable. The selection of reflectors and diffusers includes two sizes of area light and different umbrellas – sufficient for most applications.

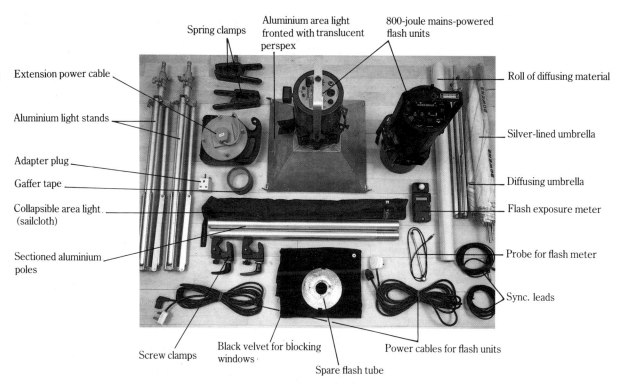

Spring clamps

Extension power cable

Aluminium light stands

Adapter plug

Gaffer tape

Collapsible area light (sailcloth)

Sectioned aluminium poles

Aluminium area light fronted with translucent perspex

800-joule mains-powered flash units

Roll of diffusing material

Silver-lined umbrella

Diffusing umbrella

Flash exposure meter

Probe for flash meter

Sync. leads

Screw clamps

Black velvet for blocking windows

Spare flash tube

Power cables for flash units

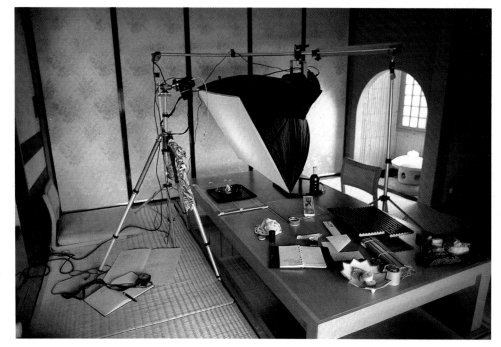

As used on location, part of the equipment laide out above is used to construct a typical still-life lighting arrangement for a location food shot. One of the two flash units is fitted with a collapsible area light made of lightweight sailcloth – black with a translucent front panel. This is suspended overhead in a "goal-post" arrangement.

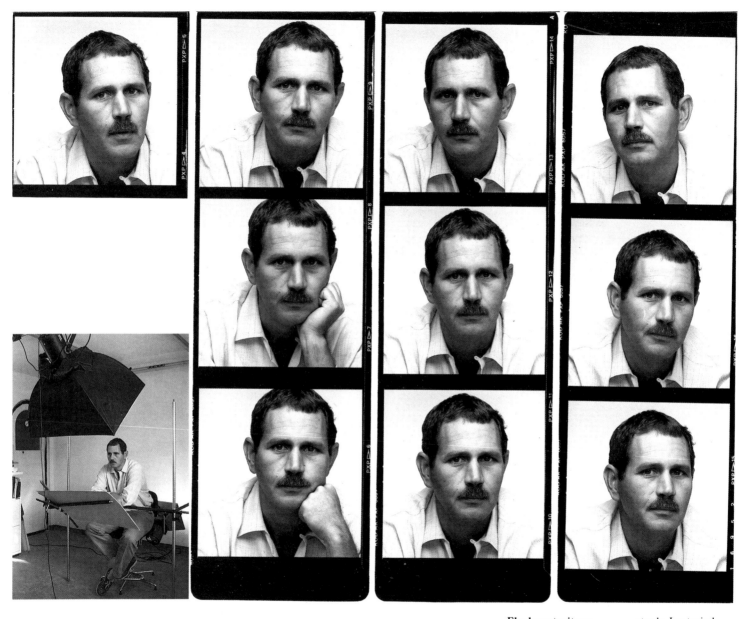

Flash portraiture
In the studio, the same basic lighting set is used for a straightforward portrait. This time, the studio's overhead ceiling track is used, in order to keep the floor free of unnecessary cables and stands. In a typical portrait session, rapid sequences of shots are taken, in order to give a choice of expression and pose. The movement involved makes flash more suitable than tungsten.

107

Portable Flash

In the range of photographic lighting, portable flash is principally a convenience, and it is important to appreciate its limitations. The units shown here are designed to be small and easy to use; with these as priorities, quality and variety of lighting take second place. There is a lot that you can do to improve the illumination with small electronic units, but the majority of the studio lighting effects shown in this section of the book are beyond their scope. You will have the most success with portable flash if you put it to the uses for which it is designed.

A typical portable electronic unit is powered by several dry-cell batteries, mostly either rechargeable or several 1.5 volt AA size, and made to be used attached to the camera (usually 35mm). The attachment is either into a standard hot-shoe, which provides synchronization, or into a fitting peculiar to each camera model, with multiple contacts to the exposure control system and viewfinder display. The latter, known as dedicated flash, is becoming increasingly the norm. If the flash is used off the camera, the synchronization or dedicated connections must be made by cable.

The batteries charge the capacitor and this, when the contact is made, releases the full charge almost instantaneously through the flash tube, ionizing the gas inside. The intensity of the light output depends on the size of the capacitor and on the square of the voltage at which the unit operates; the duration of the flash depends on the size of the capacitor and the resistance of the circuit, but is typically between $\frac{1}{1000}$ and $\frac{1}{50,000}$ second. Although this duration is faster than any shutter speed, there are mechanical limitations to synchronizing the two with a focal plane shutter. What is called the flash synchronization speed for any camera is the maximum shutter speed; the flash can also be used with any slower setting. Focal plane synchronization speeds vary, depending on the model of camera, between $\frac{1}{60}$ second and $\frac{1}{250}$ second. Synchronization with a leaf shutter in the lens is more straightforward, and works at all speeds. Flash is normally synchronized to fire when the shutter opens. This means

that if you want to take a picture (using flash) of a car with the tail lights appearing as red trails behind, you will need to photograph the car moving *backwards* – not an easy thing to do on the motorway. Second-curtain synchronization gets round this problem, because the flash fires just as the shutter is about to close at the end of a long exposure.

The measure of flash output is BCPS (beam candlepower-second), but the more commonly used value is the guide number, as this enables the photographer to calculate the aperture setting from the distance between flash and subject. Manufacturers publish the BCPS output of their units, which varies according to the film speed rating, but the conditions under which it is established are not consistent. If it is calculated with the flash being used in a small room with light-coloured walls and ceiling, the output will be higher, and certain manufacturers frequently publish fairly over-optimistic versions of the BCPS output of their units for this same reason.

The guide number is a more practical

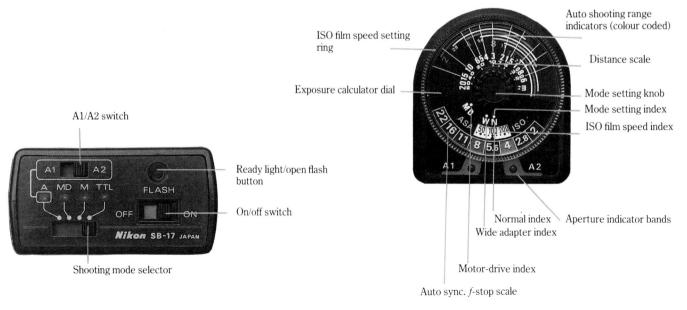

ISO film speed setting ring

Exposure calculator dial

Auto shooting range indicators (colour coded)

Distance scale

Mode setting knob

Mode setting index

ISO film speed index

A1/A2 switch

Ready light/open flash button

On/off switch

Shooting mode selector

Nikon SB-17 JAPAN

Normal index

Aperture indicator bands

Wide adapter index

Motor-drive index

Auto sync. *f*-stop scale

Cut-off with a focal-plane shutter
There is a limit to the shutter speed that can be used in synchronization with flash if the camera has a focal-plane rather than a lens shutter, generally between $1/60$ and $1/125$ second, depending on the make. This is because the blinds can only be moved physically across the film gate so fast; for shorter exposures than this, the gap between the blinds has to be made narrower than the film frame. Then, the almost instantaneous flash can only expose a part of the image, as in this example.

The standard portable flash arrangement is with the unit fitted directly to the top plate of the camera, giving direct lighting from very close to the lens. The inherent drawbacks of this are listed *opposite*.

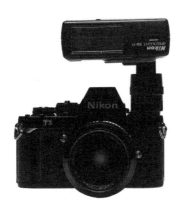

On-camera fittings vary between makes of camera. The most common design is a metal shoe into which the flat square base of the flash unit slides.

Dedicated special fitting

X-sync. hot shoe

Dedicated hot shoe

Shoe only, no sync.

measurement of output, and is also published by the manufacturer. It also varies with the film speed rating, and is the product of the aperture (in f-stops) and flash-to-subject distance. Under the old ASA film speed rating system, the distance is in feet, but with the DIN rating it is in meters. If only one guide number is given, you can assume that it has been calculated in feet unless stated otherwise (some manufacturers, for instance, quote guide numbers as "ISO/ft" or "ISO/m"). Hence, for what the manufacturer considers to be a good normal exposure, a flash unit with a guide number of 80 would have to be used with an aperture setting of f 8 if the subject were 10 feet (3m) away. So, if the flash unit is set to manual – for maximum output – the exposure can be set by dividing the guide number by the distance to the subject.

In most circumstances, however, this is not necessary as the majority of units have an automatic system for controlling the exposure. In the simpler and older method, a photo-cell measures the light reflected back from the subject, and a thyristor circuit responds extremely rapidly to quench the flash discharge. This is satisfactory up to a point, but a more sophisticated method, dedicated flash, incorporates a number of improvements. As the name implies, dedicated flash is the use of a camera and flash unit that are designed specifically to work together. The two units then function in a totally integrated way. Typically, a dedicated flash unit creates a display of functions in the camera's viewfinder: a "sufficient light" signal appears as long as the exposure does not totally drain the capacitors of the flash, and a ready light comes on in the viewfinder when the flash has recycled. In a few models, dedicated flash units meter exposure from the film's surface during exposure by means of a photocell incorporated into the camera body. Most of the information is displayed in the camera's viewfinder, including an indication if the exposure is insufficient. In the display illustrated here, the under-exposure warning is a flashing light; in effect, this shows that the flash has discharged at its maximum output.

On-camera flash: Problem checklist
● Exposure is only good for one distance, because the light fall-off is along the line of view. Thus backgrounds are typically dark, and off-center foreground obstructions typically over-exposed.
● Intense reflections in shiny surfaces facing the camera (spectacles, windows, etc.). Lack of modelling lamp prevents preview.
● Red reflections from retina of the subject likely, particularly with a longer focal length lens (this makes light more axial).
● Poor impression of the form of the subject.

Flash Bulbs

For practically every application that you can think of, flash bulbs have been superseded by electronic flash, for very good reasons. Bulbs are bulky, need to be disposed of after firing, cannot conveniently be diffused, and offer none of the sophisticated linkages that most photographers are accustomed to with dedicated flash. Also, automatic cut-off of the flash once a certain amount of light has reached the film is not possible.

One type of bulb does have an outstanding advantage, however, even though there may be few occasions when you might need it. This is the high-output bulb. The M22B daylight-coated flash bulbs shown here individually have high guide numbers. If assembled with the lightest possible triggering mechanism and holder, they are, weight for weight, the most efficient portable lights currently available. Fitted into multiple heads and fired in synchronization, a few together give a higher output than any other comparable source. Changing bulbs after an exposure is something of a performance, and encourages first-time accuracy. Bracketing exposures is not normally a reasonable option.

Compared with electronic flash, the pulse through a flash bulb is much slower, and peaks less sharply. Many cameras no longer have flash bulb synchronization, and the normal synchronization speed is much too rapid: using this speed, much of the flash output will be lost. To get the maximum exposure from one of these large bulbs, use a slow shutter speed of no more than 1/30 second.

The guide-number table gives a rough indication of output, but the surroundings will affect it, as will the reflector holder used. The best method is to calibrate the bulbs and holders by testing them first, either with a flash meter, or by exposing colour transparency film (better for this purpose than negative film, as the processed results will be exactly what you shot, unaffected by printing compensations).

The value of these high-output bulbs is when portability is essential – not only an independent power source, but also lightweight – but the level must be high as well. Very few triggering systems are now available, and they are bulky, but in this respect bulbs are easy to use. All that is needed is a sufficient battery voltage. For the cave shots shown here two bulbs were triggered simultaneously with the batteries in an adapted holder. If you experiment yourself with ways of triggering these bulbs, take sensible precautions in handling them. During the period of discharge, they are dangerous.

There is no problem in wiring them in series, unless the length of wiring is considerable. If it is (and there are no tables for this; you will have to work it out by testing), there will be a voltage loss which might be important if you are already using the lowest voltage batteries that will trigger the bulbs. Long wiring in series may also delay synchronization; in this case, use an even slower shutter speed.

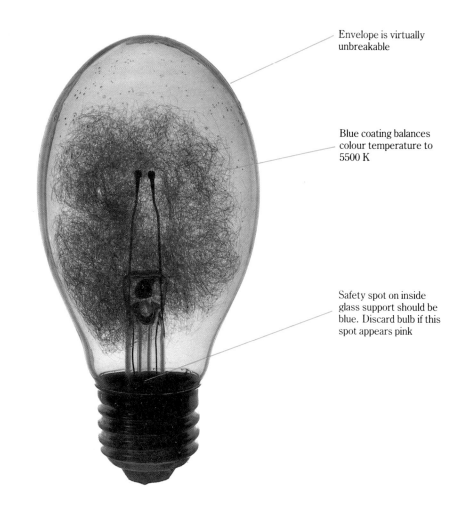

Envelope is virtually unbreakable

Blue coating balances colour temperature to 5500 K

Safety spot on inside glass support should be blue. Discard bulb if this spot appears pink

High-power flash bulbs are at their most useful in situations where a strong output is needed to cover a large area, yet there is no mains electrical supply. In this example, the location was a large cave in Borneo, where collectors scale the walls to collect birds' nests. Flash bulbs were used here from the ground and by one of the collectors (near the center of the picture). No synchronization was attempted; instead, the bulbs in their dish reflectors were wired to temporary battery packs and fired manually, with the camera set to a time exposure on a tripod.

Studio Tungsten

Tungsten lighting is incandescent, created by burning a tungsten filament at a controlled rate in a sealed transparent envelope (glass in the case of traditional lamps, a quartz-like material in the case of more efficient tungsten-halogen lamps). Regular photographic tungsten lamps work on the same principle as ordinary domestic lamps but have much higher wattages, between 200 and several thousand. Their light output is therefore much higher, and the colour temperature is controlled, at 3200 K (312 mireds) in nearly every design. This standardized colour temperature is also that of Type B colour film, and this is the material of choice for colour photography with tungsten lighting. If regular daylight-balanced film is used, a blue 80A conversion filter is needed: this has a mired shift of -131, the difference between 3200 K and 5500 K. Some lamps are available with a blue coating to the glass, giving a colour temperature that approximates that of daylight. These are intended more for use in mixed lighting conditions, such as combined with daylight, than for straightforward studio use.

Traditional photographic tungsten lamps are available with wattages ranging from 275 to 1000 at their rated voltages (110, 120, 220 or 240); their light output is in proportion. Of those commonly available for still-life photography, most have standard screw or bayonet fittings for use in a variety of holders and reflectors.

Photofloods have similar fittings, and a similar appearance, but shorter lives, often as little as eight hours. They have a colour temperature of 3400 K, very slightly bluer than other tungsten lamps and matched to the now uncommon Type A colour film. With Type B film, an 81A filter gives the necessary correction (or an equivalent lighting filter can be fitted to the lamp), although the difference is sufficiently small for many photographers to ignore it. As with photographic lamps, be careful about using them in ordinary domestic fittings which may not be able to tolerate high temperatures. These uncomplicated traditional tungsten lamps are inexpensive, but blacken with use as the burnt tungsten redeposits on the glass; their light output and colour temperature become lower. They are now seldom used in professional studios.

The more efficient version of tungsten lighting is the tungsten-halogen lamp. This uses the same coiled tungsten filament but it burns at a much higher temperature in halogen gas. As a result, these lamps maintain virtually the same light output and colour temperature throughout their life; they also last longer than traditional lamps and are smaller for their equivalent wattage. Available wattages range from 200–10,000, although the most powerful are intended for cinematography; the highest normal wattage for still photographic lights is 2000. The light output is the same as that from a new tungsten lamp of traditional design of the same wattage.

The design of tungsten-halogen lamps varies to suit the different makes of lighting unit, but the two main types are both 2-pin: single-ended, which is intended to be used upright, and double-ended, which is used horizontally. It is important for safety and for the life of the lamps to use them *only* in these positions.

There are other important precautions. Never touch the quartz-like envelope with bare fingers as the greasy deposit will cause blackening and shorten the lamp's life. Instead, use paper, cloth or a glove. If you do accidentally touch the surface, wipe the finger-marks immediately with spirit. If you travel with tungsten lights and carry two sets of lamps for different voltages (110/120 and 220/240), be careful to identify the ones fitted before switching on: using a lower voltage lamp on a higher voltage circuit will immediately burn it out and may cause damage if it explodes. Not all lamps carry the voltage information on them, so make

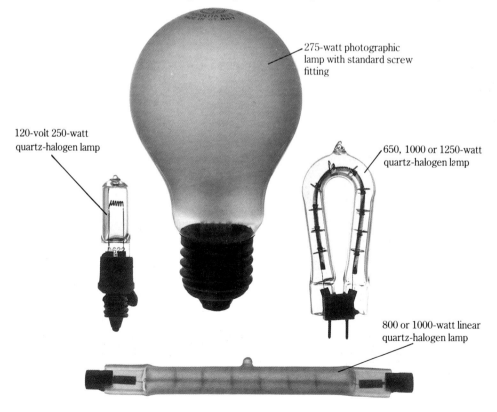

275-watt photographic lamp with standard screw fitting

120-volt 250-watt quartz-halogen lamp

650, 1000 or 1250-watt quartz-halogen lamp

800 or 1000-watt linear quartz-halogen lamp

sure they are in clearly-marked containers if you store them away from the fitting.

These lamps have high operating temperatures because they are very efficient, and can set fire to flammable materials, such as wood, paper and fabrics. Keep a careful eye on the position of the light, and keep it at a distance from anything that might be damaged (in particular, the light's own cable: certain parts of the housing can melt it through to the core, which would be extremely dangerous). If in doubt about damage to something, keep touching it to see if the heat builds up. Never enclose a tungsten-halogen lamp in order to modify the light; it needs good ventilation, because of the high operating temperature. Many light housings have folding doors that can be closed to protect the lamp when not in use (open, some act as reflectors, others as barn doors); never operate the light with these doors closed or even partly closed.

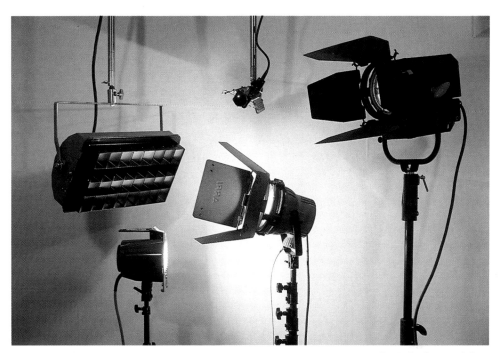

Clockwise from top left: Ballancroft 2500-watt northlight fitted with honeycomb or "eggcrate"; Lee-Lowell 800-watt Totalite with barn doors; Rank-Strand 1000-watt Polaris manual spotlight; 800-watt Arrilite; Hedler 2000-watt videolux.

The envelopes of high temperature halogen lamps are very susceptible to oil and grease, which they absorb and which will shorten their life. Use gloves or protective material when changing and handling lamps.

Beam control

All tungsten light housings incorporate some kind of reflector behind the lamp, partly to make use of all the light radiated (and so increase the light falling on the subject), and partly to control the beam. The deeper and more concave the reflector, the more concentrated the beam. As it is more difficult to spread a beam that is already tight when it leaves the housing than it is to concentrate a broad beam, most general-purpose housings have reflectors that give a spread of between about 45° and 90°. Light that gives tighter concentration is for more specialized use (see focusing spots on pages 134–5).

Many housings allow some change to the beam pattern by moving the lamp in and out of the reflector, or by moving reflector doors. Barn doors fitted to some housings have a slightly different effect: they cut the edges of the beam rather than concentrate it. The beam patterns from most housings show a fall-off from the center outwards; even with a well-designed reflector, there is still an intense concentration of light in the lamp's filament. One method of reducing this fall-off in the design of the housing is to cover the lamp from direct view with a bar or a spiller cap. If the reflector dish is large as well, the result is a degree of diffusion. Even softer, but less intense, light is possible if the inside of the dish is finished in white rather than bright metal.

Filtering

Used alone in the studio, tungsten lamps normally need no colour filters, as long as the appropriate film is used. However, tungsten lighting is frequently used on location, in interiors, and this is often in combination with existing lighting, like daylight and fluorescent light. As a result, lighting filters are often needed for converting the colour temperature or for correcting the colour to that of fluorescent lamps.

The most common filters are blue, to match daylight; full blue is −131 mireds, half-blue −68 mireds and quarter-blue −49 mireds. They are available as heat-resistant gels (actually plastic film), glass and dichroic. Dichroic filters are partial mirrors, reflecting red back to the lamp and passing blue; they are not always consistent, and ideally should be checked with a colour temperature meter.

Some housings have built-in filter holders; others are used with frames attached in front. With frames there is a danger of spill from the gap between them and the light. This can either cast reddish patches of light on the scene, or else reduce the overall colour temperature. You may need to flag this spill, or to wrap more gel around the gaps (but be careful of heat damage).

◀ **Lamp position**
Moving the position of the lamp in its reflector changes the spread of the beam. When it is as far back as possible, the beam is relatively narrow; moved forward, the lamp is not as enclosed, and so spreads more.

▼ Beam control by moving lamp, as in diagram *above*.

1 Standard spread

3 Bounced-light position

2 Wide spread

4 Naked lamp effect; no cut-off

◀ **Reflector angle**
Some tungsten lights in which the lamp position is fixed allow a lens precise control of the beam spread with hinged reflector panels. These are the basic configurations of a Lee-Lowell Totalite.

▼ Beam control by moving barn doors.

Filters
It is often more convenient to filter each lamp rather than to use a lens filter on the camera. Fittings vary, but usually avoid enclosing the lamp to prevent over-heating.

A universal fitting is an outrig frame, such as the one shown here, which attaches in front of the light. It is essential to use purpose-made non-flammable filter material with lamps.

Daylight control and tungsten conversion filters
This range of filters, intended for use over light sources, is designed for raising and lowering colour temperature, and for reducing levels from certain sources.

85N3 combines the effects of the 85 and N3 filters. Mired shift +131; 33 per cent transmission.

85N6 combines the effects of the 85 and N6 filters. Mired shift +131; 17 per cent transmission.

N3, a neutral filter, reduces light level by 1 stop. 50 per cent transmission.

N6, a neutral filter, reduces light level by 2 stops. 25 per cent transmission.

⅛ CTO converts 5500 K to 4900 K for very slight warming. Mired shift +20; 92 per cent transmission.

¼ CTO converts 5500 K to 4500 K, or 4000 K to 3200 K for slight correction or when daylight is warm. Mired shift +42; 81 per cent transmission.

½ CTO converts 5500 K daylight to 3800 K, or 4500 K to 3200 K for partial correction or when daylight is fairly warm. Mired shift +81; 73 per cent transmission.

85 used over windows or flash-heads to convert 5500 K to 3200 K, the standard window correction when using type B film and photographic tungsten lamps. Mired shift +131; 58 per cent transmission.

⅛ blue boosts 3200 K to 3300 K. Use as for ½ blue *left*. Mired shift − 12; 81 per cent transmission.

¼ blue boosts 3200 K to 3500 K. Use as for ½ blue *left*. Mired shift − 30; 74 per cent transmission.

Full blue is standard correction filter from tungsten (3200 K) to daylight (5500 K). Commonly used over photographic tungsten lamps with daylight-balanced film. Mired shift −131; 36 per cent transmission.

½ blue for partial conversion from 3200 K to 4100 K to compensate for voltage reduction or to boost domestic tungsten when used with photographic tungsten lamps. Mired shift −68; 52 per cent transmission.

⅓ blue for partial conversion from 3200 K to 3800 K. Use as for ½ blue *left*. Mired shift − 49; 64 per cent transmission.

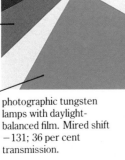

Tungsten on location

If you have little or no experience of using photographic lighting out of your home or studio, you may feel some reluctance to using it on location. However, although this is understandable, there are fewer difficulties than you might imagine, and the ability to work confidently with mains-powered lights anywhere, even outside, will make an enormous difference to the range of images of which you are capable. The relatively low cost of the simpler tungsten lamps make them an accessible introduction to location lighting, and the projects on pages 76–7 are strongly recommended as practice for building confidence.

The previous section on available artificial lighting should have demonstrated that, despite its reportage and scenic possibilities, taking controlled pictures at reason-able shutter speeds and with some choice of aperture and depth of field is, to say the least, difficult. If you want to manage the image and to design shots according to plan, then interior and night-time photography needs strong lighting. Portable flash has limited power and lacks the facility of modelling lamps that allow you to preview the results and make fine adjustments.

Location lighting with tungsten differs from that with mains flash in a few important respects. We will return to flash location shooting later, on pages 140–3, but the practical differences are as follows:

● Tungsten lighting shows exactly its effect, to the eye as to the film. Balancing the intensity, and to a little extent the colour, to other ambient lighting can be done just by appearance. Mains flash dis-plays its effect by means of modelling lights, which show neither the same intensity nor the same colour.

● Provided that there is no important movement in the scene, tungsten lamps allow a much bigger build-up of light, and so more exposure to the film. Flash is limited by the product of its output and recycling time; tungsten lighting, being continuous, simply requires more time.

● In terms of relative output, tungsten lamps weigh less and are less bulky.

● Power calculations are easier. The requirements are continuous and are known from the wattage. Mains flash draws unevenly, in surges as the capacitor needs recharging.

A 1000-watt tungsten light, wired to a portable gasoline generator, was used from outside to light the interior of this car being used at dusk by a private investigator in Los Angeles.

Selecting the equipment

The criteria for choosing tungsten lighting suitable for location work are relatively high output, light weight, sturdiness and stability. Tungsten-halogen lamps are the most efficient for their size, which affects the size of reflectors and fittings. A system such as the one shown in the kit layout on this page fulfills these conditions, and can also be the basis of regular studio lighting. It lacks some of the sophistication of larger units and so allows less precise control of lighting quality (such as lenses to produce tight, shaped beams).

Supports must also be transportable, which limits the sturdiness and height of regular stands. Various kinds of clamps, however, make it possible to use local supports to save carrying weight (even if only bannister rails and edges of tables). Look at the kit layout and its annotations on this page for detailed suggestions.

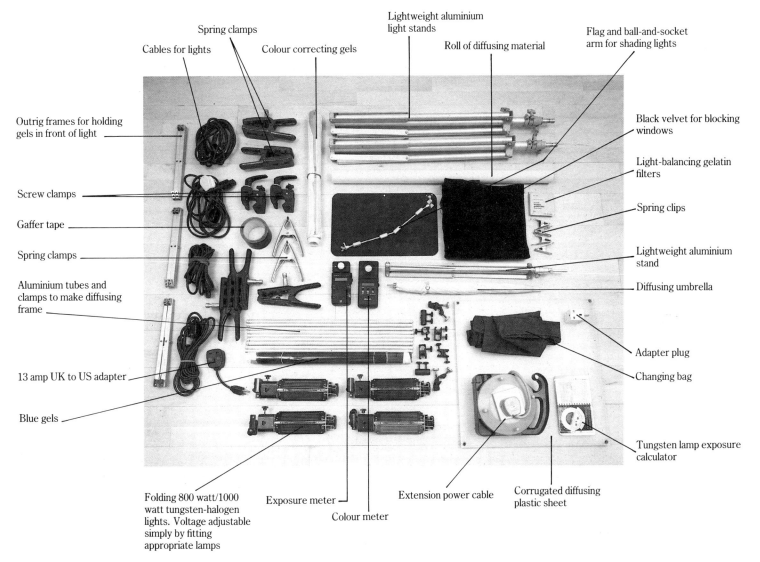

Spring clamps

Cables for lights

Colour correcting gels

Lightweight aluminium light stands

Roll of diffusing material

Flag and ball-and-socket arm for shading lights

Outrig frames for holding gels in front of light

Black velvet for blocking windows

Light-balancing gelatin filters

Screw clamps

Gaffer tape

Spring clips

Spring clamps

Aluminium tubes and clamps to make diffusing frame

Lightweight aluminium stand

Diffusing umbrella

13 amp UK to US adapter

Adapter plug

Changing bag

Blue gels

Tungsten lamp exposure calculator

Folding 800 watt/1000 watt tungsten-halogen lights. Voltage adjustable simply by fitting appropriate lamps

Exposure meter

Colour meter

Extension power cable

Corrugated diffusing plastic sheet

Power requirements

You have two possibilities: mains or a gasoline-powered generator. Of these, mains is much more likely to be used; even the smallest practical generator with an output of 3 kilowatts (3000 watts) needs a pick-up or other utility vehicle to transport, and is more than likely to damage an ordinary car being loaded and unloaded.

The first thing to be sure of is the voltage and to be certain that the lamps are the same. Photographers who travel through countries regularly use equipment that will accept both 110/120 volt and 220/240 volt lamps, and carry a set of each. It is easy to mistake one for the other (surprisingly not all lamps are themselves marked with their voltage) and although using a high-voltage lamp on a lower voltage supply will just identify the mistake with a dull glow, making the opposite error will immediately destroy an expensive lamp. The answer is to mark each box or container clearly with the voltage.

If you are in doubt about the local voltage, it will be marked on almost any electric lamp in a room. The 10 per cent difference between 110 volts and 120 volts and between 220 volts and 240 volts is noticeable as a very slight difference in colour temperature, and for complete accuracy, an 82 (bluish) or 81 (amber) filter may be needed. However, also realize that peak domestic use of appliances in a city, especially in the morning and evening, may also cause a slight voltage drop. For most photography, this kind of difference is, however, not critical.

Safety systems vary from country to country. In the United States, the most common means of protection are breakers which trip to open the circuit when there is an overload; in Britain, the normal system is a fuse in each plug and another, of higher amperage, in the circuit. Breakers are easier to work with, as they only need to be switched back on; for fuses, spares are needed, and it helps to carry some with you on location. In either case, find out where the breaker/fuse box is located. In any unfamiliar location find out whatever you can about the circuits: how many there are, which sockets apply to which, and what the maximum loading is.

Cables and plugs

One method, if you travel extensively, is to carry a collection of different plugs. Another is to buy the plugs you need at a local store. Hot-wiring without adequate protection (squeezing bare wires from the light cable into the socket) is dangerous and should be avoided.

Extension cables are usually needed, but the longer they are, the more the voltage at the lamp head will drop. With tungsten lighting, voltage differences affect colour temperature, and a 10 per cent drop will cause a loss of colour temperature that would need an 82 or 82A colour balancing filter to correct. To be absolutely certain, use a colour temperature meter.

The most convenient type of cable is kept coiled on a drum, but be careful how you use it. If the cable is used while still partly wound on the drum, a substantial load will cause the cable to overheat by induction. In immediate use this heat reduces the cable's capacity, sometimes by as much as half; in the long-term, if the heating is enough to anneal the metal inside, its full capacity may be lost forever. Always open up all extension cables. When using one cable to supply more than one lamp, first check that the circuit will carry this load, and then that the cable will, also. The table *right* shows how to work this out. You can also make calculations according to the following equations:

$$amps = \frac{watts}{volts}$$

$$watts = amps \times volts$$

$$volts = \frac{watts}{amps}$$

Power requirements (amps)
Use the top of the table to find the amps drawn by the most common lamps. You can add together the lamps that you are using to find the maximum power that they will draw. Compare this with that of the circuit or circuits that are available. The lower half of the table shows total amperage for several aggregated wattages.

	110v	120v	220v	240v
275-watt photoflood	2.5	2.3	1.2	1.1
375-watt photoflood	3.4	3.1	1.7	1.6
500-watt photoflood	4.5	4.2	2.3	2.1
650-watt tungsten-halogen	5.9	5.4	3.0	2.7
700-watt tungsten-halogen	6.4	5.8	3.2	2.9
800-watt tungsten-halogen	7.3	6.7	3.6	3.3
1000-watt tungsten-halogen	9.1	8.3	4.5	4.2
2000 watts	18.2	16.7	9.1	8.3
3000 watts	27.3	25.0	13.6	12.5
3250 watts (5×650 watts)	29.5	27.1	14.8	13.5
4000 watts	36.4	33.3	18.2	16.7
5000 watts	45.5	41.7	22.7	20.8
10,000 watts	90.9	83.3	45.5	41.7

Service and accessory kit
Not all of these items are essential, but at some time or other they are useful in maintaining or adapting lighting equipment.

Sharp-nosed pliers

Duct tape, for basic repairs and for attaching lights

Drum cable extension, sockets both sides (UK fittings)

Soldering iron

Short extension cable

Swiss army multiple-tool penknife

Hot-wire connection box (safety design prevents live exposed wires) for attaching cables without plugs

Pliers with wire cutter and stripper

Set of jeweller's screwdrivers

Connector strip

Plastic hose strip

Spare fuses in used film canister

Bayonet-to-screw bulb adapter

Selection of plugs for different countries

Live-circuit tester (small lamp glows when live)

Connector

Toggle switch

Insulating tape for binding over exposed wire

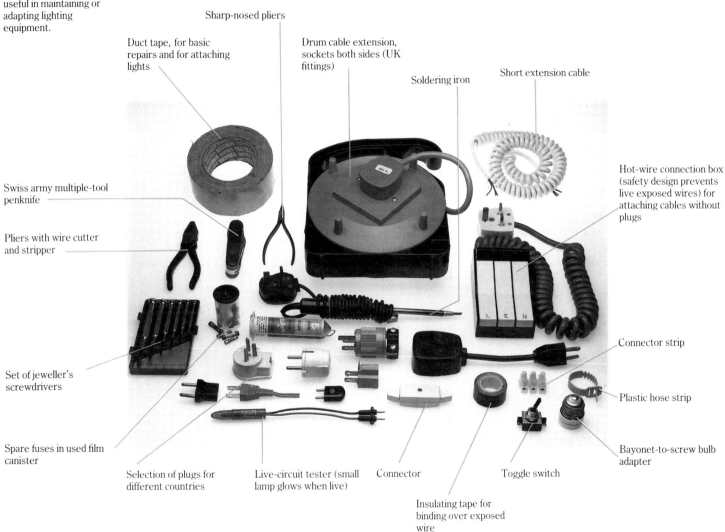

Battery Portable Tungsten

The power needs of even a 250-watt lamp are considerable, particularly if compared with a portable flash unit. Portable tungsten lighting, therefore, requires heavy batteries, and for most still photography has few advantages. However, in certain picture situations it is irreplaceable: if there is no possibility of using a cable to the location from a mains outlet, and if the shot is of a static outdoor scene at night, battery portable tungsten is likely to be more practical than portable flash.

Most night-time location shooting is not quite so clear-cut in the choices it offers. There is no doubt that it is worth almost every effort to find a mains outlet. Most single circuits will safely power 7 kw or 8 tungsten-halogen lamps of the type shown on page 113. The size of output bears little comparison with the 30-volt lamps of 150, 250, or 350 watts commonly available in portable units.

When mains cabling is impossible and a portable gasoline generator too noisy or difficult to transport (the smallest useful one, with a 3kw output, weighs about 19 lbs – 18.5 kg), a battery-portable tungsten unit allows shooting that would otherwise be impossible. The maximum output of a single pulse sets a limit to the distance over which a portable flash unit can be used. Tripping the flash several times will increase the output, but the recycling time limits even this, and the recharging delay increases as the batteries lose power. Time exposures with continuous lighting are, by comparison, uncomplicated. Battery-portable tungsten is, in any case, standard equipment for video and film work.

The relatively low output is a consistent problem, and makes ordinary diffusion impractical; a diffusing screen absorbs too much of the light. There is usually some facility for adjusting the spread of the beam, but the usual effect of a hot central spot and rapid fall-off towards the edges of the beam pattern is not a particularly attractive quality of light. However, in the circumstances under which you are most likely to need battery-portable tungsten, there are ways around this.

Provided that the subject is static, like a building, and that you can use a time exposure with the camera on a tripod, a basic technique is to have an assistant or helper stand out of view and play the beam over the subject in a pattern, covering a wider area than would be possible with a rigidly-positioned light. If the view covers a large area, walking around with a lamp (again, being careful to stay out of view and not to aim the light towards the camera and so cause flare), will also overcome the bright foreground/dark background problems associated with the light fall-off from a single light source close to the camera.

The best way of calculating exposure is to use an incident meter, although you will need to take into consideration any movements of the beam: if you play the beam over twice the area that it can cover, you should double the exposure indicated by the meter. As a reminder, also consider reciprocity failure. Most tungsten-balanced films are designed for shutter speeds faster than a second, and need filtration and extra exposure at slower settings to compensate for reciprocity failure. Some tungsten-balanced colour negative films, such as Kodak Vericolor Type L, are specially formulated for long exposures and need no correction as long as the shutter is open for between $\frac{1}{50}$ and 60 seconds.

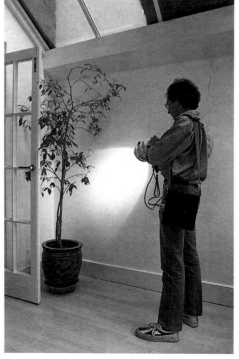

Beam control
On portable lights that have a beam control (by moving the position of the lamp), test the spread on a plain white wall. Narrowing the beam concentrates a higher level of light.

Battery-powered
portable tungsten lamps
like this draw
considerable power, and
need heavy battery packs
that need frequent
recharging.

Battery unit

Lamp with hand-grip

Cable to battery or
power pack

Mains power pack and
battery charger

Battery-charging
connector cable

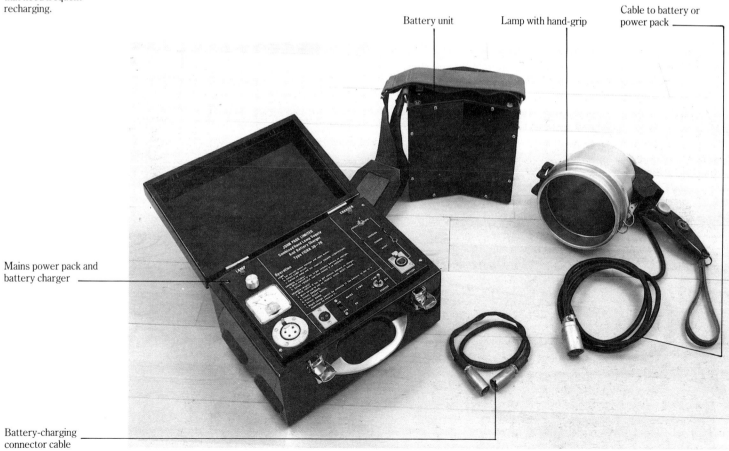

Fluorescent Light

Although not normally a first choice of studio lighting, fluorescent lamps can sometimes be very convenient. The problems are those already described on pages 78–83, although the principal one of colour balance can be overcome by using lamps specifically balanced for photography.

Even these may not be perfectly balanced to within 10 points on the Wratten series of colour compensating filters; a problem which is not uncommon with other kinds of studio lighting, however. The first step with whatever model of fluorescent lamps you have chosen is to make a colour test. In particular, make the tests at the apertures and shutter speeds that you will normally be using. The reason for this is that, as the intensity of fluorescent lamps is considerably weaker than that of photographic tungsten lamps, exposures may involve some degree of reciprocity failure. This is most likely in still-life shooting but it calls for good depth of field and, therefore, small apertures.

Colour correction is less necessary if you are using fluorescent lighting as a background, as shown in the example *right*. In this case, the exposure is normally set to reproduce the back-light as white, and this will usually drown any small colour difference (it will, however, be obvious in the thicker parts of a transparent or translucent object that is being backlit, such as the edges of a glass). Colour testing is best performed with the light aimed from the side, top or front.

As already mentioned, fluorescent light is a pulsating source and fluctuates in intensity; it is usually best to use a slow shutter speed, below ¹⁄₃₀ second. In nearly all studio photography, this is in any case necessary for good depth of field. If you are using a large bank of fluorescent lamps, this potential problem, although small, can be overcome to an extent by wiring the lamps successively on different phases of a three-phase supply, thereby ensuring that two out of three lamps will always be emitting at full output.

These disadvantages apart, fluorescent lighting can be very useful for some kinds of studio work. It is a cool form of ambient lighting and so is not only more comfortable to use in close-up, but will not affect heat-sensitive subjects to the same degree as would tungsten lighting. Also, fluorescent lamps make it easy to produce an even spread of light. The projects here are designed for use with fluorescent light boxes, as most photographers using colour transparency film will probably own one, and these have the advantage of giving an extremely even area of illumination. Producing consistent diffusion from corner to corner and edge to edge in an area light is important for all kinds of still-life photography, and is difficult with a single tungsten lamp or coiled flash tube. Linear lamps, however, need only a trough reflector behind them to produce an even spread. For this reason, a light box makes an excellent back-light, with virtually no darkening towards the edges.

Outside the studio, fluorescent lamps are useful as fill lighting in fluorescent-lit interiors. When diffused, as in a light box, they are particularly useful for alleviating shadows in a portrait if positioned just below the camera.

Project: Base lighting

If you already have a light box, use it as shown here for a basic still-life shot. As recommended above, test for colour first. The evenness of the illuminated area makes it particularly useful for still-life subjects with reflected surfaces, such as glass and polished metal, and the bright reflection will be clean and rectangular.

As a base light, this is probably the most convenient of all types of lighting. Whereas ordinarily the light output is too low to mix conveniently with flash, used like this, the combination is generally successful. For the exposure readings and ways of balancing the output from the sources, see the recommendations on pages 78–83.

Back lighting
The even spread of illumination from an ordinary light box makes it ideal for backlit arrangements of objects. A well-designed make should have no hot-spots. Some filtration may be needed in colour photography to balance the light box with other light sources.

Still-life lighting
As an alternative to normal photographic lighting, two light boxes intended for viewing transparencies are suspended from ceiling tracks. Again, the valuable quality that they offer is a completely even rectangle of light – particularly useful with certain reflective subjects, such as glassware or polished metal.

Comparing light levels: Fluorescent versus tungsten

	800-watt Tungsten	800-watt Tungsten +acrylic diffuser	Single fluorescent tube	Fluorescent light box: two tubes
Exposure at 3 feet (1m) ISO 100	EV9.5	EV8.5	EV7.5	EV8
Relative intensity, *f*-stops	Reference	−1 stop	−2 stops	−1½ stops

Diffusion

The practice of diffusing a light is so well understood as to need hardly any explanation, but it is a good idea to understand the principle of why it works. Light is diffused by shining it through some translucent material; the important effect of this is to increase the area of the light source. Think of the naked lamp, whether flash or tungsten, as the raw source of light, small and intense. Unless there is a lens and a beam focusing mechanism, the pattern of light will be intense in the middle, falling off rapidly towards the edges. The beam may also be uneven in shape, depending on the construction of the lamp and built-in reflector. Check this for yourself by aiming the light directly at a white wall from fairly close, then stand well back and look at the spread of the beam.

Placing a sheet of translucent material in front of the lamp makes this sheet – the diffuser – the source of light for all practical purposes. Try this for yourself with a lamp on a stand, aimed horizontally. From in front, the light is intense and small; this is why the shadows that it casts are deep and hard-edged. Now take a rectangle of translucent acrylic of the type similar to that used for light boxes. Hold it in front of the lamp; if it is very close, or very large, you will see a bright center grading outwards to darker edges: exactly the same as when the lamp was aimed at a white wall. Move the sheet away from the lamp and towards you until it looks to be fairly evenly illuminated. This is efficient diffusion, and the source of light is now the acrylic sheet.

The area of the light is larger, and so the shadows it casts have soft edges and are less intense overall, as the photographs and diagrams on these pages show. One side-effect is that the intensity of the light is reduced, and this is more or less in proportion to the degree of diffusion. The greater the thickness of the diffusing material, the more light it absorbs, and if the diffusion is increased by moving the light further away, natural fall-off will reduce the intensity.

There are three factors involved in the degree of diffusion; three ways in which you can increase it or decrease it. The first is the thickness of the diffusing material (two separated sheets have the same effect as one single, thicker sheet). For any given distance between the light and the diffuser, the optimum thickness of the diffuser

Shadows and contrast
Diffusing a light source weakens the shadows, while at the same time reducing highlights. On subjects with strong relief and pronounced detailing, this gives a clearer image and a better sense of form.

Umbrella
Perhaps the most commonly used diffuser in photography is a translucent umbrella, being easy and quick to put up and fold away. Nearly all studio lights have a tube or groove to accept the pole.

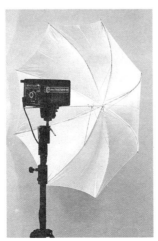

Beam test
Before diffusing the light, first check the pattern of illumination by aiming it onto a white wall. Look for the shape, the fall-off at the edges, and any hot-spots. This pattern will be duplicated on a diffusing surface.

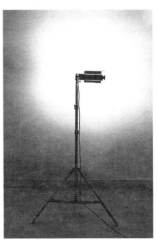

Screens
Almost any translucent material can be made into a diffusing screen, which can then be suspended or propped in position. Here, ¼ inch opalescent acrylic gives a strong diffusing effect.

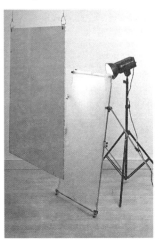

occurs when it absorbs any fall-off from the center of the beam. In other words, the diffuser needs to be sufficiently thick to give the effect of a thoroughly even coverage, from corner to corner. If it is thinner, the light will appear brighter in the center and darker towards the corners – the area of the light will be, as a result, a little smaller. However, if the diffusing sheet already projects an even light, increasing its thickness will only lower the intensity, not create any more diffusion.

The second factor is the distance between the light and the diffuser. The greater this is, the wider the spread of the beam, and the less noticeable the fall-off from center to edge. This, therefore, also increases the area of the diffused light, although again, as long as the illumination is

even across the sheet, moving it further from the light does nothing to help.

If we now turn from the light source to the subject, the amount of diffusion in the light it receives depends on the third factor, size. The larger the area of light appears from the position of the subject, the more its diffusing effect. Imagine yourself as the subject underneath a typical area light. If the rectangular area light is small or far away, it occupies only a small part of the "sky", and the shadows it casts will be fairly hard-edged and deep. If it is replaced with a larger rectangle, or is brought closer, it fills more of your view. The light reaches you from a greater angle, and this weakens the shadows and softens their edges.

The important measurement is the relative apparent size, a combination of the size

of subject, size of area light, and the distance between them. One way of combining these elements in one measurement is to take the angle of view from the subject to the light, making allowance for the size of the subject. As a general guide, as long as the light appears the same size as the subject or larger, it is diffuse.

The extreme of diffusion occurs when the light surrounds the object from all visible sides (the qualification of "visible" is important; light from opposite the camera contributes nothing). To achieve this, the diffusing sheet must be shaped to wrap around the subject. We return to this special case of enveloping light on pages 162–3, but for now compare this studio version with the natural diffusion from a completely overcast sky (see pages 46–51).

The essential difference between naked and diffused light is in the treatment of the shadows. 1 The shadow edge from an undiffused lamp is hard because the source is small. 2 If a diffuser is placed in front of the light, some light from the larger source weakens this shadow edge. 3 As the closer view shows, only a small central circle behind the spherical subject is completely hidden from the diffused light.

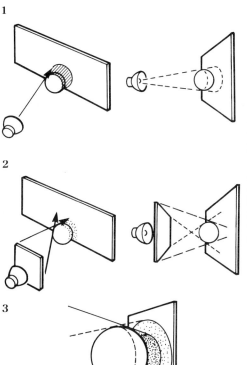

▶ **Variations on diffusion**
Using **1** as the reference, the amount of diffusion can be changed in four ways. Using a thicker diffusing material (**2**) gives a more even area of light, up to a point. Moving the light further away (**3**) also makes the diffused area more even, because the beam is spread. A larger sheet of diffusing material (**4**) increases the area of the light source, while moving it closer to the subject (**5**) makes it *relatively* larger.

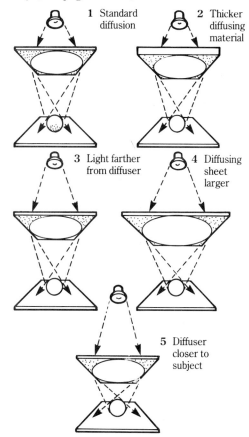

1 Standard diffusion
2 Thicker diffusing material
3 Light farther from diffuser
4 Diffusing sheet larger
5 Diffuser closer to subject

Diffusing materials have other qualities which are not always noticeable but affect the construction. One is texture, apparent in fabrics, netting and the corrugated plastic shown on page 127. To some extent, this texture actually helps the diffusing effect by scrambling the light that passes through, making the diffuser more efficient. However, if any part of the subject or setting is highly reflective – a polished surface, perhaps, smooth metal or a liquid – there is always a possibility that the diffused light will appear as a reflection; if so, any texture in the diffusing screen will be visible, and this may spoil the image.

Another quality is the shape of the diffuser; this also becomes important when its reflection can be seen, but even with non-reflective subjects, it may matter if you use the diffused light to cover only a part of the scene. The fall-off from a diffused light is soft and gradual, but if you need it to occur precisely, following a line, then the diffuser must have an appropriate shape. The simplest and least obtrusive shapes are rectangular, and are the staple lighting for still-life photography. Portraiture rarely needs this kind of precision and umbrellas are more usual.

Allied closely to the shape of the diffuser is control over the amount of spill from the sides. The space between the diffuser and the lamp allows direct light to escape, and this will reflect off any bright surroundings, including the walls and ceiling of the room and equipment used close to the set. Often this may not matter, but there is a danger in forgetting that occasionally it might.

One basic method of limiting the spill is to shade the lamp with barn doors or flags (see pages 154–5), angled so as to limit the beam of light as much as possible to the diffuser. A more efficient method is to seal the gaps entirely, effectively enclosing the light. This design of light fitting is known as an area light or window light, and is very popular for still-life photography. There are several possible designs, all box-like. Ideally, the interior of the fitting helps to control the beam so that the front translucent panel is evenly lit: most such fittings are shaped to act as reflectors and have reflective surfaces either in bright metal or white.

Enclosing a light like this is only safe if the heat output is low, and this is a good time to consider the relative merits of flash and tungsten for diffusion. Tungsten lamps, particularly the highly efficient tungsten-halogen variety, generate a great deal of heat, and the majority of diffusing materials, if not actually inflammable, can warp and discolour if placed close. Fittings that enclose create a build-up of heat, and cannot safely be used with tungsten lamps unless they have a built-in electric fan or ventilation. For choice of diffusion, flash has major advantages over tungsten.

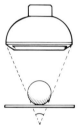

1 Large area light gives good diffusion, measured by angle of view from subject.

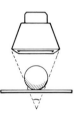

2 Small area light from closer gives same angle of view, and same diffusion.

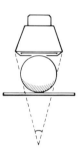

3 Same light with larger subject has less diffusing effect. The angle of view must include the edges of the subject.

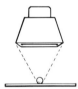

4 Same light with smaller subject has a greater diffusing effect.

Area light
This is probably the most popular kind of diffusing fitting for still-life work, but can only safely be used with flash because the fitting encloses the lamp, making it dangerous with tungsten. Area lights are made in aluminium, and in fabric for collapsible versions.

Slatted lights and honeycomb
Tungsten lamps can be softened to a degree with metal slats, as in the larger light shown here, or a honeycomb grille, as in the smaller.

Diffusing materials

Tough white diffusion: Heat resistant, but similar properites to tracing paper

Tough rolux: Dense diffuser which gives soft almost shadowless light, useful for adding several lights into a single large area source

Roscoscrim: Perforated material for reducing transmission by 25 per cent through windows

Opal tough frost: Like light tough frost but less dense

Light tough frost: Like tough frost but less dense

Tough frost: Medium diffuser, spreading the beam but keeping the center

Quarter tough spun: Like light tough spun but less dense

Light tough spun: Like tough spun but less dense

Tough spun: Slight diffusion, softening edge but maintaining shape of beam

Corrugated diffusing plastic sheet

Light tough rolux: Like tough rolux but less dense

Tough silk: Slight diffusion, maintaining directional qualities of light

Grid cloth: Reinforced material that can be sewn

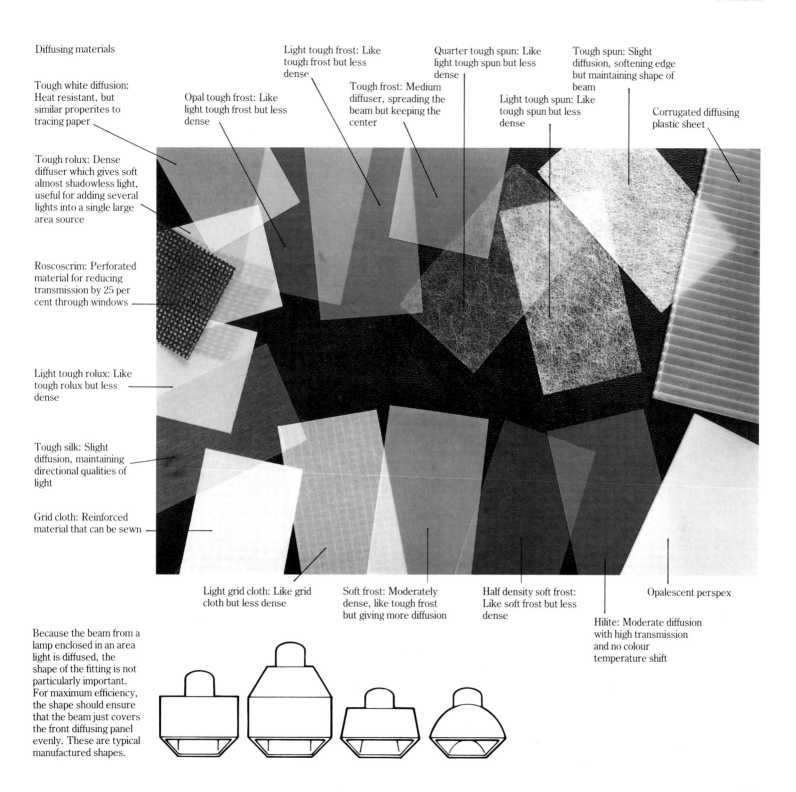

Light grid cloth: Like grid cloth but less dense

Soft frost: Moderately dense, like tough frost but giving more diffusion

Half density soft frost: Like soft frost but less dense

Opalescent perspex

Hilite: Moderate diffusion with high transmission and no colour temperature shift

Because the beam from a lamp enclosed in an area light is diffused, the shape of the fitting is not particularly important. For maximum efficiency, the shape should ensure that the beam just covers the front diffusing panel evenly. These are typical manufactured shapes.

Testing for neutral colour

Although it is normally safe to assume that the basic light source, if purpose-built for photography, is colour-balanced, there is usually no guarantee that the diffusing material will not add a cast. In practice, most of the materials are neutral: if a material looks white to the eye, it will probably transmit the light without altering any of the wavelengths. Nevertheless, you should test the materials that you finally choose. Use colour transparency film to be able to judge the results accurately.

This is not as wide-ranging a colour test as the kind you would do for a new film; if the diffusing screen makes any difference at all, it will be very small, within CC10 on the colour compensating filter scale, and likely to affect all colours in the subject. To check for very fine differences, use a neutral grey card, something familiar (like your hand), and the shadow of the neutral object on a white surface. Between them, these three should show up any differences. Take one shot with no diffusion, and then however many others are necessary to test the different screens that you have.

Projects: Diffused light and subject

Measure the light loss at normal working distances from fitting a variety of diffusing screens. Use a hand-held incident meter, making one reading of the naked light and others of the different screens. Before you decide which screens to use, and before constructing any special fittings, like area lights, make sure that the output is sufficient for the kind of photography, film and lens apertures that you will normally use.

Vary the relative sizes of diffusers and subjects to see the difference in effect on the shadows and contrast.

This kind of arrangement is suitable for making colour tests; a Kodak colour separation guide and grey scale, your hand, a neutrally coloured object to cast a shadow, and a black-and-white print.

Extreme diffusion
Following the principles outlined on the previous pages, the lighting for this arrangement of spices was made as diffuse, and so shadowless, as possible by using a large diffuser from a short distance. Additional shadow fill was provided by side reflectors.

Moderate diffusion
Using the opposite
techniques to those on
the facing page, the
lighting for this still-life of
Leonard da Vinci's
surgical sketches
involved a diffuser
smaller than the subject
at a distance. The result
is the soft shadow edges
typical of diffused
lighting, but with fairly
strong contrast.

Reflection

Bouncing light off a bright surface is mainly an alternative to diffusion. Its effects are very similar, both in principle (it increases the area of the light) and in the way it softens shadows and lowers contrast. Although it is difficult to control bounced light as precisely as diffusion can be controlled, and so is not as useful for still-life shooting, reflective lighting can be very easy and convenient. Suitable surfaces are commonly available, and photographic lamps can often be used naked, without any fittings at all.

Go back to page 124 and the test for a beam pattern of a lamp. This is the basic arrangement for lighting by reflection: the light aimed directly away from the subject towards a white surface. You can see the potential problems for controlling the light just by looking at the set-up. The silhouette of the lamp and stand appears in view, the beam is not even and does not have precise limits, and changing the direction of the lighting would involve moving both the light and the reflecting surface separately (which is not possible with a wall).

What reflection can do particularly well is to produce extremely diffuse lighting; so soft as to be almost shadowless. The value of this is when you simply want to increase the level in order to use a smaller aperture or shutter speed, without the appearance of introducing another light. If this at first seems contradictory, try the following project for yourself.

Project: Using reflected light
Take a room that is quite brightly decorated (white walls and ceiling are best), and set up the camera for an overall shot by the existing artificial lights. Measure the light level, which will probably be less than ideal, needing a long exposure for good depth of field. Take one photograph. Then place a photographic tungsten lamp on a stand just behind the camera, aimed upwards and backwards as shown in the diagram. Keep the lamp just above head level, but not much higher: the greater the distance from

the lamp to the ceiling and walls, the more the beam will spread and the more diffuse the lighting effect. The result, compared with the first photograph, will be a significantly higher level (needing a shorter exposure) but it should not be particularly obvious that you have added another light. There will be no definite shadows to identify the new lamp.

Materials
Although this kind of makeshift lighting is useful in a wide range of situations, particularly on location, reflection can also be used

Basic reflection technique for a normal room is to place the light on a stand, high enough so that its beam does not strike the subject or camera directly, and aimed upwards. A corner may often give more effective reflection than a plain area of ceiling.

more locally, with sheets of different materials cut to size. There is a greater choice than for diffusing materials; a reflecting surface is, after all, opaque, so that almost any moderately flat or convex surface will do, as long as it can be finished in white or silver. Usually, reflecting surfaces are chosen for convenience of handling and positioning. Umbrellas are the most common purpose-built reflector, but card, board, polystyrene and fabric are all used extensively in studios. Most of those illustrated here can be made quite easily and inexpensively. As with diffusers, you should assem-

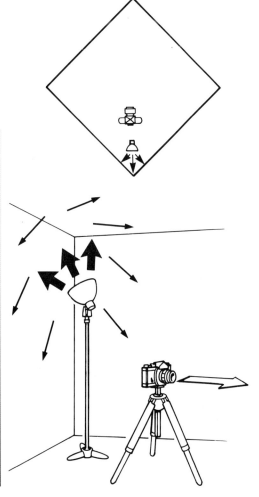

ble a variety of different reflectors before starting on the last section of the book (pages 156 following).

The diffusing effect of reflected lighting – that is, its ability to soften shadows and lower contrast – depends on a number of things. These are similar to the factors that control diffusion, and include the distance from the light to the reflector, the apparent size of the reflector from the point of view of the subject, and the surface qualities of the reflector. The *shape* of the reflecting surface – something that does not usually matter with diffusers – is also important.

The structural arrangement often means that the light unit is the closest thing to the subject. This sets a limit to how close the light can be positioned, to avoid not only the lamp appearing in view, but also the support and cable and reflector.

Another important precaution is to control the light spill, both from affecting other parts of the scene and background, and from causing lens flare. If the lighting direction is more or less frontal, and the lamp and reflector in front of the camera, at least some of the light is likely to shine directly into the lens. Use the lens and light-

shading techniques described on pages 154–5. Enclosing the lamp and reflector at the sides, as with the area diffusers on the preceding pages, is not possible.

So, while the easiest way of increasing the effect of a diffuser is to bring it closer (so making it appear larger), with reflected light the best option is to use a larger reflecting surface from further away. This is, fortunately, much easier to do with reflectors than with diffusers – finding extra white surfaces is usually no problem, and several can be taped or clamped together to increase the area.

Umbrellas
The sheer convenience of umbrellas makes them the standard means of broadening the area of light from photographic lamps, and they are used extensively in portraiture. The interior linings vary, from white cloth to a silver foil finish, and this affects the softness of the illumination.

Silver lining

White lining

					Crumpled dull	Crumpled shiny	Smooth dull	Smooth shiny
Mylar/mirror								
Aluminium foil								
Fabric			White			Metallic		
White card/paper								
Painted hardboard	Matt white	Semi-matt	Gloss	High gloss				
Polystyrene								

Maximum diffusion
Most light loss ←————————————→ Miniumum diffusion
Least light loss

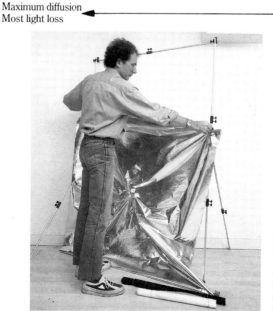

The collapsible frame shown on pages 65 and 117 can be assembled as a reflector, using different materials. Here, a silvered fabric is fitted for maximum reflection.

131

The type of reflecting surface is worth close study. These four things control the effect: the texture of the surface, its shininess, its colour, and its shape. The greatest diffusing effect is from a roughened, dull-white surface, the least (actually, none at all) from a mirror. This is the full range, but within it individual materials can be treated to have a smaller range of diffusion. For instance, aluminium cooking foil has a dull side and a shiny side, and the diffusing effect of each can be increased by crumpling to different degrees. Note that the maximum diffusion really is white; a grey surface, for instance, is less bright, but gives no more diffuse a reflection.

The least-diffuse end of the scale is occupied by mirrors and bright metallic surfaces. Lighting by this kind of reflection does nothing to soften shadows; it has the different function of redirecting the light. With careful positioning, this can make free use of one lamp to create additional sources of light. Provided that there are no obstructions, these reflected surfaces can then be diffused if wanted. Shape also affects the degree of diffusion. The maximum diffusing effect is from a flat surface, which reflects the light evenly. However, a concave shape will reduce the diffusing effect by concentrating the light – which is the subject of pages 134–5.

The final use of reflectors is to fill in the shadows opposite the main light. We deal with this separately on pages 150–3.

Projects: Measuring bounced light

Using a white wall and ceiling, or some other large reflecting surface, measure the difference in light levels when the light is placed at different distances from the surface. Make the measurements with a hand-held incident meter from the same subject position, so that the total distance travelled by the light remains the same.

Compare the effects of bouncing light from different directions in a small room. Place the light in positions similar to those illustrated here.

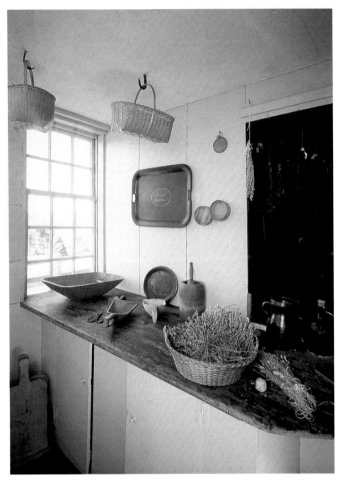

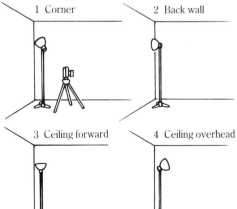

Lighting balance by reflection
One of the best uses of bounce lighting techniques is the least noticeable – boosting the overall level in an interior when daylight is visible through a window. Here, a single 1000-watt halogen lamp, filtered with a full blue gel (see page 115) was sited behind the camera, pointing up and back to give a shadowless increase in lighting.

1 Corner 2 Back wall

3 Ceiling forward 4 Ceiling overhead

5 Side wall

There are several variations possible on basic bounce lighting techniques. Experiment with the ones illustrated here.

Matt white foam material that produces extremely soft reflection with no colour temperature shift.

Polystyrene block, available in large lightweight sheets, suitable for free-standing reflectors

Tracing paper, if used as reflector, gives very soft effect and weakens too-strong light

Perforated scrim material, silvered. Double use as reflector or diffuser

Matt-white textured reflector for soft effect

White plastic sheet

Crumpled aluminium cooking foil (bright side up)

White art board

Aluminium cooking foil (bright side)

Aluminium cooking foil (matt side)

Grid cloth

Small mirror. Virtually 100 per cent reflection

Mylar, a specular flexible mirror surface available in sheets. Used as a relay mirror to reflect sun or lamp into second reflector

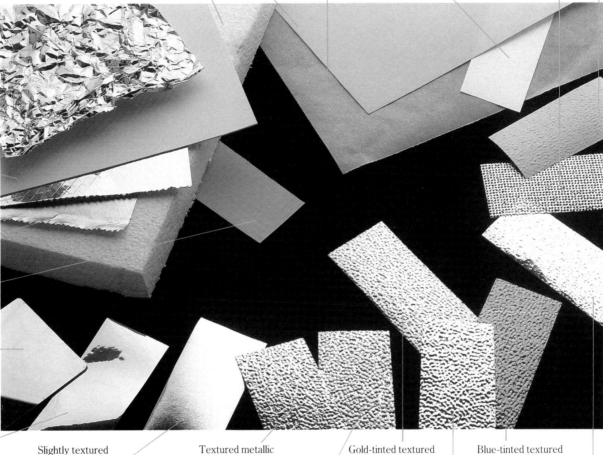

Slightly textured mirrored surface. Directional but not specular

Textured metallic surface, flexible, moderately directional. White on reverse

Gold-tinted textured metallic reflector

Blue-tinted textured metallic reflector converts 3200 K light ot 5000 K daylight. Mired shift −131

Softer, broader version of reflector *left*

Textured metallic reflector with pale blue tint, to raise colour temperature very slightly, by a mired shift of approximately −10

Almost weightless reflector material, with textured metallic finish. Can be crumpled, and curved around almost any shape

Concentration

Although diffusion increases the area of a light source, concentration is not its complete opposite. A diffuser certainly spreads the illumination, but then so can a naked lamp if unshielded and used without a reflector fitting behind. Concentration is concerned with the area of light that falls on the subject – its size, shape and the sharpness of its edges. Light from a diffuser can, to an extent, be concentrated on a small area, although it is easier to work with the beam from a small light source because it is more manageable. Light can be concentrated at various points in the beam: by shaping the reflector behind the lamp, by using a focusing lens, by flagging the light at the sides, and by masking it close to the subject (including placing a black card with an aperture cut into it in front of the light).

The most efficient method by far is to use a lens, and this is how focusing spots and luminaires work. This makes it possible to produce a sharp-edged circle of light on the subject; its size can be varied. If a card cut to shape is placed at the focal point of the lens, the circle can be altered to an aperture of any other shape. Although focusing spot fittings are available for flash units, they are mechanically simpler for tungsten lighting, as the focus can be judged by sight (the modelling lamp in a flash unit is usually in a slightly different position and has a different shape from the flash tube, and focusing the modelling lamp will not always have exactly the same effect on the flash.

This is extreme concentration, and not needed very often in most studio photography (although it is very useful for rim-lighting effects, such as highlighting hair in a beauty or portrait shot). The basic kind of light concentration is created by shaping the reflector of the lighting unit itself. This, as we have already seen on pages 114 and 128, has a different kind of focusing effect. Except in those lamps (usually tungsten) that contain a control for moving the relative positions of the lamp and reflector to alter the beam, all the standard reflector fittings are designed to give what is considered to be a normal beam: in the region of 60° to 90°. This is really quite concentrated, but additional reflector fittings are available which narrow the beam still further. The most efficient reflector design is parabolic.

Apart from using reflection to concentrate the beam, other methods work subtractively – that is, by cutting off the light at the edges, leaving just the central part – with the result that the beam loses some intensity. Fittings on the light include a snoot, or cone, and various types of mask such as flags and barn doors (see pages 154–5). Any other masks, such as black card, can be used closer to the subject; the closer they are, the better defined are the edges of the illumination. Finally, if you cut a hole in a large sheet of black paper or card and suspend it in the light path just out of view, you can create an effect similar to a focusing spot, although not as precise.

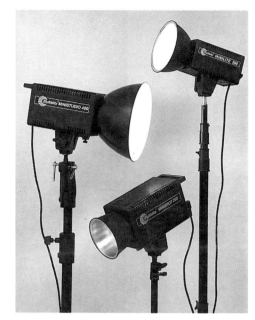

▲ Mild concentration
Standard dish reflectors give beam angles of between 60° and 90°: hardly spots, but considerably more restricted than no fitting at all.

Strong concentration
Snoots and lenses give the tighter beams. The two upper units here are snoots – tapering, cone-shaped fittings – while the lower spot has adjustable condensers to focus the light.

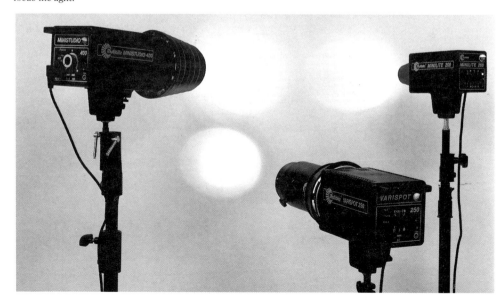

For the most effective spot-lighting effect, concentrated lights like those on page 134 generally need to be positioned at some distance from the subject. Here, to isolate the desk and typewriter from the surroundings, a 400-joule flash fitted with a snoot was suspended from a boom arm close to the ceiling.

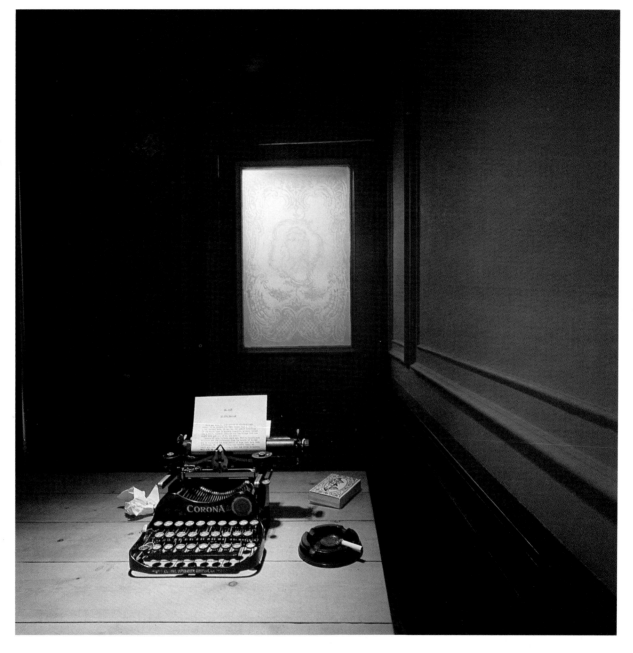

Close-up Lighting

All the regular studio lighting equipment we have looked at is designed for a certain scale of subjects and settings: the usual range of studio photography. Approximately, this generally ranges from a picture area the size of a small group of people, down to a still-life setting about the size of this book. For larger subjects, such as room interiors, the most common technique is to use more lamps, drawing more power, and to bounce the lighting off walls and other available surfaces for a broader effect.

On a smaller scale than a typical still-life, however, there are two serious problems with a standard studio light and its variety of fittings. One is the difficulty of getting it into a suitable position when the working distance between the camera and subject is a matter of inches rather than feet. The other is that the quality of lighting is often too diffuse; an umbrella that simply softens the shadows in a portrait will give flat, directionless lighting in close-up.

In working out the amount of diffusion, the size of the light relative to the size of the subject is a major factor. While adequate diffusion is something of a preoccupation with a normal scale of subjects, the opposite is often the case in close-up photography. This is partly because ordinary lighting does not provide the choice of small direct beams of light, and so limits the range of effects. Another factor is that you may often want to give the impression of a larger size to a small subject, and miniature lighting is one way of doing this.

For close-up photography and photomacrography, you will need to assemble a range of miniature lighting equipment. The layouts here show some of the possible choices. As tungsten lighting, there is a good selection of small lamps in the form of miniature torches. Their output is limited, but this is overcome easily enough by increasing the time of the exposure. The advantage of miniature torches over electronic flash units is that the latter, even if relatively small, contain capacitors and circuitry that make them a little bulky for close positioning and use.

Another method of miniaturizing the light

Miniature lighting sources and adapters

Transformer converts AC mains supply to the 12 volt DC supply needed for miniature lamps

"Grain of wheat" miniature bulb

Flexible bundle of fiber optics functions as a light guide (see page 175 for an example of use)

Miniature bulb from electrical control panel

Small half-silvered spot lamp

Arm with claw grip and mirror

Miniature bulb in thin aluminium tube

Varieties of penlight

Condenser lens of simple magnifying glass can be used to focus light

Screw clamp

Set of dental mirrors with adjustable heads, for redirecting light

Shiny black plastic

Glass mirror

Metal mirror

Beaten aluminium

is to use small reflectors, such as dental mirrors. Even a large lamp can then be used as the source; by the time it has been reflected onto the subject, it has been reduced, apparently, in scale. A third method is to channel the light, and the normal way of doing this is to use fiber optics. These are so constructed that they allow very little loss of light along their length (the conducting material is highly refractive).

In addition to making the lighting seem smaller, another principal requirement in miniature equipment is to position things accurately and flexibly, with a minimum of bulk. Thin, jointed rods of various kinds and miniature clamps are essential components.

Miniature supports

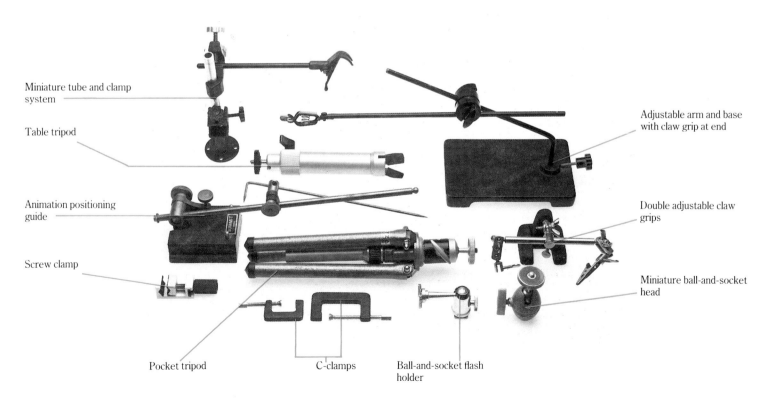

Miniature tube and clamp system

Table tripod

Animation positioning guide

Screw clamp

Pocket tripod

C-clamps

Ball-and-socket flash holder

Adjustable arm and base with claw grip at end

Double adjustable claw grips

Miniature ball-and-socket head

Supplementing Daylight

The division that we have made between found lighting and photographic lighting blurs under certain picture-taking conditions. The principal condition is when the found lighting dominates, but extra lighting is introduced to help it either technically or aesthetically. In this case, the additional photographic lighting is intended to be completely unobtrusive. Here, we look at one of the most common situations: indoor photography by (principally) natural light.

There are really three circumstances under which you would need to supplement existing daylight: two technical and one concerned with the quality of lighting. The technical circumstances are when the light level is insufficient for the camera and lens

settings that are needed, and when the contrast is too high. The third circumstance is to add the appearance of direct sunlight.

Increasing the level
In most interiors, daylight enters from only one or two windows, conventionally situated in one wall. Unless fast film is being used (and the extra graininess is usually sufficient reason for wanting to avoid this), the level of illumination inside is likely to be lower than ideal. How important this shortfall in illumination is depends very much on the subject: a portrait will need enough light for a shutter speed that guarantees no blur, even at maximum aperture, while the depth of field needed in a still-life or interior view

will require either adequate light at a reasonable shutter speed or a long exposure with its associated problem of reciprocity failure.

Whether it is essential or just convenient, supplementing daylight in these conditions involves placing lights outside the window, aimed into the room. How many lights depends on what is available and the increase in level that you need. In theory, either flash or tungsten lights can be used, but practically you are likely to find that, in order to make a substantial difference in a typical interior, most flash units have too little output. Generally, tungsten lights are easier to manage, and their effect is visible, as well as being easy to measure in one

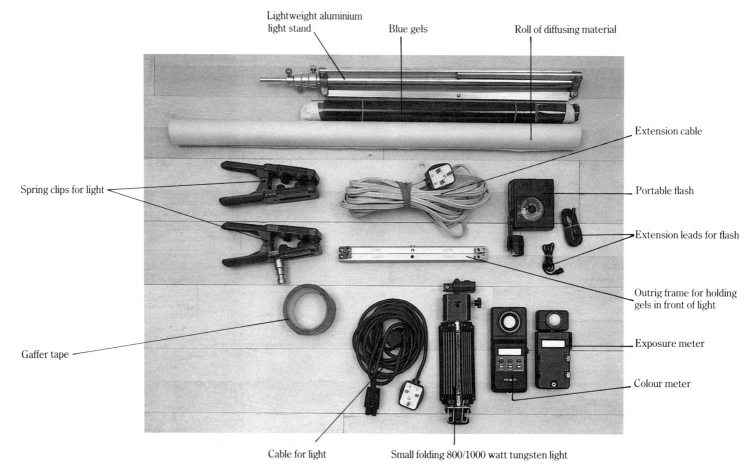

Lightweight aluminium light stand

Blue gels

Roll of diffusing material

Extension cable

Spring clips for light

Portable flash

Extension leads for flash

Outrig frame for holding gels in front of light

Gaffer tape

Exposure meter

Colour meter

Cable for light

Small folding 800/1000 watt tungsten light

ambient-light reading. Matching the colour temperature of daylight is no more complicated than fitting an 80B-equivalent blue gel in front of the lamp.

The lights will almost certainly have to be diffused, unless you are trying to mimic sunlight (see below). One method is to diffuse them with one of the conventional fittings shown on pages 124–9. Another is to cover the outside of the window with diffusing material such as tracing paper or white cloth. This is, in any case, a valuable technique for treating the window if it will appear in the shot.

Adjusting contrast

In most interiors, the lighting is characteristically from one horizontal direction with little opposite reflection, as described on pages 66–9. Views at right angles to the light source, or towards the window, may need shadow fill just to match the contrast range of the film. Danger areas are directly across the room from the window and, even in a well-lit room, a high ceiling. The most convenient technique is simply to bounce a direct light off the opposing wall, making sure that it and the cables are out of the shot. For a smaller subject, such as a person, bouncing the light off a large white card or sheet of paper is a stronger alternative. Beware of over-filling shadows; what you gain technically in legibility, you can lose in atmosphere.

Project: Adding sunlight

This is straightforward with small subjects and small rooms. Simply use a single direct light with no surrounding reflector head (to give a sharp edge to shadows). For authenticity, match the colour temperature to the angle of the light. In other words, if the light is high and shining down, it should be white or slightly yellow; but if it is more horizontal, which is more likely if you are using a regular lighting stand, make it more orange to look like a low sun. An unfiltered tungsten lamp with daylight balanced film can often look just right in this position.

Contrast balance
The bright patch of sunlight falling on the cutting table is the most important element in this shot, yet the resulting contrast was impossibly high for transparency film. To balance this without losing the basic effect, two 1000-watt lamps were bounced off the back wall.

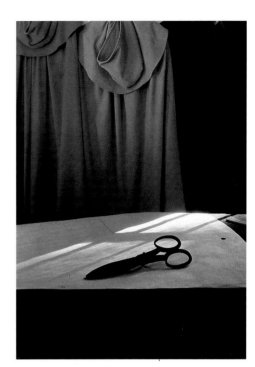

Imitation sunlight
A single powerful lamp can give a reasonable imitation of direct sunlight. Use it naked and from a fairly high angle (unless you are trying to imitate sunrise or sunset). The effect works best in a small room; in large interiors the light fall-off will look unnatural.

Using Portable Flash

Now that we have looked at the range of studio lighting equipment, and in particular at all the ways of modifying the quality of light, we return to portable flash. The opportunities available with mains flash underline the poverty of sharp, direct light from a small camera-mounted unit. The small size of the flash-head produces intense highlight reflections from shiny surfaces and hard-edged shadows. The potentially high contrast is held down by the frontal, almost axial, position of the flash; this throws more of the shadows away from the camera, but is a poor direction for modelling and boring to see repeated time after time.

The on-camera position is at least ex-tremely convenient. It helps, therefore, to know what subjects and settings do well under this kind of hard, frontal lighting. Referring back to pages 32–3, the similari-ties with frontal sunlight are obvious. You should, however, become familiar with the two or three standard techniques for alter-ing the quality of portable flash lighting. One is to remove the unit from the camera and aim it from a different direction. This is particularly simple with dedicated flash, because the automatic exposure is set independently of the position of the light; but it does require a specific multi-core cable, as shown.

When using a unit off-camera, remember that the shadows will be larger and the contrast very high unless you use a reflec-tor or a second flash unit opposite. Off-camera flash is easiest with the help of someone else to hold the flash unit.

The second technique for modifying the light is to bounce it off a nearby reflecting surface. One of the most available is the ceiling of a room, and most flash units are designed to tilt upwards and to make use of this. Portable flash does not allow you a preview of the lighting effect, so it is important to practise bounce-lighting so that you can be confident of the results when you need to use it. The light intensity is reduced drastically, and a normal problem is that it is reduced too much and there is not enough light for the photograph. In such

Direct flash
The great value of portable flash is that it makes it possible to take at least some kind of photograph in situations where there is insufficient light. Direct, on-camera flash photographs usually work best when the subject has strong tones or colours, as in this picture of an Indian Kathakali dancer.

a case, consider using a slower shutter speed so as to add the existing room lighting. As the photograph *opposite* demonstrates, this also produces a more natural image. There are not many ways of calculating the intensity of the bounced light as it reaches the subject beyond using a flash meter. One thing that you can do with a dedicated flash unit, however, is to fire the flash a few times, adjusting the aperture until you find the setting at which there is just enough light. In the case of the unit shown on page 108, this is the point just before the red light flashes its warning. At this setting the output is full, and just sufficient. In any uncertain situation, bracket exposures.

Many portable flash units have some means of swivelling the head so that it can be directed upwards for bounced lighting. The photograph *below* was taken with the configuration shown here.

Bounced flash
The simplest alternative to direct on-camera flash is to bounce the light off a nearby light-toned surface, such as the ceiling of a room. In this example bounced flash provides most of the illumination, but an exposure of ¹⁄₁₅ second allowed some of the ambient lighting to register.

Another method of using portable flash that goes beyond the simple direct frontal use is as fill-lighting for shadows. This can be done from any direction, but the most common way that it is used is facing sunlight, to show detail in foreground shadows. The one essential thing to remember is that fill-lighting is intended to be substantially less than the main lighting it faces. The best way to plan this is to think of the ratio of the fill to the principal light – 1:2 is strong, 1:4 is natural, 1:6 and less is weak (these are rough judgements).

A small flash unit can be positioned almost anywhere, as long as it has a sufficiently long extension lead. In this photograph of a security investigator working through the contents of a skip or dumpster, a flash was concealed inside, to simulate the light of the man's torch.

With closer subjects a short extension cable gives the option of holding the flash to one side, as in this photograph of a fighting cock. For cameras that accept dedicated flash, special extension cables are available, as shown *below*.

The technique is first to frame the shot and to set the exposure for the ambient lighting (leaving the shadows dark). Then, with the flash set on manual, work out from the guide number or the table on the back of the unit what the flash-to-subject distance ought to be to give the ratio you want at the chosen aperture setting. If this step seems complicated, think of it like this: the guide number or table will show you easily enough what the distance ought to be for normal, full lighting: for a 1:2 ratio, read off the distance against 1 *f*-stop smaller, for a 1:4 ratio 2 *f*-stops smaller and so on. Then, either take the flash off the camera and use it from the indicated distance, or move the camera and flash back together (possibly changing to a longer focal length).

An alternative way of reducing the flash output is to cover the flash head with something that will absorb some of the light: a neutral density filter to be accurate, or a piece of cloth such as a white handkerchief (one thickness reduces the intensity by about ½ a stop, two folds by 1 stop, three folds by 1½ stops, and so on. This depends on the thickness of the cloth; test first by holding the cloth over a meter's sensor.)

If you use this method, the calculation that you have to make first is how many *f*-stops more or less than normal the flash unit would give at the distance you have chosen and without any filters. For instance, imagine you are shooting at 4 feet (1.2m) from the foreground shadow area that you want to fill, at *f* 8, and that the flash unit at full output needs *f* 11 for a good exposure at this distance. Without thinking about ratios, the flash output already needs to be reduced by 1 stop. If you then want a 1:4 ratio, it needs another 2 stops reduction – 3 stops in all. A 0.9 neutral density filter will do this, or five or six folds of a white handkerchief. Incidentally, if you are using a non-dedicated flash with a photocell and thyrister circuit to adjust the exposure, do not cover the photocell, or it will automatically compensate.

Fill-in flash
A major use of portable on-camera flash is to fill in foreground shadows in scenes that are mainly back-lit. Without flash (*above*), the averaged meter setting of ¹⁄₁₂₅ second at *f* 8 showed little of the grapes. The normal flash setting would have been *f* 8, but this was reduced to *f* 16 for a less artificial effect (and the shutter speed changed to ¹⁄₃₀ second).

Multiple off-camera flash
The off-camera configuration shown on the facing page can be extended by adding a second (or more) flash unit(s). If the first flash is connected by a dedicated cable, subsequent units need only a regular sync. cable.

Positioning Lights

The usefulness of a light is in proportion to how easily and securely it can be supported. A few large, sophisticated lights, such as those on page 113, are self-supporting – they are supplied with their own means of positioning – but most need additional support equipment.

The first, essential function of any such fixture is to hold a light, and whatever fittings it needs to control the quality, in the right position. It is pointless having a good lighting system and then needing to make compromises in the photograph just because you cannot get the lighting direction that you would like. Certain lighting angles are difficult, particularly with large diffuser fittings, but if this is what the photograph needs, you should try to find a practical way of providing the necessary support.

Apart from being able to aim the light in the right direction and from the right height, there are a few other factors that you should consider before buying any supports. One is that it should be safe and secure. The heavier and larger a light, the more important this is. The lamps themselves usually cause few problems, and if they sit on top of an appropriate size of conventional stand, none at all.

Most lamps used in still photography are fitted either with a spigot or a socket, in either case 5/8 inch (16mm) in diameter. The same is true of most stands. The spigots fit into the sockets, and double-ended separate spigots are available to convert sockets if necessary. Some very heavy tungsten lights, not normally used in still photography, have 1 1/8 inch (29mm) spigots, and some lighting systems use, inconveniently, individual proprietary methods of attachment.

Over-balancing problems are likely to occur when the stand or fixture used is too small or lightweight for the lamp, when a heavy fitting is attached to the lamp and shifts the center of gravity, and when lighting is suspended, tilted or cantilevered out at an angle overhead. Test fixtures by shaking them gently and by applying pressure in different directions. For safety, wires, pins, clamps and so on can be attached to the lamp and a secure fixture (such as on the ceiling), in case of the support failing in some way.

Secure overhead cables by clamping or taping to prevent them hanging close to a hot lamp. Do this with ceiling tracks and other overhead fittings.

A cable trailing from the top of a stand to a floor socket is easy to trip over, and may pull both stand and light down. To avoid this, secure the cable to the stand.

Having secured the cable to the column of the stand, tape the cable to the floor between the stand and the socket.

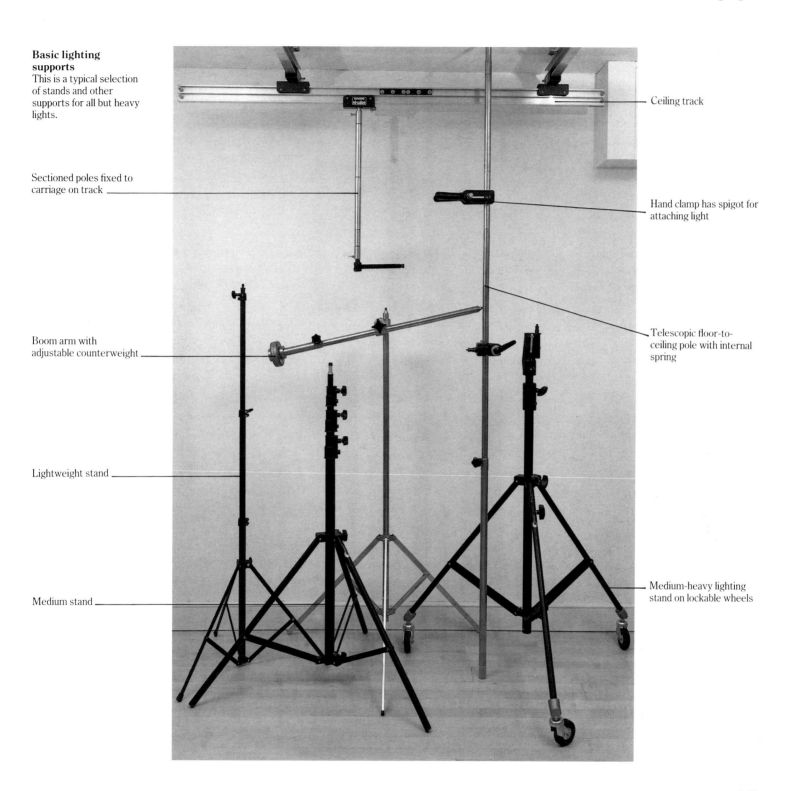

Basic lighting supports
This is a typical selection of stands and other supports for all but heavy lights.

Ceiling track

Sectioned poles fixed to carriage on track

Hand clamp has spigot for attaching light

Boom arm with adjustable counterweight

Telescopic floor-to-ceiling pole with internal spring

Lightweight stand

Medium stand

Medium-heavy lighting stand on lockable wheels

145

Next, consider how easy a particular system of support is to use. Although the support has to hold the light still for when it is in use, it also has to be erected, dismantled, moved (if only slightly), and the controls must be accessible. Some of this will depend on how much you need to alter the position of the light. For some types of photography, the range of movement may need to be very little. Whatever movements you think may be necessary, make sure that the system of support that you use will allow it easily. It may seem at first to be less trouble for a special lighting position to fix it as best you can with less than ideal, but available, supports. However, if you are likely to use an awkward position (such as overhead) several times, it will repay the initial trouble and expense of installing proper fixtures.

Finally, look at the space that the support itself occupies, and at how easy it is to erect, carry and dismantle. If there is plenty of room in the studio, this may not be an issue, and supports that do not need to be taken down frequently can be made sturdier. Stands occupy a considerable amount of floor-space, which in itself may be restricting; supports attached to the ceiling take up space which is not normally needed for anything else. If you need to use lighting on location frequently, then you will at least need some lightweight folding supports and clamps; consider whether it would be better to have two sets of support, one for the studio and one for location, or whether it would make more sense to have one set doubling for both uses.

The most common type of lighting support by far is a tripod stand, available in different heights and weights. The legs usually fold, and the central section telescopes. The heaviest tripods have a wind-up center column. Most of the lamps for which a stand is suitable are sufficiently lightweight that they can be lifted and moved easily by hand, but for heavier arrangements a base with wheels or castors is an advantage. The main reason for the

There is always a risk of the light slipping off overhead supports such as this ceiling track. It is therefore essential to fit a safety cable or strap. Here a climbing karabiner is used for quick fixing and removal.

universal popularity of these stands is that the majority of studio photographs are still taken with relatively simple lamps aimed slightly down onto the subject (in the case of bounced lighting and reflecting umbrellas, the lamp angle is upwards, but this is even more stable).

The two lighting positions that tripod stands do not allow are downwards from overhead, and upwards from close to ground level. Nor are they completely stable for a lamp with a front fitting tilted steeply downwards. It may be tempting to tilt the entire stand on two of its legs and lean the center column against the edge of a table or chair to give you a downward angle, but this is very unstable, and dangerous. The center of gravity should be at least

nearly over the center of the stand. If it has been shifted by a heavy front fitting, such as an area light, take the precaution of placing one of the legs under it; practically, this means pointing one leg in the direction in which the light is aimed. Also, for stability, take care over the cable; it can pull the entire stand over if someone trips over it, or even if it is stretched. The safest method is to run it down the center column, and then along the floor. If other people are likely to be walking around, it is good safety practice to tape the cables to the floor with gaffer tape.

Alternatives to stands are clamps, fitted with either spigots or sockets. These can be used on scaffolding, expanding floor-to-ceiling poles, and any strong edge, such as a

desk-top or table. Being lightweight, this makes them very useful for location work, although it is as well not to rely on them totally, in case there are no suitable places to attach them in an unfamiliar location.

The position that needs the strongest support, and which can cause the most problems if you try and organize it temporarily without the proper equipment, is overhead. The most stable arrangement is with the center of gravity directly underneath the fixture; if it is well out to one side, there may be excessive stress on the pole or clamp. Many lamps have a bracket which is attached to the center of gravity; hang the unit from the bracket and rotate the lamp on this. The simplest overhead structure is scaffolding of one type or another; the clamps are attached to the cross members. Simpler alternatives are a straightforward pole clamped between two stands or between two expanding vertical poles. The best system of all is a permanent set of ceiling tracks, with sliding carriages.

Vertical adjustment is usually the chief difficulty with overhead fittings; the best facility for this is an expanding and contracting pantograph, which can be operated by a pole or by remote control. If cables are used to suspend an overhead light, three or four are needed to prevent the unit from swinging and rotating. A last alternative for suspending a light is a counter-balanced boom arm. The counterbalancing weight must be adjusted for every change of light fitting and lateral movement: there is great opportunity for instability with this type of support, so be warned.

Repeating lighting positions
With a complex lighting set, or one that you may want to repeat at a future date with exactly the same results, keep a record of the positions, equipment, and power settings. It is usually enough to do this in the form of a quick sketch, including key measurements, but floor measurements are an alternative.

Support checklist
First decide on the type of lighting and fittings (such as diffusers) that you will mainly need, depending on your principal interests in photographic subjects. Then decide what the most useful lighting positions and directions will be; this should determine your priorities in buying or building supports, not what is most easily available.

- **Lighting angle** The first consideration, lighting angle depends on your most usual type of photography and the dimensions of the studio.

- **Safety and stability** This is determined by weight and position. Overhead lighting needs the most care. Diffusers may need separate supports. Keep cables clear. Use safety wires, pins and other equipment.

- **Ease of use** Within the important range of positions the equipment should be accessible, serviceable and capable of being moved easily.

- **Range of movement** This depends on the range of photographic subjects.

- **Portability** Is there enough space to leave the support equipment in place permanently? Will it need to be moved to different locations? Some supports fold up for travel, others can be dismantled easily.

- **Space** Does the support equipment occupy much space? Does this matter?

In order to repeat a lighting arrangement accurately (and so save more exposure calculations and tests), take careful notes of positions and heights of lights and stands.

Direction

With one or more of the stands and other types of support just illustrated, lamps and their fittings can be arranged at any angle to the subject and to the camera. The most common camera angles are between horizontal and about 30° downwards, but this limited range is mainly a matter of convenience, for now we are interested in the apparent direction of the light, regardless of whether the whole structure of camera, subject, and lighting has been angled or inverted to make the shot easier to take.

On page 30 the different angles of sunlight were shown in the form of a lighting sphere surrounding the subject. The same can be done for controlled photographic lighting, with a few differences. One is that several lamps can be used, so that there may be different directions; in most lighting sets, however, one direction predominates. Another difference is that the lower half of the lighting sphere becomes a practical direction; either the light can be lowered to point upwards or, as is often more convenient, the subject is laid flat and the camera aimed downwards, allowing more conventional lighting support. Nevertheless, lighting from below remains the least common direction; from our everyday experience, it looks unusual.

A third difference is that we can make a more detailed subdivision of the sphere than appears on page 30. This is a reflection of the control that is possible with photographic lighting. Our discrimination of lighting direction ought to be much stronger, because such control is possible. Small changes, in the order of just a few degrees, become important decisions, simply because they can be acted upon.

Just as the angle of the sun makes a qualitative difference to outdoor photographs, so the varieties of lighting position in a studio will be more appropriate or less appropriate for different subjects and surfaces. The individual qualities of objects are examined later on pages 158–71, but this is a good time to experiment with different lighting positions.

Project: Different lighting directions
Take a manageable subject with a substantial shape and form, photograph it with every possible lighting direction (it should be manageable in the sense that you can move it and work around it conveniently). Ideally, do this with more than one subject: a still-life object, a face, and anything else that you can think of. The more rounded it is and the greater variety of planes it has, the finer the differences will be between lighting angles. This is mainly an exercise in judging effect, but also partly a practical exercise in working with studio lighting equipment; pay particular attention to keeping the light stable and secure, avoiding such obvious dangers as overbalancing the lamp and trailing cables along the floor that can be tripped over.

The easiest lighting directions are very similar to the most common camera angles, between horizontal and 30° to 40° downwards, because for these you need only a simple tripod stand. The folded height of the stand sets a limit to how low you can position the light, although raising the height of the subject is a useful alternative.

Overhead lighting needs particular care if you lack a system like the ceiling tracks shown on page 146, but you may find that for many subjects it is the most appropriate direction. Photographers who do a lot of still-life work, for instance, usually go to the initial trouble of arranging secure overhead supports that are easy and convenient to work with. Changing to and from an awkward lighting position is, as you should discover from this project, an inconvenience that distracts your attention from the actual photography.

Overhead, back
Partial silhouette and strong top highlights. Some danger of lens flare.

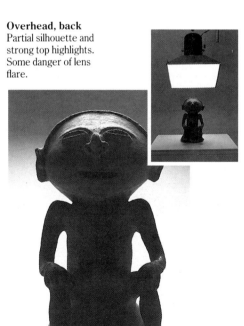

Directly overhead
Strong highlights on upper surfaces. Often needs white base to reflect light back into shadows.

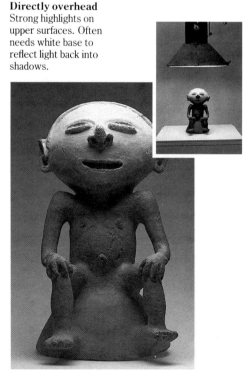

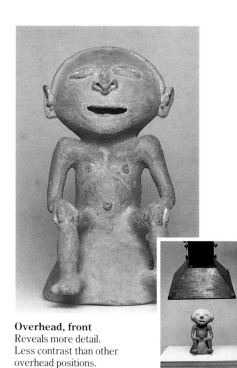

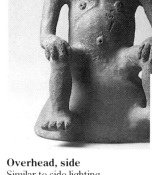

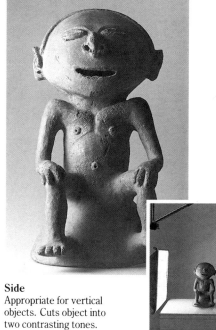

Overhead, front
Reveals more detail.
Less contrast than other
overhead positions.

Overhead, side
Similar to side lighting,
but favours upper part of
object.

Side
Appropriate for vertical
objects. Cuts object into
two contrasting tones.

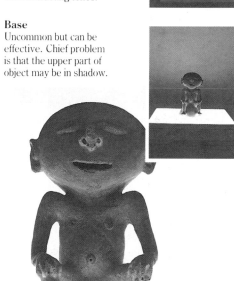

Low frontal, side
Lights object from below,
so generally an unusual,
dramatic effect.

Side, back
Similar in principle to the
overhead, back position
opposite, but better suited
to a vertical object.

Base
Uncommon but can be
effective. Chief problem
is that the upper part of
object may be in shadow.

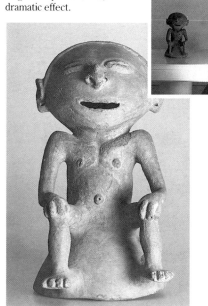

Controlling Contrast

Contrast, the difference between light and shade in an image, affects the quality of lighting and so the aesthetics of the photograph. It also has an effect on the performance of the film, because there are limits to the ability of any emulsion to record the range of brightness. In natural-light photography a certain level of contrast exists in a scene before you even think of taking a photograph, and this creates a certain type of approach: adapting to given conditions of lighting. With photographic lighting, however, and particularly in a studio, the contrast is entirely what you decide it should be. Another way of putting this is that natural light relieves you of the decision; the contrast is as it is, and there are limits to what you can do about it. Along with every other aspect of lighting, controlled studio photography forces you to select the appropriate contrast. If you choose not to bother, you are not in full control of the light.

The degree of contrast that seems appropriate depends on three things: what detail you want to stay visible in the shadows, the graphic design of the image and the atmosphere of the picture. The necessary shadow detail is usually a straightforward decision. If the purpose of the photograph is pure representation, blocked-up shadows are not normally a good idea, and the nature of the subject should immediately show whether there is important or interesting detail in the shadows (the painted frieze on the circumference of a vase, for instance).

Shadows, however, can contribute to the design of an image through their shape and by being dark blocks of tone to balance lighter ones. If they are hard and deep, their geometric effect may be reason enough to keep them like that. Atmosphere, the third consideration, is less open to exact definition, but is often the vital constituent in a photograph. High contrast and strong shadows produce the impression of hardness and sometimes drama; low contrast is gentler and less strident.

From the effect that you want to be visible in a photograph, it is then essential to measure the contrast accurately and to match it to the performance of the film. The eye, as usual, does much less well at this than an exposure meter, and either a hand-held incident meter or a spot meter is the best equipment for measuring the range between highlights and shadows. Remember that 7 stops is the normal range for shooting negative film and 5 stops for transparencies. If the contrast range *just* matches these limits (and the exposure is placed properly between them), the shadow will *just* show detail. Assuming that you expose to hold the highlights from appearing weak and washed-out, less contrast will show more detail in the shadows and more contrast will make them solid.

You can control contrast by choosing a particular quality of light, by adding reflections into the shadows and by introducing extra lighting opposite the main light. To begin with, however, you should find out what the basic conditions are in the room you are using. Most interiors, including studios, reflect some light from walls, ceiling and furnishings. The smaller the

Choosing the contrast
Strong, direct sunlight is the only source of illumination in both these still-life photographs, and it has been used intentionally at a raking angle to the surfaces to emphasize the texture. The contrast with this lighting technique is normally high; in the picture of the pen for preparing musical score sheets (*above left*) a reflector has been positioned to show shadow detail, but in the close-up of the wooden box (*left*) contrast has been left high to emphasize the relief.

room, the closer these will be to the subject and set of the photography, and so the greater the natural reflection. It is often not possible to do anything about this and may in any case not even be necessary. It simply sets a limit to the maximum that you can create without introducing blacked-out surfaces. The ideal circumstances for giving full control over contrast would be a room that produced no reflections at all; a room painted black. This would be the photographic equivalent of starting with a blank sheet of paper.

Project: Contrast range
Begin by setting a single undiffused lamp in a position for side-lighting, as shown. Before placing any subject in front of the camera, measure the basic contrast level in the room: take one reading with a hand-held incident meter facing the light, and a second with the meter facing away from the light. The difference is the contrast range. Next, hang a sheet of black material – ideally black velvet – facing the light, and take a third reading with the meter facing into it, again away from the light. The first and third readings give the maximum contrast range; if the black material makes much of a difference, the room is quite bright.

With these measurements taken, choose a subject similar to the one used in the example shown here that has a substantial form. The idea is to take a series of photographs with different degrees of contrast control. Start with the maximum contrast set-up that you have just measured. Diffusion of the main light makes some difference to the contrast, even without adding anything opposite to fill the shadows. Add a diffuser, as shown, and take the next photograph in the series.

All the subsequent changes are to the shadow fill, and for these, collect a variety of reflectors like those shown on page 33. First take a plain white card of about the same dimensions as the subject, but position it at two different distances: fairly close and then about twice that distance away.

The fall-off is striking – a loss of about 1 stop if you measure it with the meter. Now replace this card with a much larger one: the extra area of reflection increases the shadow-fill slightly.

Move onto reflectors with increasingly bright and shiny surfaces. One characteris-

tic of the brightest ones is that they have a more concentrated effect, and from the camera position the edges of the shadow area appear a little darker at the center. At some point in the sequence of increasingly efficient reflectors, the shadow-fill will become prominent; instead of appearing

No diffuser, no reflector

Diffused light, no reflector

like a natural reduction of contrast, it is strong enough to show that a reflector is being used.

Finally, replace the reflectors with a fill-light. This needs to be well-diffused, to do no more than lighten the shadows, otherwise it becomes simply a second light. Use diffusers similar to those shown on page 127. Using a light gives the extra control of being able to adjust the output but, as you can see by comparing the different versions in the sequence on these pages, ordinary passive reflectors are usually enough for a natural effect.

Diffused light, small
white card reflector

Diffused light, small
white card reflector
positioned close

Diffused light, large
white card reflector

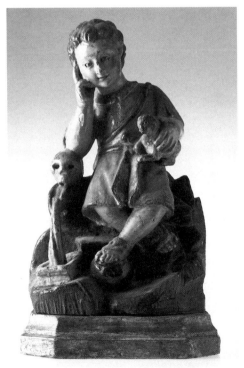
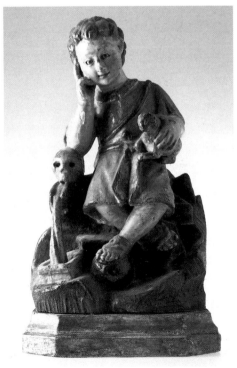
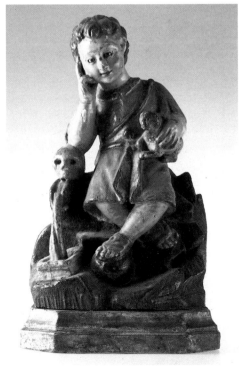

Diffused light, silvered
reflector

Diffused light, second fill
light diffused through
umbrella

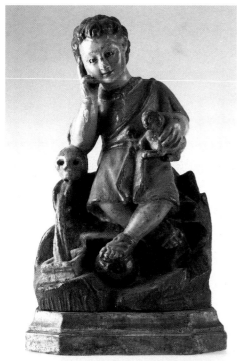

Controlling Flare

In studio lighting a variety of lamps and fittings is usual and some are often only just out of view. These are likely conditions for causing flare, particularly if you make late adjustments to the lighting and forget to check the effect carefully through the viewfinder. Flare usually occurs at the edges and corners of the photograph, and as these are the least visible areas on the focusing screen on a view camera, large format photography is particularly at risk.

Flare demands just one basic precaution: shielding the lens from light. We can be a little more precise about this. *Any* light that reaches the lens and does not come from the picture area can cause flare, so that the ideal solution is to mask down the view in front of the lens right to the edges of the image. The most sophisticated professional lens shades do just this; either by extending and retracting, or by having adjustable sides that can be moved in and out, they leave only the picture area exposed to view.

Practically, there are three places for shading the lens from flare. One, just mentioned, is on the lens itself, or just in front of it. Another is between the camera and the lights, using larger masks made of black card or similar materials on stands. The third is on each lamp. Some lamps are available with barn doors, hinged flaps that cut off the main beam at the sides. Others can be fitted with a simple flag on an adjustable arm.

The most important flare control is to cut off the spill from a direct beam. A straightforward technique is to look at the lens from in front, and move whatever mask you are using until its shadow falls across the lens and just covers it. Any further control depends on the lighting; if there are strong reflections from walls or other bright surfaces, it is wise to go one step further. To do this, move the masks until they just appear through the viewfinder, and then move them back out of sight a fraction.

Finally, a special case in still-life photography is when you are shooting onto a bright surface, and particularly with a broad overhead light. The bright surface that surrounds the picture area will produce a kind of flare that is not immediately obvious, but which degrades the image nevertheless. The answer to this is to mask down the surface itself with black, as shown in the photographs on page 155.

Accurate shading with a view camera

If the light is used very close to the edge of the picture area, as it often is in still-life photography, there is not only the danger of lens flare, but an equal danger that the mask or flag used to prevent it will appear in the shot. The most accurate technique with a view camera or a shift lens is first to set up the shot, and then to operate the shift control until the light is brought into view (at close distances, it is better to shift the back of the camera, as moving the lens panel will change the perspective slightly). Mask the light, but do this at the aperture which will be used (stopping down after shading at full aperture will affect the apparent position of the mask if it is near the lens). Shift back to the original view.

Flare weakens density here, at top of image (inverted in a view camera screen)

Lens shifted up or back shifted down

Shift brings light into view

Lens shade or mask adjusted at working aperture until it just obscures light

Lens shades

The three most common types of lens shade are (*left to right*): the screw-on or bayonet mounted shade made for a specific focal length; adjustable bellows shade that adapts to a variety of focal lengths; a simple black flag clamped in front of the lens.

Flag on adjustable arm

Barn doors

Black card on stand

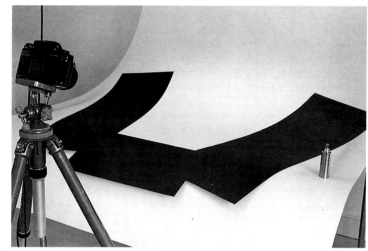

Light shades
The alternative to shading the lens is to shade the light sources. Although this is usually impractical on location, in a studio or small interior it is generally straightforward.

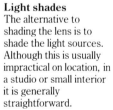

Background flare
Even a white background can degrade the image. Having set up the camera, mask down to the edges of the frame with black paper or cloth.

Do this while looking through the camera viewfinder. The position of these black masks depends on the focal length of the lens (and so its angle of view).

Masking for a 55mm lens

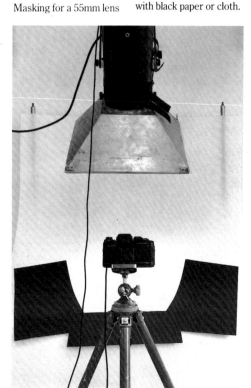

Masking for a 35mm lens

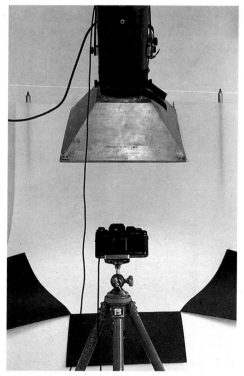

USING LIGHT

All this variety of lighting equipment and materials has been designed so that virtually any condition of lighting can be constructed, particularly in a controlled setting like a studio. The choice is considerable, and it is important to have some method for deciding which to use. On a few occasions, simply experimenting with the lighting that you have available will suggest useful effects and different treatments. As a normal approach to using light, however, trying to make the subject fit the lighting is the wrong way to approach it. If you make a habit of doing this, then one of two things is likely to happen. Either you will tend to light things in a similar way, using one lighting set that you have become familiar with, or, if you have at your disposal a large selection of lighting, what you use may owe more to chance and convenience than to suitability.

If the situation is under your control, there ought to be sensible reasons for the lighting sets that you use. There should be at least some logical thread to the process of choosing the light sources, direction, diffusion and other qualities. The most logical approach of all is to start with the subject that you have to photograph, decide what its various qualities are, which of these are the most important for the image, and then how best to convey them. There are other approaches to using light – for instance, choosing a particular type of illumination because it will convey a certain atmosphere irrespective of the subject – but this one is fundamental to clear representational photography. You can always choose to ignore the most appropriate lighting if there are good reasons for doing something else, but at least you should know what *is* the most appropriate. This is the theme of this last section of the book.

The most obvious qualities of any object are the purely visual ones: its colour, for example, or the roughness of its surface. However, what we can see of something becomes mixed up with what else we know about it, usually from experience, and what we feel about it from its associations. Colours, for instance, not only help to identify an object; they are in themselves expressive. Orange and red are intense and warm, irrespective of where they appear. The surface qualities are essentially those of texture, and although visual, this conveys information about how it feels to the touch. (See volume II, *The Image.*)

What lighting can do is to reveal the various qualities of an object to different degrees, and although it produces a visual impression, this in turn can be used to show something of the non-visual properties. To take just one specific example, the main purpose of food photography is to give a sense of taste through pictures. The visual means are mainly those of texture and atmosphere, and these are usually conveyed almost totally through the lighting.

Take any object and imagine how to describe it methodically, in a way that covers everything important about its appearance. First, it has a shape: the outline shows this, and with most objects it changes according to the angle at which you view it. Three-dimensionally, it has a form, which may be flat, for example, or round, thin, bulky or more complicated variations on these. The weight of the object also affects the way we perceive it, and although this is not always obvious, lighting can play an important part in suggesting how heavy or light it is. The surface comes next: this has texture, anything from rough and knobbly to completely smooth and shiny. Deeper into the material of which the object is made, it may be opaque, transparent, or at any degree of translucency in between. Finally, every object has an intrinsic colour; apart from the colour of the light that strikes it, its composition determines which wavelengths are absorbed and which reflected. Conveying this accurately, intensely, or in any other way depends on the type of lighting. We take each of these subject qualities, and see what the most appropriate lighting quality is for each. We can then create this by selecting some of the lighting equipment and materials illustrated in the previous section.

Revealing Shape

One of the most obvious qualities of an object is its shape. It is even more a quality of the image than of the real object, being two-dimensional; the projection of the outline onto the film. The importance of shapes varies, and is influenced by other material qualities. For a spoked wheel, for example, it is by far the dominant feature; the outline alone tells you almost everything there is to know about it. For a handful of sand, shape hardly matters at all; the texture and weight are much more significant. So, even before you begin to think of how lighting can help, it is important to consider the shape in context. There are other qualities to convey, and it is not always possible, or even desirable, to give each one equal attention.

Lighting is well-suited to showing shape for one good reason: shape is a quality of the edges of a subject, and the simplest way of defining these more strongly is by contrast. Apart from the inherent tone and colour of the subject, the contrast between it and the background is set by light. Light against dark or dark against light are the two obvious choices; in either case, the more even the tone of the subject, the less there is to distract the eye from its outline. This makes silhouettes very strong for showing shape; none of the details facing the camera are visible.

Silhouettes, however, are an extreme way of depicting any object, and have only occasional uses. Under normal conditions, more of a subject needs to be shown, and the shape must be included as part of an overall combination of qualities. If the object is light in tone, then a dark background will make its edges more prominent, as long as the lighting is sufficiently diffuse and frontal to cast no strong shadows over them. Strong side-lighting against black, for instance, would obscure half of the outline. Another method, also against a dark background, is to use rim-lighting, dealt with fully on pages 180–1. At its most effective,

this technique picks out just the outline, and so can express the shape very powerfully. Its success depends heavily on the surface texture of the object. Finally, the background itself can be manipulated to emphasize shape. If you use standard direct back lighting, as described on pages 176–9, with a translucent screen behind the subject, the back of this sheet can be shaded with black card. If you make the shape of this shading act as a frame for the subject, it will draw attention to and reinforce the outline.

Only a few objects have the same shape from most viewpoints. Most offer a choice, and it is important to study this first. Much depends on how recognizable and representative you want the shape to be: the spoked wheel mentioned above would be obvious from the side, but unrecognizable end-on. The more effectively that the lighting emphasizes the shape at the expense of form, the more careful you should be in choosing the angle of view.

A line is drawn around the shell and a rough, oversize mask cut out of black paper.

The paper mask is fitted underneath the acrylic of a light box to soften the edge.

The underside of the shell is painted black to keep the silhouette dense.

Projects: Emphasizing shape

Take a number of subjects with different outlines, some obvious, some unfamiliar, but all reasonably clear and well-defined. For each, first decide on the angle of view that gives the most representative shape, and then choose what seems to be the most appropriate lighting technique from those described above. Note that for a strong silhouette you will need to block all frontal reflections, and this may mean arranging black card or material on either side of the lens to absorb the light.

Now choose one subject which has reasonably strong qualities of shape, form, weight, texture and colour. If it is translucent or transparent as well, so much the better, although one object will not have every one of these qualities. Use this object for as many as possible of the projects on the following pages, but each time emphasizing just one quality. To start with, photograph its shape only.

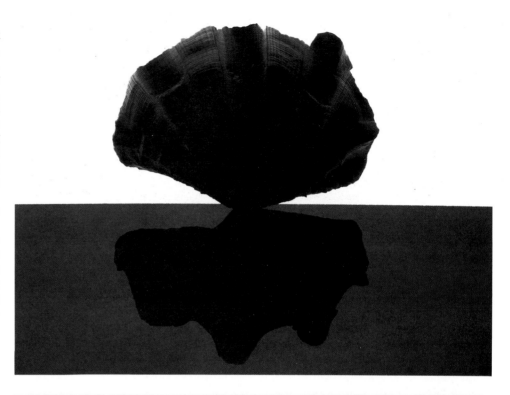

The object chosen for this project was a half shell, and two treatments were tried out to show its silhouette. In one (*above right*), the shell was supported on a ledge of black acrylic against a light box; the reflection in the acrylic emphasizes the shape by repetition. In the second (*right*), a pure silhouette was photographed with a soft mask added to highlight the shape.

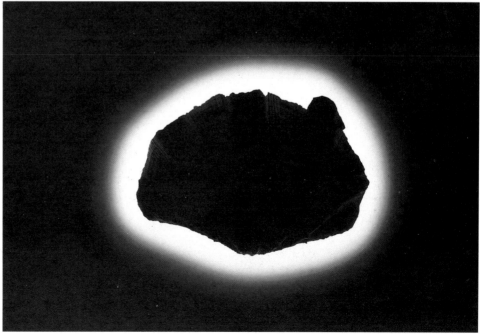

Revealing Form

The form of an object is a little less easy to define than its shape. Unlike shape, form is essentially three-dimensional, the representation of volume and substance. Whereas shape becomes strongest if treated as a purely graphic quality, as in a two-tone silhouetted image, form is a plastic quality, and needs a lighting technique that stresses roundness and depth – full realism, in effect. Lighting for form inevitably results in representational photography.

In principle, then, the techniques for showing form involve using the modulation of light and shade. This means that the lighting should be directional, throwing distinct shadows, and from an angle that gives a reasonable balance between the light and the shade. Strongly frontal or back lighting does not work particularly well; in the first, the shadows cover only a small visible part of the object, while in the second, the lit areas appear very small. Any version of side lighting, however, gives a modulation that is more equally divided.

There are two things involved in using light and shade in this way. One is the darkening of the surface from one side of the object to the other; this alone gives an impression of bulk and volume. The second is the shadow edge itself. Its shape and position as seen from the camera give more detailed information about the relief. Both of these qualities can be altered in three ways: by the direction of the lighting, the strength of the contrast, and the degree of diffusion. Each of these is dealt with in more detail elsewhere – refer to pages 124–9 and 148–53 for the techniques. Much depends on the object itself, but even if we leave this aside for a moment, there is no single ideal method of lighting to show the maximum volume. Decide this for yourself in the following project.

Project: Simple volume

Take the simplest form that you can find easily: a sphere, an egg, or something similar. Photograph it with varieties of side-lighting (slightly frontal to slightly back), diffusion and contrast. What you should find is that there is a range of perfectly acceptable lighting, and not one that stands out obviously as being the most effective. Note, incidentally, that exact 90° side-lighting gives a straight shadow-line; this, particularly if hard-edged from an undiffused light, confuses the impression of roundness.

Project: Different objects

Next, take differently shaped objects, with varying degrees of complexity of form, and for each arrange the lighting for what you consider to be the most three-dimensional image. As a side exercise, rotate each object and adjust the lighting until you produce the strongest shape of shadow edge. This will usually strengthen the impression of relief. Also, pay particular attention to the background. As the focus of our attention is on the object itself, the setting should be neutral, but adjusting the tone of the background will have an effect on the form of the object. Try, for instance, shading the background in the opposite direction to which the object is shaded. This can enhance depth.

Project: The same object used for Shape

Finally, continue the project started on page 159, using the same object but lighting it differently to reveal the form. Here, we continue with the shell.

Modelling: Lighting variations
Lighting controls modelling, which is essentially the treatment of form and relief. The three lighting variables are the angle, diffusion and contrast, as the three diagrams illustrate.

Lighting angle

Diffusion

Contrast

Modelling: Effects
There are two things involved in modulating light and shade to show form. One is the contrast between the lit and shaded parts, the other is the actual shape of the shadow edge as it traces the relief of the surface.

The degree of shading from side to side across the image gives an impression of depth.

Shallow

Deep

The line of the shadow edge gives an impression of the relief.

Shallow

Deep

<div style="float:left">Light slightly to front</div>

Moderate diffusion, no reflector

Full diffusion, no reflector

Full diffusion, with reflector

<div style="float:left">Light slightly behind</div>

Moderate diffusion, no reflector

Full diffusion, no reflector

Full diffusion, with reflector

▲ **Project: Simple volume**
Small changes to the lighting make delicate but appreciable differences to the way the form of an object is recorded. A pre-Columbian pot was used for this project; in the top three pictures the lighting is slightly frontal, and in the three pictures *above* the lighting is slightly back.

▶ Continuing the shell project started on the previous pages, the same object is here used to convey form. The lighting technique is straightforward diffuse side lighting, with fine adjustments made to the position of the light so that it gives the maximum tonal range, from bright to dark.

Revealing Weight

Although a very tangible quality, weight has few visible clues. It is, nevertheless, usually important to give some feeling of it in a photograph. Apart from anything else, the weight of an object helps to complete the impression of substance.

One obvious method of showing weight is to have one object pressing down on something softer, such as a rock on a crumpled fabric. By contrast, a photograph of a feather floating on water shows how light it is. However, this is hardly a lighting exercise. Light and shadow can only work in a more suggestive way. There is, to be honest, not a great deal of choice, and the one effective method is to light from above so that the shadows form a pool underneath the object. These shadows fall on the base supporting the object, and this base is an important element in the picture.

Weight is a matter of gravity, so that anything that reinforces the impression that gravity operates will help. Hence, if the base is level and prominent, as in the photograph *opposite*, it can be seen to have a strong relationship with the object resting on it. The lower the camera angle, the more obvious become the points of contact between the object and the base; this also helps to show that there is a quality of weight.

Project: Contrasting weight
Take both a dense, compact object, such as something made of stone, and one that is lightweight, such as a feather or leaf. For both, try to emphasize the weight, but in the case of the first object, show how heavy it is, and the second, how light.

Also change the lighting on the object that you have already used for Shape and Form, and show its weight.

The weight of the shell already used in the two previous projects is very little, and a side view in particular makes it appear fragile and delicate. To emphasize this, base lighting was used, with a light aimed upwards to a curved translucent acrylic sheet. The background was allowed to shade off to a dark tone to emphasize the lit scalloped edges of the shell.

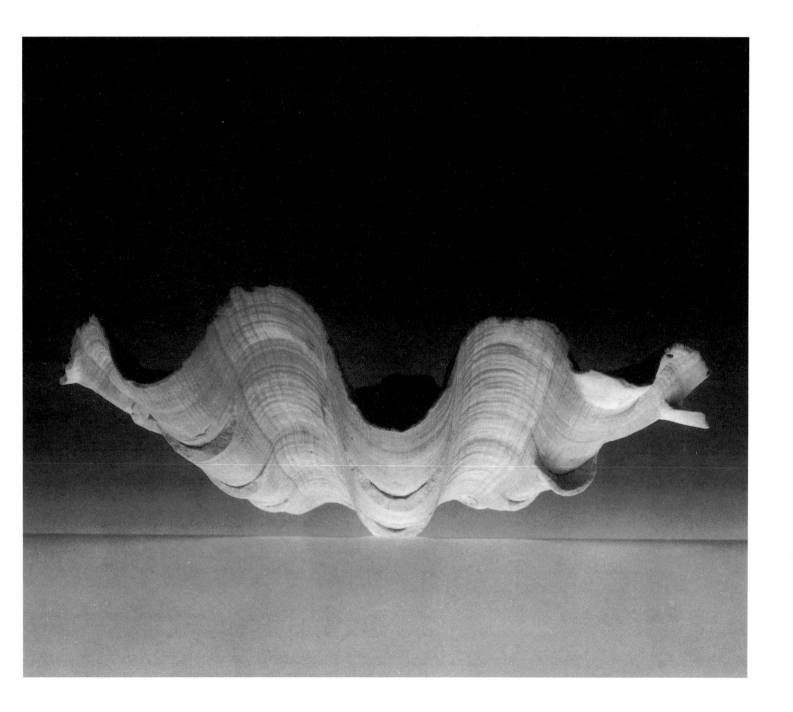

Revealing Texture

Texture is the tactile quality of a surface; of the skin of an object rather than its body. It is mainly, but not entirely, a matter of local relief, with rough and smooth as the two extremes. This in turn depends on how closely you look at a surface: from a few inches, a block of concrete appears, and feels, rough, but seen as part of a building from a distance, it looks completely smooth. A girl's skin may be smooth enough in a head-and-shoulders portrait, but if you shoot a close-up of just the lips, you will find that an enlargement will show all kinds of imperfections.

What we can call the coarseness range of texture has upper and lower limits. The upper limit is when the relief is so strong that it affects the actual shape of the object; it is no longer a quality of the surface, but of the thing itself. The lower limit is the point at which the surface appears smooth. From the examples mentioned at the start, you can see that this is entirely relative. At some degree of magnification, the smoothest surfaces have a strong texture. It is also subjective; there is no measurement that you can apply.

Strictly speaking, even a mirror-like finish is a texture of sorts. Experience of natural lighting shows what the most effective studio conditions should be. Go back for a moment to side lighting on pages 34–5, and in particular to the photograph of the paper lantern. As a general rule, a naked lamp at a raking angle to the surface is the classic treatment to give strong texture. As a reminder, a sunlit aerial picture is included here; if you imitate this with a photographic lamp, the result will usually be effective.

However, the actual angle should depend very much on the coarseness of the texture. If the relief is strong and deep, a very shallow angle may lose detail unnecessarily. One technique you should consider is to add a reflector opposite the light to lighten the shadows and preserve this detail (see Controlling Contrast, pages 150–3). If you move a lamp to an increasingly acute angle, there comes a point at which most of the

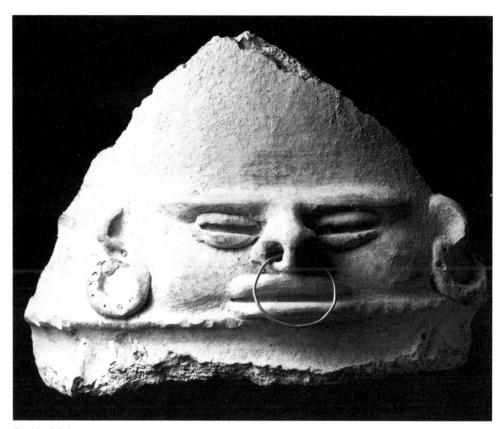

On this slightly curved fragment of a pre-Columbian pot, the texture is that of the granulated surface. Partially diffused light aimed from an angle that grazed this surface gave the strongest impression of texture.

Texture in landscapes
For comparison, see how the same principle of a hard light source shining at an acute angle brings out texture on a much larger scale. Here, the view from an aircraft of petrified trees and sand-dunes in western Australia's Pinnacles region reads clearly and strongly in late afternoon sunlight.

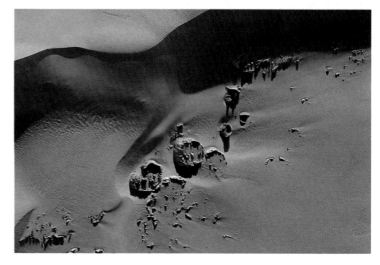

surface falls into shadow, and texture suddenly becomes lost (this, of course, is what happens at sunset). Strong texture can accommodate some degree of diffusion. Texture may not be the only quality that you want to bring out, and the best lighting may be that which only just reveals the essential texture and no more.

Finally, some surfaces may combine two or more layers of different texture. A wrinkled fabric, for instance, has the texture of the weave and the texture of the wrinkles. The lighting angle that suits one may be less satisfactory for the other.

Projects: Experimenting with texture

As a basic exercise, take a surface with distinct, hard-edged relief, such as a rough brick or the crust of a loaf. Experiment with the two basic lighting variables, angle and diffusion. Vary each, and from the results decide which gives the strongest and clearest impression of texture. Remember that hard light from a small naked source and an acute angle to a flat surface will always make textures seem strong, but this may be at the expense of legibility.

Next, collect together the following different surfaces, or those of them that you can find easily, and produce the best textural photograph that you can for each: silk, leather, glazed ceramic, fur, a metal grille, gravel. Note carefully the different adjustments that you need to make to the position of the light, its diffusion, and the position of the surface.

Finally, produce the textural image of the object already selected for the other qualities (see page 159).

The texture of the glaze on these pots also contains the trademark. Carefully adjusted side lighting picks these up and shows a slightly undulating surface.

A micro-chip on an old book cover shows a contrast in two textures: reflective metal against the detailed relief of leather. Top back lighting treats both reasonably well.

Silk is one material that contains two visible textures at the same time: the folds and wrinkles, and the shot effect of the weave. A diffuse light and careful folding shows both.

Using the same shell as on page 159, the treatment of texture is to use a small naked lamp at an angle to the "grain" of the surface, and to crop in tightly so the shape of the shell does not distract attention from the detail of the ridges.

Revealing Translucency

An object is described as translucent when just some light passes through it: not enough to be able to see clearly through the object, but sufficient for it to glow when back-lit. Almost all of the diffusers shown on pages 124–9 are translucent. Unlike transparency (looked at on pages 168–9), translucency offers considerable choice in treatment. With lighting, you can make it the major feature, or you can ignore it. The material will look quite different from one extreme to the other.

In fact, before we go into the methods of showing up translucency at its best, an important first consideration is how much to make of it. Translucent objects can certainly be lit dramatically, and because this opportunity exists, it is tempting to take it. However, the ways of showing translucency tend to conflict with other kinds of lighting, and may not always be appropriate for the picture you have in mind.

Using back lighting

The principal way of dealing with translucency is to use back lighting. One usual precaution, however, is to confine the back light to right behind the object. The reason for this is that translucent objects always absorb some light, and can often be quite dark. If you use the kind of broad area back lighting that you can see in the photograph on page 176, for example, any relatively dense translucent material will lose out significantly in comparison with its background. The strongest impression that you can give of translucency is to place the object against a dark background and place a light source directly behind it, shining straight into the material but hidden from view by the object's outline.

There are a few ways of doing this. A large object causes little difficulty since its size will hide the back light. If it is small, however, you will need to find a way of either reducing the apparent size of the object or masking it down so that no illumination spills around its edges (this will be easier if you shoot a close-up).

Project: Maximum translucent effect
To show the translucency of the shell, strong back lighting was used and all surrounding light cut out by means of a mask. A close-up view was chosen for the final photograph to make the most of the pattern of different thicknesses.

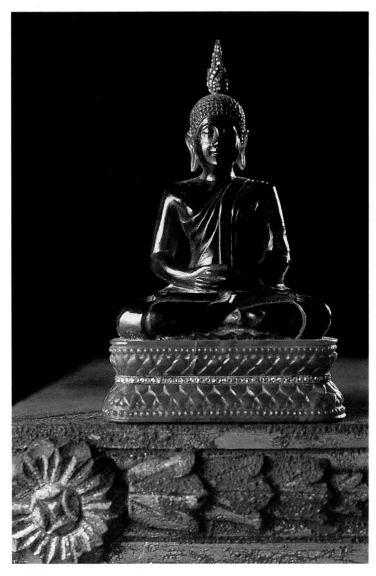

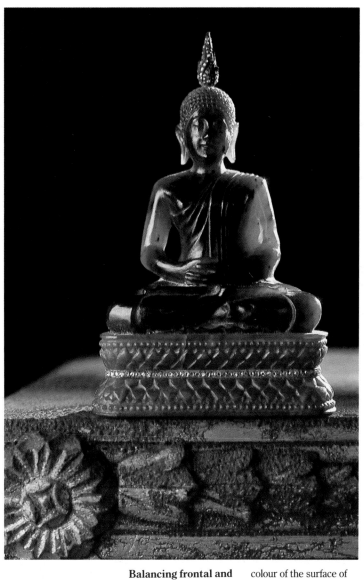

Project: Maximum translucent effect
Continue with the object chosen for all the
other projects. Also, take a variety of trans-
lucent objects and take pairs of photographs
of each. One of the pair should treat the object
as opaque, using lighting that is more or less
frontal. The second photograph should
extract as much translucency as possible
from the object. Compare the different
impression that each technique gives.

**Balancing frontal and
back lighting**
The colour of a
translucent material may
be quite different by
reflected or transmitted
light, as this pair of
photographs of a jade
buddha illustrates. Lit
conventionally (*left*), the
colour of the surface of
the jade is dark and dull.
Back lighting (*above*),
however, shows a rich
glowing green. Note that
it is usually important to
retain some frontal or
side lighting to convey
the basic shape and
normal details.

Revealing Transparency

Of all the possible physical qualities of an object, transparency needs the greatest care in lighting. You can, if you want, ignore most of the other qualities, but transparency is visible whether you like it or not. A transparent object simply shows its background. As a result, it is the lighting of the background that needs major attention, and the most common method of photographing something transparent is to make the light the background.

Effectively, this involves some kind of back lighting in most situations. Although it is hardly a rule, there is rarely any other way of showing the transparent qualities of an object and yet keeping the image simple and legible. If the transparent object has to feature strongly in a photograph, then it needs some variety of lighting to show through it. The most obvious and cleanest technique is trans-illumination of the kind shown here in the photograph of a bottle of whisky. For this, the light source needs to be broad and fairly even – a job that the light box shown *opposite*, for example, performs perfectly. The full variety of trans-illumination is covered a little later in this book, on pages 176–9.

Things that are completely transparent, such as clear glass bottles and jars, set an extra problem: that of making a clear, legible picture. The edges of an object define its shape, as has already been discussed on pages 158–9, but in a transparent material there is always a danger that these edges become lost to view. As an exercise, take a broad back-lighting source, such as a light box, and place a small glass object on it, in the middle. If the glass is much smaller than the light box, some of its edges may be almost invisible. Now take hold of the object and stand with it in front of you well back from the light. As you move it away, you should be able to see that the edges darken and become better defined. This is a characteristic of back-lit transparent objects; the extra thickness of the edges refracts and reflects in such a way that they pick up dark areas nearby.

Standard treatment for transparent materials, such as this bottle of whisky, is even, diffuse back lighting. A light box, area light or sheet of smooth translucent material can all be used.

Outline definition
Resting directly on a light box, the tops of these old medicine jars are poorly defined because of the broad surround of lighting.

Lowering the light box while supporting the jars on a sheet of glass has the effect of making the back lighting smaller in area. Now the darker surroundings are reflected in the edges of the glass, giving better definition.

To get the maximum definition of outline in a bottle or glass like those shown here, the simple answer is to mask down the area of the back light as much as possible. This is not the same thing as masking down for flare, as we saw on pages 154–5. The masking here must be behind the transparent object. There are two methods for this; one is to use black cards or flags, the other is simply to move the light source further back. Both of these alternatives do the same thing: they have the effect of making the light source smaller.

Calculating the exposure for back lighting needs care but is not particularly difficult. With a broad back lighting source such as the ones shown here, treat the background as a highlight. This gives you two fairly simple methods of measuring the exposure. One is to take a direct meter reading, either with the TTL meter in the camera or a hand-held meter pointed directly towards the object with its reflected light fitting. The reading you get will then be between 2 and 2½ stops brighter than average, so simply add that amount of exposure to the camera setting. The second method is to use a hand-held meter with its reflected-light dome, with the sensor pointing directly towards the back light. This will give an exposure setting that will be within ½ a stop of a good exposure – depending, of course, on personal taste.

Revealing Colour

Colour, as we have already seen at the beginning of the book (pages 8–9), is created by wavelengths. We see colour because we can tell the difference between the wavelengths, and we can see it in both light and in objects. This makes colour slightly different from the other qualities that we have just looked at; the light that you use to show the colours of something may itself be coloured. In practice, there are two things to think about when using photographic lighting: how accurately you can reproduce the colours you see in the subject in front of the camera, and to what extent you can alter the intensity and hue. Faithful colour reproduction becomes an important issue when copying paintings and making similar representational pictures.

Light plays two roles in conveying colour.

One is its own colour balance – how neutral or "white" it is – the other is the quality of diffusion and direction, which controls the reflections and shadows that can weaken the appearance of colour in an object. We have already looked at colour balance (pages 74–85), and seen how much more important it is to balance the light source to the film than to the eye. Basically, light that appears to have no colour when photographed – 5500 K with daylight film, 3200 K with Type B, and 3400 K with Type A – is neutral in the sense that it will show grey as grey and every other colour exactly as we are familiar with it. Not only is a balanced light source neutral, it gives the maximum colour contrast, which is to say that the biggest spread of hues appears under white light.

If the light is itself coloured, it will reinforce the image of any similarly-coloured object. Imagine a red barn at midday and at sunset. The red will appear more intense when the sun is low and its light orange or reddish. This is occasionally a useful technique to remember, but there is a drawback. The tinted light will desaturate any other surrounding colours, and there will be less contrast between the hues. As much of the impression of intensity of a colour comes from the opposition of complementary and other different hues, this tends to become lost.

The direction and diffusion of the light is also important, because of the effect this has on surface reflections and shadows. If you turn a shiny coloured surface towards the light until it catches a reflection, you can

Project: Maximum colour effect
Very diffuse lighting was used to convey the colour of the shell, to avoid highlights, and a black velvet base was chosen to enhance the delicate hues. Note from the darker and lighter versions *below* that colour intensity can be altered by changing the exposure. Bracket exposures and compare the colour differences.

see the colour suddenly weaken, and almost disappear in some instances. A point source of light will make a smaller reflection than would a broad area, and for a flat surface a small reflection is easier to avoid, provided that you can find the right viewpoint. Hence, bright direct sunlight can give intense colour.

The opposite is more likely for a pattern of small surfaces, all at different angles. This is what happens with grass, for example, as some of the blades will always catch the sun; green grass usually shows off its colour best in cloudy weather. Apart from reflections, the angle of the light also controls shadows, and the more of these that there are, the less the area of bright colour. Diffusion softens the shadows, and in this way helps the colour remain rich.

Adding colour with light
To bring out the rich browns of this herb mixing box and surrounding woodwork, the normal daylight was supplemented with an unfiltered 3200 K tungsten lamp, giving warm, reddish tones.

Using the background for colour
As a way of enhancing the colour contrast in this photograph of a cactus, the background was tinted green (by means of a Wratten 58 green filter over a small flash). It blends with the cactus, so making the yellow flowers stand out more clearly.

Full Lighting Control

So far, the different qualities and functions of lighting have been separated and, as far as possible, the examples have been chosen to demonstrate these one at a time. Frequently, however, one subject and one photograph combine a number of lighting problems, and the decisions in building up the set have to balance all of them. As an example, here is one still-life object which is in one sense simple but in another complex. Initially, this single uncomplicated carving in jade seems to call for a straightforward approach, particularly as one of the prerequisites of the photograph is to represent the reclining horse clearly. However, as we go through the process of examining it carefully and deciding what precise qualities to bring out, we will see that this needs a considerable degree of sophistication, in judgement and in technique.

In a situation like this, it helps to know something of old jade carvings. What makes the piece particularly fine is the rare grey colour of the jade, the skill and detail of the carving, and the grace and accuracy with which the lines of the horse have been captured. It contains a sequence of curves that combine to bring the horse to life. Nearly all of the dynamic force in the carving is in the head, neck and forelegs; the rest of the body falls into gentle, passive curves.

The piece is small but powerful, and one of the principal aims is not to lose this impression – to give the image of the carving presence. It should not look small, so one of the first decisions is to shoot horizontally, on a level with the horse, and not from above. The detail in the carving, such as the work on the nostrils, is good enough to sustain a close look, and so large format film is the natural choice to show this kind of detail as well as possible. Large film also shows virtually no grain, and so preserves gentle graduation of tone.

The first step is to hold the piece and rotate it slowly, to see the effects of different angles of view. One feature is

The finished photograph of a finely carved Chinese jade horse combines different lighting techniques, described in sequence on the following pages. Most still-life photography involves considerable time, and careful consideration of form, shape, colour and other physical qualities of the subject.

particularly prominent: the repetition of the curves in the neck and jaw. This determines the position for the camera.

With the positions of the horse and the camera virtually settled, the main part of the work is the lighting. To do full justice to the jade, the photograph should capture both the particular polish of the surface (neither glassy nor marble-like, but a luster unique to jade) and the slight translucency of the stone – what a jade expert called its "liquidity". This means combining two kinds of lighting: one for the surface (the main light) and one for its translucency (back lighting). The main light chosen is an area light considerably larger than the carving fitted to a flash-unit and suspended directly overhead. This design of light gives a broad, almost shadowless illumination and, particularly important for this polished object, gives a clean, unfussy reflection; a naked lamp, for instance, would give ugly pinpoint reflections.

The next step is to throw light through the edges of the piece, and for this a pre-formed sheet of opalescent acrylic was supported on a steel and aluminium framework. A light placed below and behind this base provides an enveloping back light. Some time was needed to fine-tune the effect of both lights, and to balance them to each other. A small mirror to one side, just out of the picture, lightened up neck shadows. The finishing touch to the lighting was a catch-light in the horse's eye. This sparkle can make quite a difference to normal portraiture, and it was felt that here it would help to bring the piece to life. Unfortunately, the soft main lighting had already been carefully designed to avoid just this kind of reflection on the rest of the horse. The answer was a fiber-optic bundle connected to a third flash-unit. The fiber-optic was held in position close to the horse's head, shining just on the tiny area around the eye.

1 The subject is a jade horse, about 6 inches (15 cm) long. This photograph, taken by the light of a window, deliberately shows almost everything that can be wrong with a still-life. The colour has a distinct cast from the skylight, there is no sense of translucency, the depth of field is insufficient, and the angle of view shows no appreciation of the graceful lines of the carving.

2 With the lighting plan already decided in principle from a previous look at the horse, the basic set is erected in the room: an overhead area light and a preformed translucent light table for back lighting.

3 With the lighting roughly arranged, the horse is carefully examined. At this stage all room lights are switched off. The important decisions to be taken now are the position of the horse and the angle of view, and the balance of main light to back light.

4 The horse is positioned as finally shot (see page 172), and the camera focused. A longer-than-standard focal length is used at a low angle, to give presence to the carving. From here, the overhead area light will make a large shaped highlight on the upper curves of the horse.

5 The position and angle both seem to be right, and with little possibility of any important changes, the size of the image is measured carefully. The shot is intended for the cover of a magazine, so it is critical that the dimensions and proportions are correct.

9 With the meter's head rotated, several readings are taken of the back lighting. The shape of the light table gives a degree of base lighting. This is deliberate, to kill any shadows that would otherwise appear underneath the horse. The angle and output of the back lighting flash unit are adjusted until the final balance is achieved.

10 Before any reflectors are positioned close to the carving, the horse is carefully cleaned. Pieces of hair and dust are picked off with tweezers, the surface is brushed, and then given a few bursts of compressed air. This process is important because in close-up even dust will be visible in the photograph.

11 The rounded shape of the carving leaves no serious shadows, and the side or front reflectors often used to reduce contrast are not necessary. The recessed part of the neck, however, is felt to be just a little dark; to relieve this, a small mirror on the end of an adjustable arm is positioned just out of camera view.

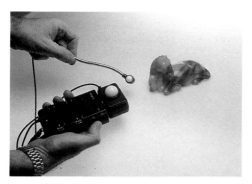

6 The main overhead light is measured: this, rather than any other lamp, will determine the exposure. A miniature extension probe is used to take precise incident readings from different parts of the carving. Allowing for the bellows extension on the camera, the light intensity is enough for an aperture setting of just over *f* 32, which will give good depth of field.

7 To make a slight improvement to the sharpness, the front panel of the camera is tilted a little forwards, and then swung a fraction to the left. These two small movements serve to align the plane of sharp focus more towards the axis of the carving.

8 A second flash unit is positioned underneath the light table, pointed upwards to create a back light for the picture. Because a slightly concentrated effect is wanted, shading away from the center of the picture, the flash is used naked. The translucent acrylic of the light table gives some diffusion, and the loss of focus on the background gives the appearance of more.

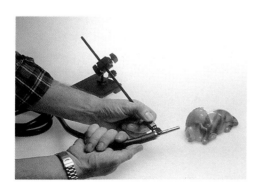

12 To produce a tiny catchlight in the eye of the horse without changing the lighting that has already been built up, a fiber optic is positioned with a clamp on the left, just out of the frame.

13 The other end of the fiber optic is attached to a third flash head, placed under the table for convenience.

14 With the lighting set complete, the effect is judged on Polaroids before shooting on normal film.

Back Lighting and Base Lighting

This is the studio version of shooting against the sun. To be more accurate, it compares best with shooting into a reflection of the sun, as in the photograph of the moose on page 38, or into twilight; the usual techniques are designed to create a broad background of light rather than a point source. Studio back lighting normally has one of two uses. Alone, or with minimal fill from the front, it provides the setting for a silhouette. Used with stronger frontal or side lighting, it ensures a clean, bright background, without shadows. The real skill with back lighting is in knowing how to control the shape and evenness of the area. The most difficult of all is a completely even

light from one side of the picture area to the other, on a large scale.

It sometimes helps to think of this kind of lighting as similar to the broad area lights that we looked at on pages 124–9. In this case, however, they are used facing the camera rather than out of frame to one side or above. Refer back to those pages, and you can see that there are several translucent materials that will do the job of diffusion well enough, but very few that are completely textureless. This is critical if the light is to form the background to the shot. There should be no wrinkles, streaks, spots of dirt, or even pattern in a fabric. To an extent, the distance of the back light behind

Basic technique
For a straightforward set-up, place two lights on either side of the background, aiming them inwards so that the beams cross. Check with a hand-held meter that the illumination is even across the area, adjusting the light positions as necessary. Diffusers can be added later if wanted.

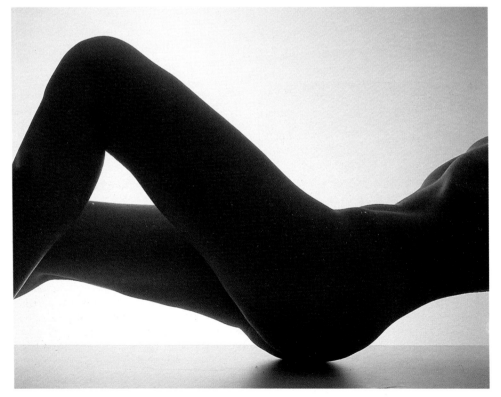

Back lighting by reflection
Back lighting, already demonstrated on pages 158–9, is used here to silhouette a girl's legs. To give a shading effect on the white wall background, the lamps were fixed at ground level, pointing upwards. Sheets of translucent acrylic diffused the light to give even illumination, and the lights were concealed from view by placing them under the low table used as a base.

a subject will help to make some of these less obvious because they are likely to be partly out of focus, but the best precaution is to use only a completely smooth material, like acrylic.

The chief problem with a direct back lighting source is to make the illumination even. Although there are many occasions when it is preferable to have a concentrated back light, as in the photograph of the jade horse on page 172, this is relatively simple. With a single lamp, there are two basic ways of evening out the light: one is to increase the thickness of the diffusing material, the other is to spread the beam. Both reduce the light level. The most efficient way of increasing the diffusion is in two stages, by placing a smaller diffusing sheet in front of the lamp. To spread the beam, either adjust the beam focus control on the lamp (if it has one), or move the light further back. It also helps a little to position bright reflectors at the sides, to throw some light onto the edges of the main back lighting sheet. Adding extra lamps makes it possible to overlap the beams, but even this needs care and skill. Usually, it is easier to produce an even spread if you cross the beams, aiming each lamp towards the farther side of the back lighting sheet.

With all these methods, do not rely on your eye to judge the evenness, but use a hand-held meter taking a series of readings all over the back lighting sheet. To measure the light for exposure, the most straightforward method is to use a hand-held meter at the position of the subject, aiming away from the camera towards the back light. If you use the reflected light setting, without the meter's translucent dome, the exposure should be between 2 and 2½ stops more than the meter reading to give a clean white effect. If you use the reflected light setting, take the reading exactly as it is. If, instead of shooting a silhouette, you combine the back light with a normal frontal, top or side light on the subject, you will need to balance the light levels from the two lamps.

Direct back lighting is not the only

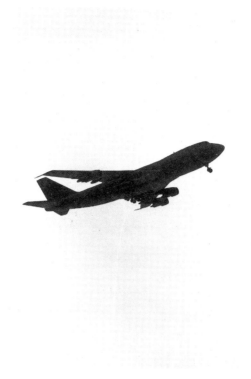

method. Reflected back lighting is in many ways simpler to arrange, and is the only practical system for a large area. The basic requirement is a clean unmarked white wall or similar surface. Aim concealed lights at this, making sure that they do not spill onto the subject: it is easier if the background is well behind the subject, and if the lights are flagged. For even lighting, use at least two lamps, crossing the beams as explained above. Four lamps, one for each corner of the picture area, are better.

Concentrated back lighting is often more interesting, giving a soft framing effect to a central image of the subject. This is easy enough to produce with a single lamp used quite close to the wall. If the wall is out of focus when the picture is taken, the shading effect will be softer. Compare this with the photographs of twilight on pages 24 and 44.

Back lighting by transmission
To produce a realistic silhouette of a model aircraft (used later in a sandwich with a stock shot of a sky), lights were aimed through a thick sheet of translucent acrylic. The model, painted black to give the maximum silhouette, was suspended on a short arm concealed from view by the camera angle.

With all back lighting, take precautions to protect the lens from flare, masking down to the edges of the picture area.

Base lighting
Base lighting is a variation on back lighting in which the lighting direction is upward. If the objects are sitting directly on the diffusing sheet, and the angle is normal (somewhere between horizontal and pointing slightly downward), the effect is of light shining up from around the base. This usually produces its most interesting effects if the objects are transparent or translucent. There is no clear dividing line between back lighting and base lighting, as the use of a curved light table on pages 172–5 demonstrates. The main differences are structural ones, in positioning the equipment and materials.

Project: Coloured back lighting

As long as the back light or base light is intended to be a clean, bright white, there is usually no conflict between it and any other light source. However, if you need it to be a certain colour, and so a certain tone, there is a real danger that any frontal or side lighting that you use to illuminate the subject will spill onto the diffusing sheet that is being used for the back light. The effect will be to drown the colour. The only answer is to separate the two kinds of lighting when you expose the film. This means making two exposures on the same frame: one with just the back lighting, the other with the frontal light only and the background blacked out. This is straightforward but a little tricky to manage without disturbing the camera or the set. With a horizontal camera angle and upright back lighting sheet, the easiest way of blacking out the background is to drape black velvet over the back lighting sheet for the frontal light exposure.

In the example here, which is structurally more complicated, the same principle is used, but with an upward-pointing light. For this project, reproduce the arrangement for yourself. A 2 foot square (0.6m) area light on a flash unit provides the source of the base light, and this is further diffused with a sheet of translucent acrylic to even out the illumination. Blue lighting gels are placed between the two. A glass sheet is placed above all these, leaving a gap underneath for the black velvet. Finally, the subject is placed on the glass sheet and a second light positioned to illuminate it, taking care with the lighting angle to avoid any reflection appearing in the glass. Add a reflector if necessary.

Measure the exposures for the two lights separately, and adjust the power settings on the flash units (or exposure times if tungsten lamps are used) so that they balance. For the first exposure, push the velvet into the gap beneath the glass, and use the side light only. For the second exposure, carefully pull the velvet out

(taking care not to move anything else), switch off the side light and shoot with the base light. If you use flash, avoid disturbing the camera by using a short extension synchronization cable rather than changing the two synchronization cables from the lights directly into the camera's socket. For comparison, take three other pictures: one with the side light only, one with the back light only, and the third with both together, less the black velvet.

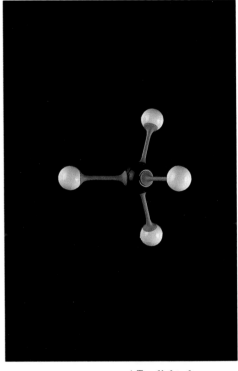

▲ **Top light alone**
The first exposure used black velvet to keep the background unexposed.

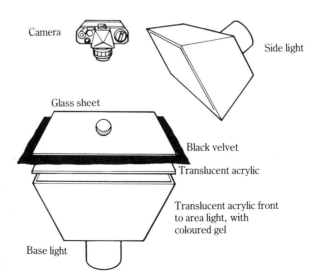

Camera

Side light

Glass sheet

Black velvet

Translucent acrylic

Translucent acrylic front
to area light, with
coloured gel

Base light

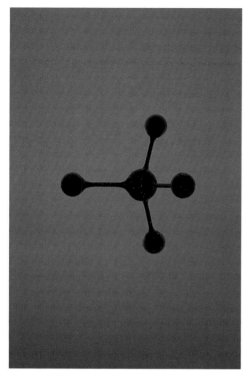

▲Back light alone
Without the black velvet, the background alone is recorded.

▼Top light
In the first exposure, the model is lit from above; black velvet underneath keeps the background unexposed in readiness for the second exposure.

▲Double exposure
When combined, the two exposures illustrated *left* give this final version.

▼Back light
For the second exposure the black velvet is withdrawn, the top light switched off, and back lighting used alone, with coloured gels.

▲Single exposure
If the two lighting techniques were used simultaneously, the top light would wash out the colour of the background.

Rim Lighting

In this lighting technique the edge or rim of the subject is picked out against a dark background. Go back for a moment to pages 38–9 and see how this effect occurs naturally in sunlight. The studio sets for rim lighting are designed to imitate this. The most dramatic, high-contrast effects are when there is no other kind of lighting used, and the brightly-lit edge defines the shape of the subject. The subjects that respond best to this kind of lighting are those with relatively simple, clear outlines. Projections tend to confuse the image, particularly if they cast shadows across the brightly-lit line of the edge. Rim lighting is also used as additional illumination, particularly in portrait, fashion and beauty photography.

The simplest rim lighting technique is to mimic sunlight: a single direct lamp aimed at the subject from behind, either by the subject if exactly behind, or by being positioned out of frame. If out of frame, it may be necessary to concentrate the beam, or at least to prevent it from spilling either onto the lens or onto other parts of the scene. If the width of the beam just covers the subject, the rim lighting effect will be at its strongest.

The essential precaution in rim lighting is to keep the background dark. Not only must the material be black, but it must be shielded from the light. One way of doing this is to have the background well behind the light; another is to have it between the light and the subject, with the beam passing close to its edge.

The exact rim lighting effect depends very much on the texture of the subject. Hair, fur and similar textures are very good at reflecting and refracting the light, and a single beam can create quite a strong halo, as the photograph on this page shows. Smoother surfaces, however, show less of a bright edge, and may need more than one light to show the complete outline of an object. The lighting set *opposite* has been set up for rim lighting with two lamps. Subjects with shiny surfaces will produce only small, highlight reflections from naked

Normally used in combination with standard frontal lighting, a common use of rim lighting is to highlight the edges of a model's hair. The technique used here is to position a lamp directly behind the model, facing forwards and undiffused. Some beam control may be necessary, with barndoors or even a snoot.

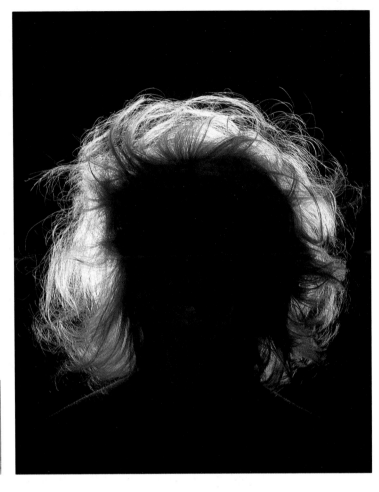

lights; in this case, an area light, or better still, a strip-light, will spread the reflection more evenly.

To measure the light for exposure, use a hand-held meter and an incident light setting. Hold the meter close to the lit edge, and aim it towards the light. This will give the minimum exposure for an outline effect; however, to make the edge appear distinctly bright, and even glowing, increase the exposure by 1 or 2 stops. It is usually worth bracketing exposures to give you a choice later, or making a Polaroid test.

Darkfield illumination is essentially this same method of lighting the edges of a subject, but on a small scale. The term comes from photomicrography and photomacrography. The structural requirements are different because of the scale: the view is usually vertically downwards, with the subject resting on a glass sheet and the lights below. As many subjects at this macro and close-up scale are quite thin – often only a few millimeters – they are also often translucent, and this can produce even more interesting lighting effects.

Project: Darkfield lighting sets
Follow the example shown here as closely as you can.

Another rim-lighting
technique, more useful
with objects that are too
small to conceal a lamp
behind them, is to direct
to lights from behind and
slightly to the side, with a
dark background. To
avoid flare, the lamps
should be heavily flagged
or fitted with snoots.

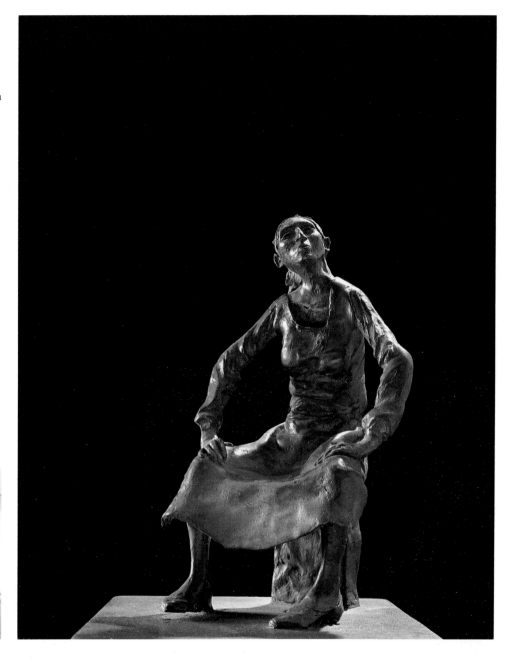

Ring Flash and Axial Lighting

Axial lighting is precisely frontal, following the axis of view through the camera's lens. No shadows at all are visible, and it is this that makes axial lighting worth the effort to create it for a few special situations. There is only one way of making true axial lighting – by splitting the beam in front of the lens – but there are, however, some close equivalents.

First, the beam-splitting method. This is how a front-projection system works, and it is possible to make something similar yourself. The principle is that a semi-silvered mirror directly in front of the lens is angled to reflect a beam of light straight forward. Being semi-silvered, it only dims the view through the lens instead of blocking it, as would an ordinary mirror. If it is positioned at exactly 45° to the view, and if a light shines onto it at 90° to the view, the beam travels precisely along the lens axis, in exactly the direction you see when looking through the viewfinder. In principle, there is no more to it than that, although setting up camera, light and mirror in alignment may demand some ingenuity. A less efficient version is possible with a thin sheet of ordinary glass (this and the semi-silvered mirror must be thin in order to avoid serious loss of image quality). Try this on a number of different subjects. The most obvious feature is the total lack of shadows; some edges that curve away from view may appear darker, but that is all. Backgrounds are dark due to the light fall-off away from the camera, exactly as with portable flash, but all fairly shallow subjects become images purely of tone and colour.

Another quality is that shiny surfaces that are face-on to the camera reflect the light back exactly into the lens. This is the origin of red-eye reflections in portraits, and the way that a front projection screen works. The screen is coated with large numbers of extremely small transparent spheres. These, like the retina and cat's-eye reflectors on highways, reflect only directly back to the viewer. The projected image in a front projection system travels along the line of view, and then back from the screen to the lens; it is invisible from any other direction. These screens are made of 3-M Scotchlite; buy some of this and experiment with your own beam-splitting mirror.

The final interesting use of axial lighting is that the lamp, however large, can be positioned out of the way. In close-up photography, where the working distances are all extremely small, this can be a considerable advantage.

For field photography of insects, ring flash has the advantage of giving predictable exposures (being attached to the lens), and casts no shadows from leaves slightly out of the line of view. It was used here for a shot of a feeding praying mantis in Guyana.

Although direct reflections from shiny surfaces are a problem with ring flash, on occasion they can be a bonus. Here, the axial lighting direction brings out the strong irridescence on a butterfly wing.

A ring light comes as close as possible to axial lighting while still using direct illumination. The lamp surrounds the lens, so giving a different type of shadowless light, in which the thin shadows from each side are cancelled out by the light from the opposite side. The conventional design is a flash unit that fits onto the front of the lens; a tungsten lamp powerful enough to give efficient lighting at normal distances would be too hot. In a special design of lens for medical use, the ring flash is integrated, and different levels of magnification are achieved by means of a set of supplementary lenses. The principal use of ring flash is for close-up and macro pictures; it is at these scales that strong shadows are often unavoidable with ordinary lighting because of the difficulty of positioning lamps close enough to the subject.

The time *not* to use axial lighting is when an important surface is both shiny and flat to the camera, as in this example of a seal (*above*). The normal lighting version, *above right*, is with a flash positioned at an angle of about 45°, and is more successful.

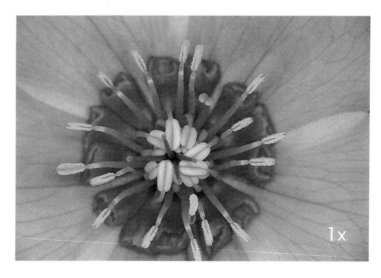

The stamen of a flower, deeply set among the petals, is an ideal subject for axial lighting. No strong shadows are cast.

Half-reflecting mirror
This home-made axial light arrangement uses a normal small portable flash and a thin sheet of glass angled in front of the lens at 45°. Light from the flash head strikes the glass; some of it passes straight through and is lost to use, but the remainder is reflected by the glass towards the subject along the axis of the lens.

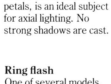

Ring flash
One of several models, this ring flash is typical in its two-part construction: the flash tube itself encircles the lens, while the power pack/capacitor is separate. As the ring flash must be attached to the front of the lens, most will fit only a limited range of diameters.

A Nikkor medical lens is a fixed-focus macro lens with ring flash built in. Supplementary lenses are used to vary the scale of magnification, and focusing is done by moving the camera or subject – this is normal practice in macro work.

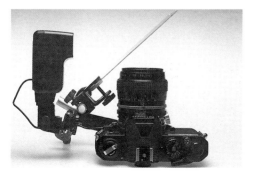
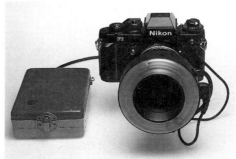

Special Light Sources

There are a number of light sources that, although used specifically for photography, are needed only occasionally and have unusual characteristics. These mainly use limited wavelengths.

Ultraviolet

Although ultraviolet is, by definition, invisible, most ultraviolet lamps emit a spread of wavelengths, at least some of which are visible. Treat what you can see only as a guide, not as a representation of exactly what the photograph will show. Colour film will record ultraviolet as a colour somewhere between violet and blue, depending on the wavelengths of the source, the dyes in the film and the exposure. If you use a filter that blocks all visible light, the film will record only the ultraviolet emission.

The most distinctive characteristic of a strong ultraviolet source is the fluorescence it creates in certain materials. White fabrics usually appear intensely blue-white because of the fluorescers deliberately included in modern detergents. Other dyes can have even more spectacular effects, such as those used in security printing as shown here. Weaker ultraviolet sources, such as sun-tanning lamps, simply appear more blue to film than they do to the eye.

Exposure is difficult to measure because the response of light meters is not the same as film at these wavelengths. Either bracket widely around the reading (by several stops) or make a test on instant colour film (Polachrome is 35mm) and still bracket.

Lasers

A laser is the ultimate in restricted wavelength, and this is determined by the materials used in its construction. The most commonly available are He-Ne (helium-neon) lasers, and these produce a red light. There is no way of filtering a laser and changing the colour, simply because it is a precise wavelength. The beam is also almost perfectly parallel, and hardly spreads at all, however many times it is reflected. The way of producing an apparent spread is

To reduce the natural reflectivity of this shell, the studio flash was covered with a sheet of polarizing material, and the camera lens then fitted with a polarizing filter. The combined polarization cut virtually all the reflections.

Ultraviolet lamps give an intense blue on colour film, which can occasionally be useful for surrealistic effects. The lighting used here for an image of cryonic suspension was a tanning lamp.

Here, an ultra-violet light source has been used to reveal security threads in West German banknotes. These threads, laid into paper during manufacture, have been dyed to fluoresce under ultraviolet light.

to pass the laser·beam through a lens or some multiply refracting medium, such as certain plastics or liquids. If you play the beam in a pattern directly over a surface, the result on film will be a pattern of lines. To photograph the path of a beam, pass it through smoke; it will reflect off the small particles in its path. If you are photographing laser beams in a clean environment, you may not be permitted to use smoke, as it would damage delicate optical surfaces. Instead, hold a cigarette paper in the path of the laser, and move the paper to trace out the path of the beam during a long exposure: the brilliant, moving spot of light on the paper leaves a trail on film.

Exposure is largely a hit-or-miss affair, and there is no point in attempting to use a meter. Overexposure has remarkably little effect, however: the red light from a helium-neon laser will still look red after many times the exposure it needs to register on film.

Polarized light

Unlike sunlight, the beam from a photographic lamp is not naturally polarized. It can, however, be made so by covering it with a sheet of polarizing material. If this is done a polarizing filter over the lens will have its usual effect of reducing reflections from non-metallic surfaces. More interestingly, cross-polarization can be used to display stress effects in certain plastics. The strongest way of doing this is as shown here – with polarized back lighting. Judge the effects by eye through the viewfinder.

The polarizing sheet and filter will each reduce the light intensity reaching the film. The amount varies with the type, but is about 1½ stops for each. Note that in back-lit cross-polarization the background will be between white and deep blue-violet, depending on the angle of the polarizers to each other. If the object is small and the background relatively large, this will affect the exposure (and may also create flare in the white-background version).

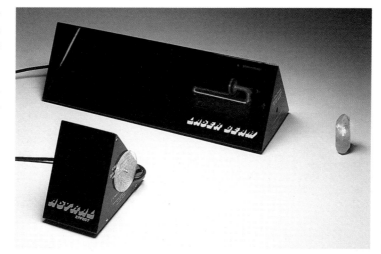

A low-powered helium-neon laser is ideal for colour photography. The beam, although invisible in dust-free air, gives an intense red when refracted and reflected. In the photograph *below*, the laser beam illuminates quartz prisms used in an Apollo moon experiment.

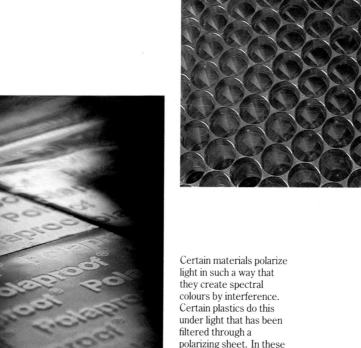

Certain materials polarize light in such a way that they create spectral colours by interference. Certain plastics do this under light that has been filtered through a polarizing sheet. In these security tabs made by Polaroid, the plastic and polarizer are sandwiched together.

Glossary

Area light Diffused photographic lighting in the form of a box that encloses the lamp, fronted with a translucent material. The effect is similar to that of indirect daylight through a window.

Axial lighting A method of illuminating a subject in which the light travels along the lens axis, thereby casting no visible shadows. The normal method is by using an angled half-silvered mirror, and is a part of front-projection systems.

Back lighting Lighting from behind the subject directed towards the camera position.

Barn doors Adjustable masks fitted to the front of a photographic lamp to prevent light from spilling at the sides. Consists of two or four hinged flaps on a frame.

Base lighting Lighting from underneath the subject directed up.

Beam candlepower-second (BCPS) A unit of measurement of the maximum light output of a lamp in a reflector. It is commonly used to measure the output of electronic flash.

Boom Lighting support in the form of a metal arm that pivots on a vertical stand. It is generally counter-weighted and adjusts laterally. Useful for suspending lights high over a subject.

Bounced light A method of increasing the area of illumination, and thereby diffusing the light, by aiming a lamp towards a large reflecting surface, such as a ceiling.

Candela Unit of intensity of a light source, derived from the candle, and now defined as $\frac{1}{60}$ the density of 1 cm^2 of a blackbody radiator at the freezing point of platinum. Carefully calibrated tungsten lamps are used as working standards.

Capacitor Electrical device that allows a charge to be built up and stored. An integral part of electronic flash units.

Colour balance The adjustment of any part of the photographic process to ensure that neutral greys in a subject will have no colour bias in the image.

Colour bias/colour cast Overall tinting of the image towards one hue.

Colour temperature The temperature at which an inert substance glows a particular colour. The scale of colour temperature significant for photography ranges from approximately 2000 K (reddish colours) through 5400 K (white) to above 6000 K (bluish colours).

Darkfield lighting Lighting technique used in photomacrography and photomicrography, in which the subject is lit from all sides by a cone of light directed from beneath the subject; the visible background remains black.

Diffuser Material that scatters transmitted light, so increasing the area of illumination.

Diffusion The process of scattering light to soften the illumination.

Direct reading Common term for reflected light measurement. *See* **Reflected reading.**

Dolly A rolling trolley to support either a camera tripod or a light stand. The wheels can be locked for stability.

Double exposure Making two separate exposures on one frame or sheet of film.

Electronic flash Artificial light source produced by passing an electric charge at high voltage through an inert gas in a sealed transparent container. The colour temperatures in photographic systems is usually 5400 K, the same as standard daylight.

Exposure In photography, the amount of light that reaches the film. It is a product of the intensity of the light and the time it is allowed to fall on the film.

Exposure value (EV) Series of values for light that link the shutter speed and aperture. A single EV number can represent, for example, $\frac{1}{60}$ second at f 5.6 and $\frac{1}{250}$ second at f 2.8.

Fiber optic Optical transmission system in which light is passed along flexible bundles of light-conducting strands. The light is reflected with great efficiency within each fiber in the bundle.

Fill light Illumination of shadow areas in a subject.

Flag A matt black sheet held in position between a lamp and the camera lens to reduce flare.

Flare Non-image-forming light caused by scattering and reflecting in the lens. It degrades the image quality.

Flash bulb Transparent bulb containing a substance that ignites with a brilliant flash when a low-voltage charge is passed through it. Flash bulbs are expendable, but are now much less common than electronic flash.

Flash synchronization Camera system that ensures that the peak light output from a flash unit coincides with the time that the shutter is fully open.

Fluorescent Material that emits light when exposed to invisible short-wavelength radiation, or that converts a wavelength of light energy to a longer wavelength. A fluorescent material is added to some photographic papers to make the white areas on the print appear lighter.

Fog filter A diffusing filter used in front of the camera lens to simulate mist or fog.

Fresnel lens An almost flat lens that has the properties of a convex lens, by means of a series of concentric circular stops. Combined with a focusing screen, it distributes the image brightness evenly, performing the same function as a condenser lens.

Gelatin filter Thin coloured filters made from dyed gelatin that have no significant effect on the optical quality of the image passed.

Graduated filter Clear glass or plastic filter, half of which is toned, either coloured or neutral, reducing in density towards the center, leaving the rest of the filter clear. It can be used to darken a bright sky, or for special effects.

Grey card Card used as standard subject for a reflected light meter such as the TTL meter in a camera. It reflects 18 per cent of the light striking it, and represents mid-tones in the subject.

Halogen Name for the chemical group that includes the elements bromine, chlorine and iodine. Silver compounds of these elements form the light-sensitive crystals used in most photographic emulsions.

Heat filter Transparent screen used in front of a photographic lamp to absorb heat without reducing the light transmission.

Highlights The brightest areas of a scene, and of the photographic image.

Hot shoe Fitting on a camera body similar to an accessory shoe, but containing the electrical contacts necessary to trigger a flash unit when the shutter release is pressed.

Incident light reading Exposure measurement of incident light, made with a translucent attachment to the exposure meter. This reading is independent of the subject reading.

Interference The variation in energy level caused by the superposition of two waves of nearly the same wavelength. Colours in soap bubbles and oil films are caused by interference between a direct and a reflected wave. Lens coatings function on a similar principle.

Illuminance Measure of the strength of the light received at a point on a subject.

ISO Current, internationally accepted film speed rating (International Standards Organization) made up of the ASA/DIN ratings (commonly abbreviated everywhere except Germany to the ASA rating).

Joule Unit of output from an electronic flash, equal to one watt-second. This measurement permits the comparison of the power of different flash units.

Kelvin (K) The standard unit of thermodynamic temperature, calculated by adding 273 to °C.

Key light The main light source.

Key reading Exposure reading of the key tone only.

Key tone The most important tone in the subject being photographed, as judged by the photographer.

Kilowatt Unit of electric power, equivalent to 100 watts.

Light box Translucent surface illuminated from behind by fluorescent tubes balanced for white light, used for examining transparencies or negatives.

Lux Unit of measure of illuminance.

Mired Abbreviation of *micro-reciprocal degree*, a notation for colour temperature that is sometimes used for calculating the appropriate colour-balancing filters needed with different light sources. The mired value of any light source is 1 million divided by the Kelvin value.

Mixed light Different types of light source combining to illuminate a single scene.

Modelling lamp The continuous-light lamp fitted next to the flash tube in studio flash units that is used to show what the lighting effect will be when the discharge is triggered. Modelling lamps are usually low-wattage and either tungsten or fluorescent, and do not interfere with the actual flash exposure.

Multiple flash The repeated triggering of a flash unit to increase exposure (with a static subject). Sometimes also called serial flash.

Mylar A specular flexible mirror surface available in sheets.

Nanometer (nm) Unit of measurement, equal to one billionth of a meter, used to measure light wavelength.

Neutral density filter Grey filter that reduces exposure to the film when placed over the lens, without any alteration to the colour.

Opalescent The milky or cloudy white translucent quality of certain materials, valuable in the even diffusion of a light source.

Outrig frame Open metal frame that fits in front of a lamp and can be used to carry filters, gels or diffusing material.

Pantograph In photography, a device constructed of interlocking, pivoted metal arms that allows the extension and retraction of lamps.

Photoflood Over-rated tungsten lamp use in photography. Being run at a higher voltage than normal, the light output is increased, and the colour temperature can be balanced at 3200 K or 3400 K, but the life of the lamp is correspondingly short.

Photographic lamp Any lamp specifically designed for photography – that is, having a consistent light output and at a recognized colour temperature (usually either 3200 K or 3400 K).

Prism Transparent optical element with flat surfaces shaped to refract light.

Radiation Process of emitting energy.

Reflected reading Exposure measurement taken directly from a subject of the light reflected from it. The normal method of TTL systems.

Reflector Surface that reflects light aimed at it. The shine and texture of the surface, as well as the colour and tone, determine the quality of the reflected light.

Refraction The bending of light rays as they pass through a transparent material.

Ring flash Electronic flash in the shape of a ring, used in front of and surrounding the camera lens. The effect is virtually shadowless lighting.

Scrim Mesh material placed in front of a lamp to reduce its intensity, and to some extent diffuse it. One thickness of standard scrim reduces output by the equivalent of about 1 *f*-stop.

Serial flash *see* **Multiple flash.**

Shadow detail The darkest visible detail in a subject or in the positive image. Often sets the lower limit for exposure.

Skylight Light reflected from the atmosphere which, together with direct sunlight, makes up daylight. Generally bluish, skylight causes outdoor shadow areas to reproduce as bluish in colour photographs.

Snoot A tapered black cone that fits at the front of a lamp, to concentrate the light into a circle.

Spotlight A lamp containing a focusing system that concentrates a narrow beam of light in a controllable way.

Spot meter Hand-held exposure meter that measures reflected light from a very small area of the subject. The angle of acceptance is often only 1°.

Strobe Abbreviation for "stroboscopic light". A rapidly repeating flash unit that can be used, with multiple exposure and moving subject or camera, to produce a distinctive type of multiple image.

Thyristor circuit Electronic device used in electronic flash circuits to stop the electric charge when the photosensor indicates that enough light has reached the subject for correct exposure.

Through-the-lens (TTL) meter Exposure meter built into a camera, measuring reflected light from the subject.

Tungsten light Artificial light created by heating a filament of tungsten wire electrically to a temperature at which it glows.

Tungsten-halogen lamp Tungsten lamp of improved efficiency, in which the filament is enclosed in halogen gas, which causes the vaporized parts of the filament to be re-deposited on the filament itself rather than on the envelope.

Watt Electrical unit of power. The wattage of tungsten lamps indicate their relative light output.

Watt-second Unit of energy, equal to one joule.

Selected Bibliography

Adams, Ansel, *Examples*: *The Making of 40 Photographs*, New York Graphic Society, Boston, 1983.

Adams, Ansel, *Natural Light Photography*, Morgan & Morgan, 1952.

Adams, Ansel, *Yosemite and the Range of Light*, New York Graphic Society, Boston, 1979.

Focal Encyclopaedia of Photography, Focal Press Ltd, 1978.

Freeman, Michael, *Concise Guide to Photography*, Collins (UK); Amphoto (US), 1984.

Freeman, Michael, *The Photographer's Studio Manual*, Collins (UK); Amphoto (US), 1984.

Haas, Ernst, *The Creation*, Penguin Books, 1978.

Langford, Michael, *The Complete Encyclopaedia of Photography*, Ebury Press, 1982.

Meyerowitz, Joel, *Cape Light*, New York Graphic Society, Boston, 1978.

Porter, Eliot, *Intimate Landscapes*, Metropolitan Museum of Art/E. P. Dutton, 1979.

Samuelsone, David W., *Motion Picture Camera and Lighting Equipment*, Focal Press Ltd, 1977.

The Manual of Photography, Focal Press Ltd, 1971.

Magazines
American Photographer
Modern Photography
Popular Photography
Zoom

Index